CUBS 100

• DAN CAMPANA & ROB CARROLL •

CUBS 100

A CENTURY AT WRIGLEY

Introduction by Len Kasper

THE
History
PRESS

Published by The History Press
Charleston, SC
www.historypress.net

Copyright © 2016 by Dan Campana and Rob Carroll
All rights reserved

First published 2016

Manufactured in the United States

ISBN 978.1.46711.802.6

Library of Congress Control Number: 2015956829

CONTENTS

CONTENTS

CONTENTS

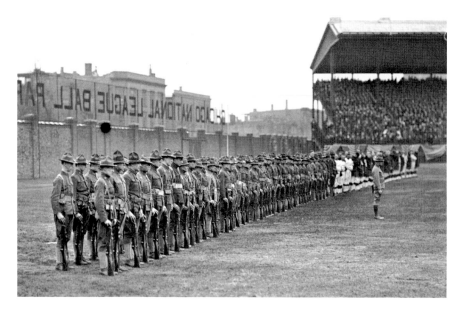

Pregame ceremonies took place before a packed Wrigley Field for Opening Day in 1917, the second season the Cubs called the ballpark home. *National Baseball Hall of Fame Library, Cooperstown, New York.*

PREFACE

Cubs 100: A Century at Wrigley brings together a collection of uniquely personal memories and some of the biggest moments at the Friendly Confines to try to explain the undeniable relationship linking Chicago's North Side team to its home since 1916. From the ballplayers who took the field to the fans in the stands, there have been many witnesses to the baseball history on display at Clark and Addison over the last century. Those voices tell the Wrigley-Cubs story best.

The book's life began to take shape just as Wrigley started to change after the 2014 season. Rob made regular trips to observe the historic renovations in their early stages. By January 2015, he and Dan had set out to find the storytellers you'll find in these pages. Many e-mails and phone calls—not to mention considerable help from folks you'll find in the acknowledgements—were needed to land some of the notable names who shared their stories. Interviews took place over the phone or in person, while some stories were collected through e-mail. Every story in the book was written by Dan or Rob or edited from a requested submission. Although the Chicago Cubs are referenced throughout the book, *Cubs 100: A Century at Wrigley* is not affiliated with the team.

ACKNOWLEDGEMENTS

This book could not have been created without the help and support from some truly wonderful people. In particular, we'd like to show our appreciation to the following folks (in no particular order) who made a big difference—in their own special ways—during this project:

John Horne with the National Baseball Hall of Fame; Paul Johnson; Shawn Touney with the Kane County Cougars; Bob Horsch (horschgallery. com); Fran Sylve; Denise Crosby; Lowery Organ Company; Kristen Taylor; Sandra Fugate; Jon Erik Alvarez with the Miami Marlins; Paul Campana; Victor Gonzalez; Rebecca Hale with the Seattle Mariners; Joe Ahern; Greg Casterioto with the Philadelphia Phillies; Louis Barricelli with MLB Network; Jim Anixter; Brian Corbin; Rachel Levitsky with the Major League Baseball Players Alumni Association; Vector Management; Rich Buhrke; Jennifer Eckersley; John Nolan of the Fort Wayne Tincaps; Stewart McVicar; Wes Jameson; Tom Nichols of the Dayton Dragons; Tim Hagerty of the El Paso Chihuahuas; James Stack with the Clare Friars; Tony Andracki of Comcast Sportsnet Chicago; Michelle and Steve Cucchiaro; Bob Vorwald of WGN Sports; Tim Schonta; Kyle Dawson with the Sugar Land Skeeters; the Bensenville Public Library; the Elmhurst Public Library; the Schaumburg Public Library; the Poplar Creek Public Library for a distraction-free zone; Facebook Cubs fan groups; baseball-reference.com for countless pieces of game information and hours of silly distractions...and everyone who liked or followed us on Facebook and Twitter.

ACKNOWLEDGEMENTS

As you read the names attached to these one hundred stories, know we owe them the ultimate gratitude for contributing their time in the variety of ways they did.

A special thanks to…

John Richmond, Cynthia Abell, Eric Schmidt, Chris Davis, Chad Anderson, Terri Hilt, David Auberti, Ricky Hedrick, Krista Van der Leest, Peter Wilhelmsson, Len and Kim Duchnowski, Chuck and Jenn Kennedy, Keith Thoms, Tadd Swanson, Matt Junker, Pat Yarbrough, Corey Johnson, Tim Benker, Teresa Ruminski, Jen Slepicka, Kurt Van der Leest, Scott Nowling, Michael Mullen, Barrett and Brooke Sowizrol, Nancy Tiffen, Becca Broda, Grandma Strong and Rob's mom.

Rob would like to give a very special thank-you to his fiancée, Jillian, and their dogs, Benny and BlackJack, for putting up with him constantly talking about the Cubs and Wrigley Field.

Dan also wants to thank his family—Jen, Ryne and their little dog, Kaner—for their love, support and understanding every day of the year, especially when deadlines are looming.

And the biggest thank you of all goes to the 2015 Chicago Cubs for giving us, and all fans, a wonderful season to remember. Your on-field success brought life back to Wrigley and provided us with several deadline extensions.

STORIES FROM A CENTURY AT WRIGLEY FIELD

1. BECOMING A "CUB GUY" AT WRIGLEY

LEN KASPER, CUBS TV ANNOUNCER, 2005–PRESENT

The iconic nature of the ivy. The scoreboard in center. The contours of the bleachers. The funky way the wells work in each corner. There's no other ballpark like Wrigley Field in baseball, probably in the world for that matter.

It's always been a very special place because of all of the day games, the atmosphere and the fact that it was Chicago. This has always been viewed as, if not the number one city for players to travel to, certainly in the top two or three. So there was always a little extra juice, I guess, when you came to Wrigley.

The first time I was at Wrigley was 1992 as a Marquette student. I found a way to get a press pass for a Cardinals-Cubs game. I don't remember a ton about it, but I do remember seeing Harry Caray at the ballpark, which was a huge thrill. Even with the renovations going on and the like, when I walk in I know the ballpark is going to look exactly like it did it in 1992. That's the timeless nature of Wrigley. Over the years, we've heard from fans who came back to the ballpark for the first time since 1965 or their first time was in 1957. Just the idea that Wrigley remains the same place fundamentally as it was back then is pretty darn cool.

As tiny as the visiting television booth is here, I always viewed it as a special trip—never a time when it was routine coming to the ballpark. And

-

while I didn't do play-by-play, I was a small part of the Marlins radio crew in 2003 in the postseason. So I was at all of the games during that National League Championship Series, Games 6 and 7 included. I've never felt an atmosphere at a sporting event like I did in those games.

I'll never forget Game 1, when Sammy tied the game with a home run in the ninth off Ugueth Urbina. I was actually behind the Marlins dugout, so all I could really see when I looked out through the tunnel was the pitcher. I heard the crack of the bat and the crowd go crazy, and then I saw Sammy do his hop as he went past the dugout—I knew that we were probably going to extra innings. Then, for Game 6, I stood in the Marlins dugout when it ended because one of my jobs was to do an interview right after the game—and what that atmosphere was like. I had no idea two years later that I'd become the Cubs announcer. But to witness that whole thing, those two days, Games 6 and 7 at Wrigley Field, I really gained a big appreciation for how important the Cubs and that ballpark are to Cubs fans. And so, when I took this job, even though I was on the other side in '03, that experience being there during the NLCS, I think, was really important to me.

Nobody is prepared—and now I mean this in a good way—for what the Cubs thing is about unless you live it. There's nothing like it. And I feel the weight of Cubs fans, especially in the years like 2007, 2008, when you're right there and you've got a chance to win. When you win, the enormous elation; when you lose, the enormous disappointment. It's almost like I can feel it in my chest when I'm calling the game. And that doesn't exist elsewhere. It is a daily soap opera. Even in the years we've had recently, the season we lost 101 games, for that three-hour period, it matters a lot, and the Cubs always matter. As a team broadcaster, there's nothing better than to call games for a fan base that doesn't hang on your every word, but they hang on every pitch. So you know, just to be a small part of that is...is a huge honor and when people tell me within the business, "You have the best job in baseball," my answer is, "You're right."

Doing a home game at Wrigley Field is unlike doing a game at any other park because of all the other stuff going on. And it's always a challenge I love: the high-wire act of live TV and the fact that you never quite know what you're going to get in a seventh-inning-stretch guest. The one thing I do every day is I turn—because we're facing the camera and have our backs to the field—like twenty seconds before we go on the air to look over my shoulder at the flags because the wind can change in two minutes. The last thing I want to do is hit the air live at one o'clock and say, "Wind blowing

out" as you see the flags have now turned around and it's blowing in. That happens. And there's no other ballpark where the weather has such a big effect on the way that game is going to be played that particular day.

The uniqueness of the ballpark always helps in what we do. Obviously, you get more excited for games that matter more and...and for those big matchups when the crowd is really into it—that's easy to get motivated for. But it's easy for me to get motivated for any game at the big-league level and especially at Wrigley. No matter how interesting the baseball is, there's always stuff environmentally at the ballpark that we can talk about. We get good shots of fans doing fun stuff in the bleachers, the wind direction, the temperature, the seventh-inning-stretch guest. There are all these other things that we incorporate into just about every broadcast. I always try to be cognizant of the game being the number one thing, and when it's not a particularly compelling game, making sure that we're keeping people entertained. Especially with high definition now for every ballgame. I don't think anything looks better than a day game at Wrigley Field on the big HD screens in a lot of living rooms.

The ballpark does sell itself, and the experience sells itself. The benefit of being a TV announcer today with high definition is that it's so gorgeous. I'll often record games just to see what it looks like because we're in the booth and sometimes we don't get the same exact look that you get at home. I want to go back and go, "OK. How did somebody experience this sitting at their home watching this?" It's breathtaking.

By far, the most exciting call of my career came in late June 2007, Lou Pinella's first year at Wrigley. The Cubs were trailing the Brewers by six and a half or seven and a half games; it wasn't particularly close. We go to the bottom of the ninth, the Cubs have a runner on. First pitch from Francisco Cordero to Aramis Ramirez was a slider that Aramis hit out the ballpark, and the Cubs won the game in walk-off fashion. It was a total surprise. It came out of nowhere. I was not really a broadcaster in that moment. I was a fan. You can hear it in the call that I couldn't believe what I just saw. You could hear the excitement in my voice. I joked about how my voice cracked, and that was fine because it was a completely emotional, genuine reaction.

It turned out to be the game that turned the team's fortunes around in 2007. It's also a game a lot of Cubs fans remember. And if some fans were not quite sure if I was one of their guys, that was the day where I think a lot of people went, "OK. He's a Cubs guy."

Harry opened the door for every broadcaster who sits in that chair from here to eternity to be able to let his hair down whenever he wants to. I think

he felt this was the greatest place in the world and you should be here. I would never try to be Harry or mimic Harry. But I think he opened a lot of doors that we benefit from. Let's put it this way: We're allowed to have fun. We're allowed to get emotional. We're allowed to be fans at times, and I think that feels comfortable to a lot of Cubs fans.

2. Inseparable Icons

The Cubs and Wrigley

Cubs mythology exists for many reasons, not all of them good. Yet the lore and gore of the team's history would be diminished beyond recognition if the Cubs did not play on baseball's greatest stage: Wrigley Field. It is one of sports' greatest codependent relationships, a combination frequently challenged by outsiders

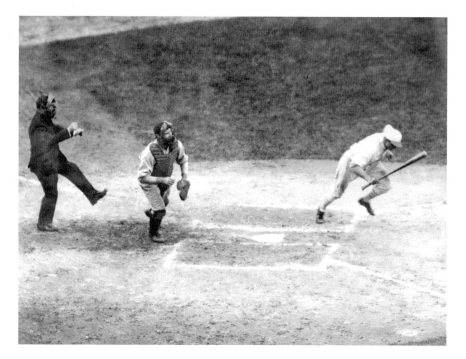

Jimmie Foxx leaves the batter's box after hitting a home run during the 1929 World Series at Wrigley Field. Foxx hit two homers in the series—both at Wrigley—as the Philadelphia Athletics beat the Cubs in five games during what was the early part of the Cubs' World Series drought. *National Baseball Hall of Fame Library, Cooperstown, New York.*

who, at different times throughout the years, suggested the ballpark's novelty is what put fans in the seats because the team on the field wasn't any good.

Born as Weeghman Field in 1914 on the grounds of a former seminary, the park at Clark and Addison became home to the Cubs in 1916, and in what would be considered a corporate naming agreement in today's

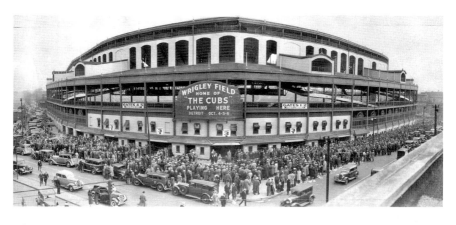

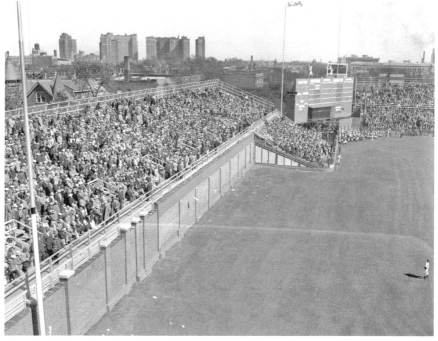

The Cubs and Detroit Tigers met in the 1935 World Series, with the Tigers winning the series in six games. Nearly fifty thousand fans filled Wrigley during each of Games 4 and 5. *National Baseball Hall of Fame Library, Cooperstown, New York.*

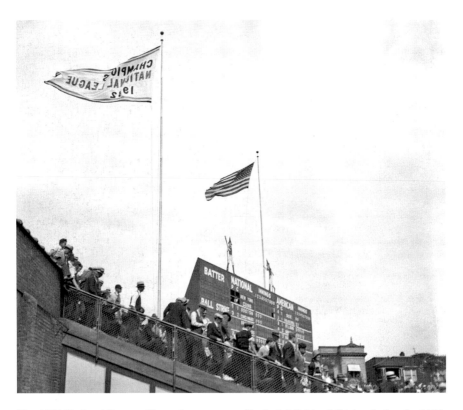

The 1932 National League Champions pennant flies in left field at Wrigley during the 1933 season. *National Baseball Hall of Fame Library, Cooperstown, New York.*

world, a decade later it was renamed Wrigley Field for William Wrigley Jr. of chewing gum fame. What has happened in the last century is equal parts astonishing, head scratch inducing and seemingly pure fiction.

The Cubs are most commonly known as "Lovable Losers," a moniker many true fans dismiss as quickly as the idea of cheering for the Cardinals. The first half of the team's tenancy at Wrigley was actually filled with World Series appearances, although none resulted in a championship. If you aren't aware, the Cubs haven't won a World Series since 1908.

Still, the Cubs won Wrigley-era National League pennants in 1918, 1929, 1932, 1935, 1938 and 1945 but went an unimpressive 2-11 in World Series games played at the Friendly Confines (the 1918 "home games" were played at Comiskey Park on Chicago's South Side because of its larger seating capacity).

The last Cubs World Series win at home came on October 8, 1945, in extra innings of Game 6 against the Detroit Tigers. Two days later, on October 10, the Tigers jumped out to an early lead in Game 7 and never

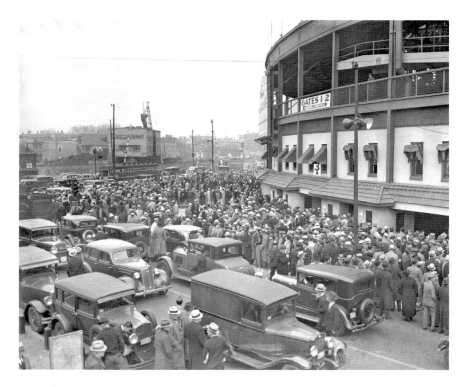

A massive crowd lines up at Clark and Addison before a 1945 World Series game. The Cubs, who lost the series to Detroit in seven games, haven't played a home World Series game since October 10, 1945. *National Baseball Hall of Fame Library, Cooperstown, New York.*

looked back to take the series. This began a wait that totaled 25,380 days as of Opening Day 2015 for another World Series game at Wrigley.

The history hasn't always been dim. For every small crowd that forced the closure of the upper deck in the 1970s, there was an exciting individual performance or milestone achieved between the lines within the park's brick, ivy-covered walls.

Sam Jones, Don Cardwell, Ken Holtzman, Burt Hooton and Milt Pappas all tossed no-hitters for the Cubs from Wrigley's mound. From the batter's box, Andre Dawson cranked his 400th homer, Ernie Banks joined the five-hundred-homer club and Sammy Sosa launched countless bombs, including key ones to pass Roger Maris's legendary mark, during the 1998 home run chase with Mark McGwire. And it wasn't just Cubs making history. Pete Rose tied Ty Cobb on the all-time hit list at Wrigley in 1985. Years earlier, in 1962, Stan Musial broke the then National League record for runs scored when he touched the plate for the 1,860th time.

St. Louis Cardinals legend Stan Musial crosses the plate to score his then National League record 1,860th run. It is one of the many milestones, by the Cubs and their opponents, achieved at Wrigley. *National Baseball Hall of Fame Library, Cooperstown, New York.*

Opposite, bottom: The Cubs demolished the right and left field bleachers after the 2014 season before reconstructing the iconic seating area. A cold Chicago winter delayed the work, which extended the ballpark's footprint farther onto Waveland and Sheffield Avenues and added two large video boards, and left the bleachers empty until May. Fans filled the stands throughout the season after the bleachers fully reopened in June. *Dan Campana photo.*

Gabby Hartnett's *Homer in the Gloamin'* in 1938, baseball's first-ever radio broadcast; Kerry Wood's twenty-strikeout game; and All-Stars galore have all added to the legend of the Cubs-Wrigley relationship since the team played its first game in the park on April 20, 1916.

Just as the Cubs have gone through a wide range of rebuilding efforts on the field over the years, Wrigley has itself undergone structural and cosmetic improvements. Most notably, major renovations began in 2014 with the tearing down and rebuilding of the legendary bleachers and installation of massive video boards.

Work continued into 2016, the Cubs' 100th season at Wrigley, with the construction of new team offices, parking and a plaza on what is commonly

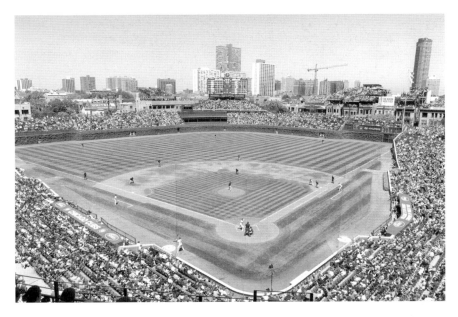

Looking out at Wrigley Field from the upper deck behind home plate is one of the most majestic views in all of sports. Seen here in 2013, the bleachers have undergone the most changes over the last century, including the 2014–15 renovation project. *Jenkins Imaging photo.*

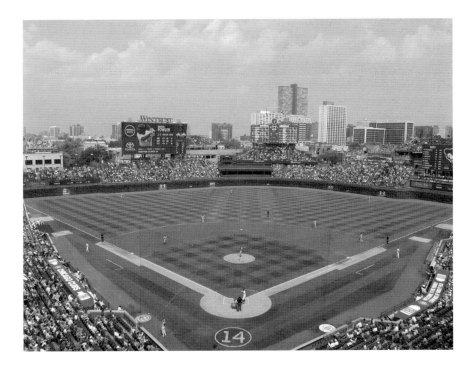

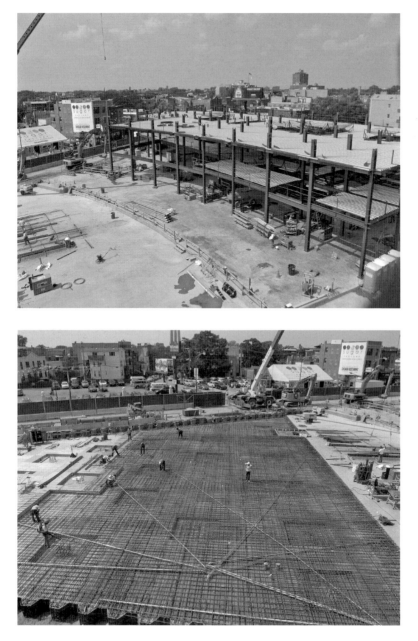

Commonly known as the "triangle" property, the stretch of land on Wrigley's west side along Clark Street previously housed a restaurant, player parking and even a car wash in recent decades. As part of the ballpark's renovation, this area will be home to a parking deck, team museum and other attractions. Beneath it, the Cubs will have a state-of-the-art clubhouse several times larger than their current locker room area. *Dan Campana photos.*

known as the "triangle" property near Waveland Avenue and Clark Street. Beneath that space, a new Cubs clubhouse—a truly modern clubhouse—is being built to finally bring player amenities into the twenty-first century.

With all change comes uncertainty and anxiety. The new video boards dwarf Wrigley's classic hand-operated scoreboard. The mere presence of the Jumbo Tron–style displays in left and right fields has pushed the legendary Ballhawks to near extinction as fewer baseballs reach Waveland and Sheffield. The hand wringing and criticism of the changes to Wrigley's look are on par with the way fans have sat in the stands for years and talked about the team on the field.

What is constant is Wrigley's endurance and the endearing quality of the Cubs. Neither is perfect, but neither would be the same without the other. Sports-talk chatter about moving the Cubs to the suburbs as a way to motivate a winning culture fell on deaf ears. The Cubs can win at Wrigley, not in spite of the classic baseball monument. And put just about any other baseball team in Wrigley to see if the devotion and dedication of its fans will be as strong for as long.

The seemingly infinite Cubs fan base nurtures both Wrigley's legacy and the eternal hope for the Cubs' success. Jersey-clad supporters of all ages are the fuel that keeps Wrigley and the Cubs in tandem on the journey. They don't do it blindly, as some accuse, but within the context of what is in their hearts—one team, one park, forever linked by a love of the game, an appreciation for their shared history and a sense of community forged on warm summer days and wind-blowing-in nights.

3. ME, MY WIFE AND WRIGLEY

DAN CAMPANA

It almost seemed too soon to ask the question, but sometimes you just have to go for it.

About six weeks earlier, I had met this beyond-cute, petite, brown-haired girl named Jen for the first time. She dressed nicely; I showed up with a well-worn Cubs hat on and a face covered with a few days' worth of scruff. A couple hours of talking sparked a relationship that was immediately fun and exciting for both of us as we sorted out the world just a few months into our post-college lives.

It must have been the buzz and energy of all the time we spent with each other that brought on the idea of asking her to take things to the next level so soon. And I knew there were risks because of what her dad would think. He certainly wasn't going to give his approval, but it never crossed my mind to ask him what he thought—he's a Sox fan, after all. Of course he'd object to me, this guy his daughter just met, wanting to take her to a Cubs game.

I didn't ask his permission, and Jen agreed to run away to the ballgame with me on a pleasant Sunday afternoon in May 2000. The ticket stub and some online searching reminded me of who the Cubs played (Pittsburgh) and how the game turned out (Cubs lost), but what remains crystal clear is the wonderfully perfect day we shared in the upper deck.

A couple of twenty-three-year-olds sitting at Wrigley chatting over a few beers with baseball in the background isn't hard to spot. We probably looked like any of the thousands of couples who dote and smile and sit slightly turned in green-colored seats toward each other as the game becomes an afterthought. Our conversations that day were silly and special all at once. We shared these little personal moments in a place that had always held such big meaning to me because of what happened on the field.

Author Dan Campana's parents met in the Wrigley Field bleachers, leaving little doubt about his future baseball allegiance. *Jenkins Imaging photo.*

I never enjoyed myself at Wrigley so much with baseball having so little to do with my mood.

Going to Wrigley for a Cubs game always gives me a feeling of family and warmth. She didn't have to be a huge sports fan, and it didn't matter to me that she claims she got booted from the ballpark her only other time at Wrigley. Being there with Jen for the first time—from the moment we stepped into the park until

we held hands on the postgame walk down Waveland Avenue—just felt right.

A year later, I asked her the other big question in our relationship, and we've been married since 2002. Eight years after our first Wrigley date, we brought our son to his first Cubs game.

Millions of fans step into the ballpark each season with hopes for a Cubs win to cap off their special day at Wrigley. The reality is that the volume of unique memories held in the hearts and minds of those who pass through the park's gates far outnumber the victories. And that's OK.

The stats show Kerry Wood got knocked around by the likes of Brian Giles and Kevin Young while Jen and I sat upstairs along the first base line, but I think we ended up with a win that day—and ever since.

4. Rod Blagojevich, John Cusack and Afternoons in the Bleachers

Rob Carroll

Wrigley Field is never going to be confused for Yankee Stadium when it comes to spotting celebrities in the stands. You can occasionally locate some familiar faces in the crowd that you may have only ever seen on a TV or movie theater screen. There are even some of them who forgo the luxuries of a private box to sit in the same hard plastic seats as the rest of us.

And it can be a welcome distraction when they do. For example, when the Cubs were down 11–0 to the Baltimore Orioles in the sixth inning of a late June game in 2008, you can bet I was roaming the stands to confirm rumors that John Cusack was in the ballpark. I would like to tell you we talked about the important role Chicago played as the backdrop for scenes in *High Fidelity* while sharing an Old Style, but I ended up seeing only the back of the actor's head while I stood at the top of his section. Finding John Cusack still proved to be much more rewarding than sitting in the bleachers in ninety-degree weather while the obscure Radhames Liz shut out the Cubs.

Your chances to rub shoulders with a notable name increase once you exit Wrigley. There is no underground parking for celebrities to sneak unnoticed out the backdoor. Outside the ballpark is where my most memorable celebrity encounter occurred.

Author Rob Carroll's first game at Wrigley Field in 1984 was followed by a Sha-Na-Na concert, which left him thinking postgame entertainment was something that happened every time the Cubs played at home. *Jenkins Imaging photo.*

Actually, he was more of a politician than a celebrity at the time. It was difficult to miss Rod Blagojevich's impeccable hair as I was leaving Wrigley Field following the Cubs' 8–0 shutout of the Pirates on September 23, 2007. There was a small group of four of us who sat in the bleachers for what was the final home game of the regular season that day. Half of the group walked ahead as the remaining member and I lagged behind near the Clark Street entrance to what was the player and staff parking lot. It was there that we spotted Blago getting ready to duck into a car. We had just enough, maybe more than enough, Old Styles in the bleachers that afternoon to ask for a photo with the now-imprisoned former governor.

He obliged, signed our ticket stubs and shook our hands. Predictably, I didn't look my best in the photo. It was rushed, and I'm sure the long afternoon in the bleachers didn't help either. While the photo was forgettable, it was what Rod Blagojevich said that I will never forget about that encounter.

Just as we were getting into position for the photo, he said, "Thanks for helping us get a win today." Me? Yep, he didn't thank Ronny Cedeno, who had gone 3-4 with a homer. He thanked me, who had three or four beers with a hot dog. I suppose we now know there's reason to doubt Rod Blagojevich's judgment. He is, after all, serving fourteen years in prison on corruption charges.

5. THE NEXT GENERATION REVIVES THE OLD BALLPARK

By the time Kris Bryant stepped to the plate for his first Major League at-bat on April 17, 2015, the look and vibe at Wrigley Field—both years in the making by careful design—already showed signs of change.

Beyond Padres starting pitcher James Shields, Bryant's view of the Friendly Confines featured plywood, Jumbo Tron–protecting netting and an awkwardly placed horizontal video board temporarily sitting where fans and bleachers would eventually return above the left field corner. Bryant was surrounded by a ballpark in transition.

Simplistic irony developed out of the fact that, for the last six years, Cubs fans in the stands looked at the field to see a team in the painful throes of roster rebuilding. Steel, concrete and paint helped everyone see the progress made during the 2014–15 renovations at Wrigley, but it was much harder to see the franchise improving while the front office promised a bright future.

The diamond once graced by Banks, Santo, Williams, Jenkins, Sandberg and Grace was reduced to a parade of seat warmers named McDonald, Scales and Diamond. You might not have recognized them shopping at the Jewel at Waveland and Southport if they wore their jerseys to pick up a few things after a game. The rosters became instantaneously forgettable as 2010 turned to 2011. Then 2012. Then 2013.

The left field bleachers did not reopen until May, but the new left field video board was lit up beginning with Opening Night in 2015 to give Wrigley's outfield backdrop a whole new look. *Rob Carroll photo.*

When the 2014 season opened, it didn't take long for the nagging sense to form that this would indeed be another long year of bad baseball on the North Side. The Cubs returned for their second home stand of the season bearing a 4-10 record and sat thirteen games out of first place on July 9, when a glimmer—maybe just a speck—of the future popped up unexpectedly in the form of a second baseman with a tough-to-say last name.

Arismendy Alcantara was really supposed to stick around for only a couple of days. Funny thing, though, he played well, had four hits in his second game and remained with the big club for the rest of the season. Although not one of the big Cubs minor-league prospects, Alcantara represented something of an escrow payment to fans—here's a young guy who will get a chance to prove himself. It sure beat another go-nowhere journeyman.

One month later, highly touted second baseman Javier Baez made his debut. The door was starting to open a bit. Three weeks after Baez, another key prospect, Jorge Soler, got the call and hit a two-run homer in his first game. Fans began to see the names of the future actually taking the field at the Friendly Confines. Late season games with no bearing on the standings had some meaning—let's see what these kids can do. Some hoped to get a first glimpse at Bryant before the ivy browned and 2014 ended.

That didn't happen, and when the 2015 season opened on a brisk Easter Sunday night, Bryant watched from his minor-league assignment in Triple-A Iowa. The sorta new Wrigley did debut that evening with a clunky performance representative of how the Cubs played against the rival Cardinals. St. Louis shut out the Cubs, while many fans were left in long lines for restrooms during the "pardon our dust" Opening Night.

Despite the outcome and inconvenience, Wrigley buzzed a bit differently that night.

Bryant's delayed arrival, arranged strategically for contract purposes, still beat the debut of the new bleachers. It set up an odd stretch with home run balls bouncing untouched off fresh concrete, while the ears of opposing outfielders got a rest with no fans nearby to heckle or shout.

The Wrigley crowd of 32,138 stood in respect, anticipation and relief as Bryant finally heard his name called for a pro at-bat. A rousing response like this for a guy just walking to the plate hasn't happened much since the days when Sammy Sosa provided a stop-everything moment in the ballpark. Put Sammy in the box during his glory years with a chance to hit a game-changing home run and the crowd inhaled and exhaled as one.

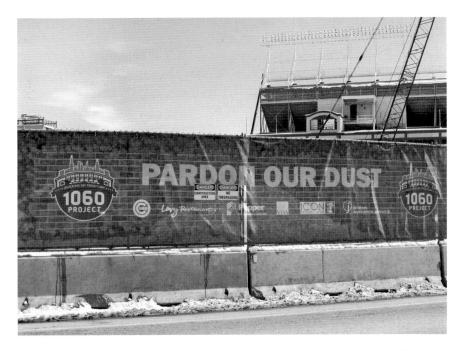

Brick-and-ivy-themed tarps covered fences surrounding construction work near Wrigley's exterior focal points through the offseason and 2015 regular season. "Pardon our dust" had nothing to do with dirt kicked up by a sliding runner. *Dan Campana photo.*

For Bryant, the fans stood and watched as Shields put him in a quick two-strike count. Bryant waved through the third pitch of his career to strike out. The stands deflated with a sharp "aww" in a way similar to reactions after a fruitless Sosa at-bat back in the day.

Bryant's fourth trip to the plate came with two men on and a chance to tie the game or even put the Cubs back on top. The crowd rose to its feet in encouragement once again. A few days short of its 101st birthday, Wrigley came to life for a crucial moment in the game—an April game, no less. Bryant pulled a harmless grounder to third, rally over.

Bryant walked away with a doughnut for his first game, but he put a charge into the crowd throughout 2015, dropping powerful homers into once-again crowded bleachers as the weather warmed up. He took a curtain call after two bombs appropriately hit on July 4. He set off a late night party with his first walk-off blast during an August win streak to solidify the Cubs' wild card position.

Backed by Bryant and fellow rookies Soler, Addison Russell and Kyle Schwarber, the Cubs kept Wrigley energized through October as they

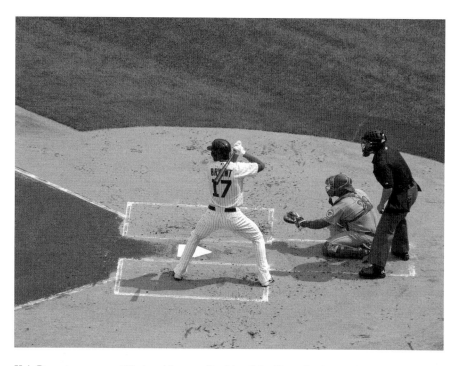

Kris Bryant was named National League Rookie of the Year after becoming a key part of the Cubs' 2015 lineup. His on-field skills were matched only by his popularity among the Wrigley faithful. *Dan Campana photo.*

literally knocked the rival Cardinals out of the National League Division Series with a barrage of tape-measure homers in Games 3 and 4. The on-field celebration that followed the clincher marked the season's final high point, as a week later, the equally hated New York Mets finished off a four-game sweep of the Cubs at the Friendly Confines. In a fitting nod to a surprising magical season, manager Joe Maddon and his team exited the dugout one last time to tip their hats to the Wrigley faithful who remained in the park through the Mets' triumph.

The season was over, but the future never felt so close.

The fruits of a lengthy wait for top prospects and completion of the early round of interior changes to Wrigley came together perfectly in 2015 as the literal and figurative foundations for the future at Clark and Addison.

6. October 14, 2004: The Bartman Game

Mark Grudzielanek, Cubs shortstop, 2003–04

The city was so electric, on fire, with the run we made in 2003, especially the last few months of the season. We closed it off for the division against Pittsburgh. I turned a double play there to end it, to clinch it at Wrigley and go into the playoffs. We went into Atlanta and beat them in Game 5 with Kerry Wood. We were riding high and feeling really good. We get to the NLCS against the Marlins, and it looked like we had things under control there for a while. We were up three games to one by playing some good, solid baseball. Fundamentals good. Pitching was solid.

We lost Game 5 in Florida, so it's 3-2 in the series. We had Games 6 and 7 at home, with Mark Prior on the mound in Game 6. It seemed like we had everything under control, up 3–0 after seven. Heading out to the field for the top of the eighth inning, and we were six outs away at that point, chills were just running through us. The fan support was just incredible, and the noise—you could probably walk on air out there. It was so crazy, and it was such a good feeling. And then you get into that inning. Prior went back out there for the eighth and got into a little situation there.

They had a man on second, and Luis Castillo was up in the situation with one out in the inning. He hits a foul ball, and you know, it's borderline in or out. Moises Alou was running to the foul line and kind of sat there. I mean, that's the weirdest thing. He was underneath it, right on the edge of the wall, right arm on the wall, glove up, and just waiting for it to come down, and then he kind of jumped up for it a little bit. Unfortunately, a hand got in the way, and it happened to be Mr. Bartman. I saw Moises's reaction and knew he would have caught the ball just by the way he reacted.

I knew he was upset a little bit by the way he reacted live, and it showed in the video. I'm out there thinking, "Oh, my God." But I said, "OK, we still have one out. Here we go." Castillo ends up walking, so it's first and third, one out, and Pudge Rodriguez is up. He singles to make it a 3–1 game. Then Miguel Cabrera comes up.

He hits a ground ball to Alex Gonzalez, and it's a chest-high, waist-high hop. No question, when the ball's at him, he catches every one. He's one of the steadiest shortstops I've played with. And it just happened to drop. It just dropped. I mean, the ball just dropped, and I couldn't believe it. I'm sitting at second base ready to turn this double play and get out of the inning, and it just kind of fell.

These two plays happened in two batters. You went from hearing all the excitement to how quiet it was all within a few minutes. You could feel it was devastating, not only in the game, but just the morale of the whole city. I mean, you could just feel the collapse, and it was just "No way could this have just happened." Just an astonishing experience to be that high and in fifteen minutes be totally just taken away from the feeling of electricity and excitement on that field, so it was truly an experience.

Unfortunately, Derrek Lee comes up and doubles to tie the game. We didn't get a chance to recover quickly enough. I mean, it was mind boggling; it threw you for a loop like "Oh, my God. We're losing now and not only by one but by four." How can you just bounce back from that in the inning? We had that error and then a couple of doubles, and all of a sudden boom, boom, boom, wild pitch, bring in a reliever—it just kept escalating, and they scored eight runs in the inning. It became so tough to bounce back and put some runners on. They ended up scoring eight in the inning, and we lost the game, which was really devastating. We left the clubhouse, and it was quiet. I thought we'd come back. It seemed like we were in a pretty good mood.

We tried to play it off and say, "Hey, we'll get 'em tomorrow. Let's go," but it was just devastating to us emotionally and mentally even though we were tied 3-3 in the series. Kerry Wood hit a three-run bomb in Game 7, but we were up in the middle of the game, and it just kind of got away from us again and we ended up losing.

We knew we were going to win, and we did what we needed to do all the way up to that point, but something weird and crazy like that happens and two or three things go wrong. I don't know if I ever just watched the last three innings of that game. I know I watched the Bartman play—it was all over the news. I saw highlights of it. My attitude in the moment was I'd rather forget and just move forward.

For a long time I was like "God, I never want to experience something like that again." But until that point, it was one of the most incredible, exciting years I've ever had in the game and being a part of it. That run in Chicago in '03 was the most fun, group-wise, in the clubhouse with the kids and the kind of players that were in there.

It was totally a team effort, and collectively, we did some things we weren't supposed to do. The fairy tale wasn't supposed to end there. It was supposed to be win the World Series for the first time in many, many years in Chicago.

That's the way it should have ended.

7. THE 1980s TRANSFORMATION: EMPTY SEATS TO THE PLAYOFFS

JODY DAVIS, CUBS CATCHER, 1981–88

For me, Wrigley is just magical to start with. It's the first Major League ballpark that I walked out of the clubhouse and onto the field. I got my first big-league hit and my first big-league home run there.

Obviously, 1984 was just a magical year to be a part of. We kind of saw the town transformed. My rookie year was 1981, and we weren't very good; same with 1982. We got a little better in '83. And then going into '84, there were no expectations. It had been so long since the Cubs had been in the playoffs. They had been through the 1969 letdown. And then, all of a sudden, in '84 we started out good, and people started showing up and you could see the excitement building because there weren't many people at Wrigley in '82 and '83.

Being a part of that transformation, with all the big games that happened there that summer, was really exciting and really a lot of fun to be a part of. We were just about unbeatable at Wrigley. I think we won close to thirty games in our last at-bat that season. Probably the highlight of my career came late in the season at Wrigley. There were about two weeks to go in the season, and we had a lead in the division on the Mets, who were coming in for a four-game series. Everyone was saying they've got to sweep us to get back in it.

Game 1 of that series, Sutcliffe was pitching, and I had a grand slam in the sixth or seventh inning to pretty much ice it. As I was running the bases, it almost felt like the city and the fans and everybody realized we're going to go to the playoffs. I'm running around the bases, and it got louder and louder. That was, without a doubt, a big moment in my career.

I can remember a lot of excitement when the playoffs started. One of the things we noticed was everything went corporate. We were used to coming to the ballpark and the same people being in the same seats in the bleachers every day. All of a sudden, none of those people were out there. All of those tickets were bought up by someone else, so we didn't know who the heck was out there. We were all excited to be in the playoffs. A lot of those guys who came over from the Phillies were a little more used to it than some of the rest of us. It was my first and only playoff series, and we felt like we were able to win that series from the start, but things didn't work out for us in San Diego.

Wrigley just has a mystique. The fans are so close that they feel like they're part of the game. I mean, they're close enough to yell at the umpires. I remember getting a guy out at home plate because the fans were screaming at me, "He didn't touch home, he didn't touch home!" from the first row. Well, I didn't see it, but we appealed, and the umpire called him out.

It's hard to believe that after all these years everybody still recognizes you. I mean, you can walk down the street two blocks away from Wrigley and people recognize you and start talking to you. They still respect you and know what I did when I was there. So it's way high up there to have played there through the majority of my career for those fans. They are great fans.

As loyal as they've been the last hundred years, they need a championship. I keep saying that if the Cubs ever win the World Series there that it'll be a vacant lot the next day because the fans will carry it home with them after the game.

8. Rejuvenated by Wrigley Field

Andre Dawson, Cubs Hall of Fame outfielder, 1987–92

During my Montreal days, I'd always enjoyed playing the day games, playing against Chicago, of course, and playing in that ballpark. It was always one of my favorite cities to visit or parks to play in. And I found there very early on just how much the Cubs fans respected the game, how they embraced their ballplayers and how you rarely heard them riding or booing their own hometown players.

When I signed with the Cubs in 1987, the Cubs fans embraced me from spring training in Arizona to day one of the season opener. And I guess, to sum it all up, I kind of looked forward to that because it was a new beginning for me, and I just wanted to enjoy that moment and make the most of it. They pretty much still had the team intact that had won in '84 or at least the nucleus of that team. And I just wanted to come in and hopefully play a role in helping them win and get back to the playoffs.

I had a pretty good spring training, even though I joined the team late in spring. Once the season started, going back to the cold, damp weather, I sort of struggled early. I had a grand slam off of Todd Worrell at a game in St. Louis, and that seemed to set things in motion. We were on the road from that point, so I extended a pretty hot road trip, and it carried over into

Baseball Hall of Famer Andre Dawson said Wrigley Field revived his career after his arrival for the 1987 season. Although the Cubs finished last, Dawson was the National League MVP and hit a National League–best forty-nine home runs, including twenty-seven at Wrigley. *National Baseball Hall of Fame Library, Cooperstown, New York.*

Chicago. It just seemed like my rhythm, my timing, a lot of positive things just started to happen on a daily basis.

Then there was the first time the fans in the right field bleachers started to bow. That was pretty exciting. It gave me goose bumps in a sense because that's when it really dawned on me that the fans are embracing me, and I can't screw this up. I want to keep them on my good side. There were times when I'd go out, and in between changing pitcher sometimes or if there was a delay, I'd engage in a very quick conversation with some of them. I just felt the warmness of the fans and, of course, taking all of this stuff in stride. That just kept me relaxed, and I enjoyed every moment of it.

There were so many exciting moments over that six-year period. One that stands out is a game when it was very hot and we scored only five runs, but I hit three home runs and won the game 5–3 against Philadelphia. My last at-bat it was so hot—I can remember changing my uniform top twice—one of those real, real humid days that you're struggling for air. Somehow I was able to hit a third home run and jog around the bases. I was pretty warm by the time I got back to the dugout and then had to go out for a curtain call.

On defense, you had to work diligently and learn the ballpark, the intricate angles involved and what the ball did coming off the ivy, how thick the ivy was or if the ball would stay in the ivy. You had to come out and get your work in during pre-game. You had to know the conditions with the wind. With the sun, it was a different type of adjustment. I'd get the sun in right late in the game, when it is on the line a lot of the time. So you had to learn to play the sun and the wind at the same time. That posed a challenge, but I pretty much figured it out—but I don't want to say I made it look easy. I did have some days out there when I was just hoping it wouldn't get in the sun, especially with the wind blowing out, because that made it much tougher.

The one thing you gotta know is you don't just come out and play the game at Wrigley; you have to make sure you get your work in because Wrigley can be tricky.

Undoubtedly, I'll always consider myself a lifetime Cub. You know, it's pretty unfortunate I didn't get to retire as a Cub or get a chance to maybe perhaps finish there. But that holds a special place with me and always will. Because for the second half of my career, Wrigley Field kind of rejuvenated me, gave me a different kind of energy, of fun. There was just something about Wrigley Field, Chicago and the Cubs fans that really made me feel like I belonged, that I was family. I'll always look back at that as the greatest time I had as a player.

9. July 27, 2015: The Wrong End of History

Tony Andracki, CSNChicago.com Cubs reporter

They always say things slow down in big moments like these.

That's what I remember as Kris Bryant drilled Cole Hamels's last pitch high into the Chicago sky.

Time seemed to just hang, suspended in the air. Nobody seemed to know how to react. Was it a homer? Would it stay in the park and become the final out to make history at Wrigley Field?

I had just gotten to the park two innings earlier, just as the fans sang along to the seventh-inning stretch. I was originally supposed to cover the game for CSNChicago.com, but the summer baseball team I run had its playoff opener, so I switched with a colleague.

Things changed on that fateful day in late July as I sat at lunch with my mom and a friend in the northwest suburbs. My phone rang—the TV side of Comcast SportsNet was calling to see if I could help gather sound bites from Hamels at Wrigley. They weren't aware that I had switched off work that day. Still, I knew our writer wouldn't be able to handle both Hamels's postgame sound and Cubs postgame coverage, so I offered to head to Wrigley when I got back to the city since I live right by there. I had no idea that phone call was a harbinger of history.

There were so many interesting storylines surrounding that Hamels start, even before his no-hitter, between all the rumors about where Hamels would end up at the trade deadline (Would the Cubs make a splash? Would this be his last start with the Phillies?), Kyle Schwarber's impact on the Cubs' lineup, the feeling that the Cubs were on the verge of something special—which they proved with a ridiculous 16-2 run after that Phillies sweep in Chicago—and Jake Arrieta's budding stardom as he took the mound opposite Hamels.

So as Bryant connected on Hamels's 129th pitch of the afternoon, I didn't know how to react either.

I had already left the press box in an attempt to try to beat some of the crowd traffic to help hold the mic for the TV cameras, and I was walking alongside the back concourse on the first base side. I stopped when I heard the crack of Bryant's bat and watched through screaming and jumping heads as Phillies centerfielder Odubel Herrera battled the wind, the sun and gravity for the ball.

When Herrera hit the ground, nobody knew if he had the ball. Even the Phillies and Hamels had to wait a second to see if the former World Series

MVP had no-hit the Cubs for the first time in 7,920 games. A brief puff of dust emerged as Herrera kicked up dirt on the warning track, and then he raised his glove to show off the ball.

As the Phillies rushed the field, I had to consciously remind myself to start moving again, hurrying down to field level while Cubs fans and Phillies fans alike jumped up and down and high-fived as if both teams had just thrown a no-hitter.

There's almost a black spot in my memory as I don't quite recall the next few minutes, just suddenly standing on the field in front of the Phillies dugout, holding the CSN mic and watching as Hamels was pulled in so many different directions for TV and radio interviews.

Cubs fans draped over the visiting dugout at Wrigley Field, shouting their praise to Hamels the same way they would if Arrieta had thrown his no-no at home. Half the crowd remained in the park, with several fans yelling to convince Hamels to approve a trade to the Cubs while he was conducting a radio interview.

It was pure madness but pure joy from a baseball fan's perspective. Who cares that the Cubs just lost? Every team gets no-hit at some point. It was history in the midst of a historic season at the corner of Clark and Addison.

It was also the first no-hitter I had witnessed live. As a lifelong baseball fan, it was torture when I missed Jon Lester's no-hitter by just one day in Boston in 2008.

As I followed Hamels's walk across the vacant Wrigley Field after his postgame press conference, I saw him looking up at the sky and the new video board in right field, taking it all in.

I couldn't help but do the same, thinking, "Man, am I glad I picked up that phone at lunch."

10. Beer, Baseball, Take a Backseat to Tragedy

Michael Czyzniejewski, author, professor, Wrigley beer vendor since 1989

I could pick from quite a few memorable moments in my days at Wrigley, from my first game in 1989, to the All-Star Game in 1990, to several playoff games over the years—even the day Hollywood came to Wrigley and filmed, or tried to, a few crowd scenes for *Rookie of the Year*.

Without question, the day that stays with me the most is June 22, 2002, the day Darryl Kile was found dead in his hotel room just prior to a Saturday

Cubs-Cardinals match-up. It was a noon game, national TV. The Cubs had a healthy Kerry Wood on the mound; the Cardinals were in first place. Really, none of that mattered, not to the vendors. It was hot, it was June and the hated-rival Cardinals were in town. What this meant to the vendors, particularly the beer vendors, was one thing: we were going to sell a lot of beer.

And that's what happened, or at least what started to happen. I usually started an hour before game time so I could sell to the fans as they filed in, watched batting practice and listened to the lineups. On a good day, a vendor could expect to finish a twenty-four-can case of beer, and maybe some of a second case, before first pitch. On a Cubs-Cardinals Saturday in June, however, with the weather cooperating, an industrious suds jockey could shoot for maybe double that, two to three loads done before the game started. Vendors work on commission, so any day that we could double our usual take was a day we'd remember, maybe talk about all winter.

I remember the crowd being early that day—thick, deep crowds waiting outside the stadium—and thinking to myself that maybe I'd start even earlier than usual. The gates open ninety minutes before first pitch, so I decided to start as soon as I received my assignment. I was not disappointed. By the time I checked in, the stadium was half filled, only ten minutes after the gates had opened. I did something then that I don't think I'd ever done before: I started with a double load, two cases instead of one.

A vendor takes out two cases at once only if he or she thinks it's worth carrying the extra weight, that it'll be easier to do that instead of running back to the commissary an extra time. In other words, if the beer sells fast enough. That was not a problem, though, as I remember that lead-off double going very quickly, me walking into the seats and immediately getting mobbed by fans wanting Budweiser and Bud Light. I sold out in ten minutes, and I wasn't the only one: the thirty or so Bud guys in the lower bowl were all pouring nonstop. It was looking to be a record day.

After that first double, I did another, and then another, and by that time, it was almost noon. I'd never sold six loads before a game before—no one had—and the vendors all started predicting crazy numbers, record numbers, some guys thinking they'd pay an entire mortgage payment from one day. Or get ahead on car payments. Or take the kids on vacation. It was going to be that type of windfall. Our excitement only made us pour faster.

I also couldn't help notice that the public address announcer, at a few minutes before noon, hadn't given the lineups yet. In fact, it became apparent that something was wrong. None of the players, from either team, were out on the field, not even in the bullpens; Gary Pressy was pumping away at the

organ, playing upbeat tunes. I was thinking that there was something wrong with the national feed, some sort of edict from the network, maybe even a non-baseball national emergency. There'd certainly be a delay: pitchers weren't warmed up, and if the pitchers weren't warmed up, the game couldn't start.

That's when the rumors started to buzz through the crowd. With no streaming or wireless capabilities yet, many fans still brought transistor radios and listened to the play-by-play. I heard someone say there was a fight in one of the clubhouses (plausible). The game balls weren't delivered (implausible). The scoreboard was broken (not at Wrigley it wasn't). The players went on strike/the owners locked them out (well…).

Eventually, the words "player" and "died" were uttered, and from there, it snowballed. The report had come through the wire. A player had died, which would explain pretty much everything. The player was a Cardinal. He'd died at the team hotel.

The player was Darryl Kile.

By 12:15 p.m., everyone in the stadium knew what had happened. Beer sales halted, and everybody—fan, vendor, usher, groundskeeper—waited to see what was going to happen.

Eventually, players for both teams filed onto the field, lined up at home plate as if it were pre-game at the World Series. Joe Girardi, ex-Cub and current Cardinal, held a microphone in his hand. The stoic, respected future manager was the obvious choice to speak. He announced that there wouldn't be a game that day. He sobbed openly, visibly in pain. The other players carried themselves with solemn dignity, comforting Girardi, comforting one another, the teams intermingling. Girardi never said the words, never announced Kile's death, but by that time, it wasn't a secret. Everyone felt what Girardi felt. The park was silent.

After the players returned to their clubhouses, some fans began to file out, the ushers ushering them, telling them the game was canceled. Most fans stayed put. I still had most of my fourth double load of beer, cases number seven and eight. Nobody had told us to stop selling. Our cut-off was normally in the seventh, and we knew that this was to prevent people from walking out of Wrigley with unfinished beers, to sober everyone up a bit before rejoining the populace. The game wasn't ending, though; it hadn't been played. There was no precedent for this.

Fans asked if they could buy my beer, and I sold it to them. Cardinals and Cubs fans were toasting Darryl Kile together, commiserating, drinking, remembering. It seemed like I was a part of that, the trusty barkeep, the

shoulder to cry on. I sold out my seventh load, got into my eighth before word went around that we were to stop selling immediately, return to the commissary and check out. I sold a few more beers on my way, was scolded by someone or another and then went home.

The Cubs and Cardinals played the next day, the Cubs winning 8–3, and I sold beer, to a still-stunned crowd, on a Sunday, everyone extra subdued. Kile had died from coronary disease. The Cardinals won the division that year, went to the NLCS and lost to the Giants, while the Cubs finished fifth, on the brink of near glory in 2003. There were many memorable games, a lot of so-called tragedies in Cubs lore, but nothing like the day they didn't play, the day the score, the uniforms or the standings didn't matter, the most memorable day of all.

11. From Black-and-White to Full-Color Wrigley

Brian Burmeister, Geneva, Illinois

I grew up on a farm in northern Illinois, and my neighbors took me along with their son to my first Cubs game in 1953 when I was twelve. Remember it was black-and-white television back then, so my first stunning realization, walking up and looking at the field, was color. How great it was—the ivy and everything—and they played the Dodgers that day. It was Campanella, Snider—all those great Dodgers players—and of course, the Dodgers were the first team really to break the color line with Jackie Robinson.

They thoroughly thrashed the Cubs that day, but that was long ago and far away. But it was a very vivid memory: the color, the noise and the ambience. There were a lot of people, but it wasn't anywhere near full—it never was back then, no matter who they played. Of course, there were only eight teams in the American League, eight teams in the National League and there was no interleague play. So we were fortunate in this town that we could go to either side of town and see the great players.

I've been to a zillion baseball games, twenty-five Major League stadiums, so I've seen a lot of them, but Wrigley was the first one.

12. Working at the "Cathedral"

Tom Daly, 1960s Wrigley Field usher

My job transferred me and my wife from the East Coast to Chicago in about 1956. You had to make a living, so we came to Chicago. I was in technical sales. At one point, and I don't know how I got the thought, but I went out and applied for a job at Cubs Park. And I got the job to be an usher.

It was the early 1960s, and it was really good—the Cubs were not good. I'd help fans find their seats kind of near third base; it was a good area. My wife thought I was enjoying it too much, and she said she wished she had gone in to apply. And I said, "I know what would have happened. I would have ended up working for you."

The fun part about it was there were people coming from all over the United States, whether they were baseball fans or whatever—they were coming to Wrigley like it was a cathedral. I had one guy who came up in front of me; he stood in a complete "T" shape like Christ on the cross, and he said, "This is it." He was not a Cubs fan, but it was baseball.

I've been to Yankee Stadium, the Polo Grounds and Ebbets Field. They're all gone, but Wrigley isn't. And here all these people are coming from all over because they like the Cubs.

13. June 5, 1998—Cubs 6, White Sox 5: First Crosstown Interleague Game

Brant Brown, Cubs outfielder, 1996–98, 2000

For the first interleague series against the White Sox at Wrigley in 1998, everything was elevated. People were there earlier. I think everyone realized how special it was to be in Wrigley and to have these two teams from the same city going at it for the first time in something that counts.

For me, it was an incredible day. From the time you woke up and started going to the field, you were excited about the opportunity to play the White Sox for the weekend. And it was definitely a special season in '98. It seemed like in the month of June, it was Sammy Sosa hitting a home run every day. You had the steadiness of Mark Grace. The character guys up the middle with Mickey Morandini and Jeff Blauser. Then you had guys like Rod Beck

and Kerry Wood breaking into the league. There were quite a few different personalities, but we all meshed together.

From the dugout that day, it was interesting to see the people dressed in black standing up cheering at Wrigley when something didn't go for the people in blue's way. It was definitely different.

I didn't start the game, but I came in the eighth and ended up with three at-bats and two hits; one of the hits was off Matt Karchner, whom we ended up trading for later in the year. I was leading off the twelfth against Tony Castillo. I remember it was lefty on lefty, and I wasn't sure what I wanted to do. So believe it or not, I think I squared to bunt on the first pitch, but it was a ball and I took it. And then the next pitch he threw me I hit for the home run.

I remember running around the bases and getting home—this is before all the water pouring and all that stuff—and Grace was right in front of me. I grabbed him and hugged him as hard as I could and picked him up while everyone else was tapping my helmet and jumping. Grace said something afterward like, "Hey, man, don't hit another one because you're going to squeeze the life out of me every time you do it." I thought that was quite funny.

This was the second in two weeks. The first one was the week before off of John Rocker.

I was having a pretty good year to that point, and later, I remember I watched the replay of the Sox game with Hawk Harrelson announcing for the White Sox. Right at the time I hit the home run, he was saying there was interest in playing me every day because I wasn't starting against lefties. And just as he said that, I hit a home run off a lefty, so it was very memorable.

14. MR. CUB ERNIE BANKS

PHIL ROGERS, MLB.COM WRITER/
FORMER *CHICAGO TRIBUNE* BASEBALL WRITER

I was born in Dallas, and I loved Ernie Banks. Being from Dallas, Ernie Banks was always of special interest, even before I got to Chicago. I saw the Cubs play in the Astrodome in 1966, which was the Astrodome's first year. Years later, I looked up the game and found that Ernie had three triples in that game at like age thirty-five with his bad knees. It was sort of a funny little tie-in with my life when I wrote the book about him, *Ernie Banks: Mr. Cub and the Summer of '69.*

The one thing you could not miss with Ernie was how beloved he is and how, anytime he was in any crowd, he was treated by the crowd and how he treated the people. You never saw Ernie be short with anybody. There were people who sometimes wondered if he was sincere because he seemed to be too good to be true. I kind of described him as a very easy guy to get to know but a very hard guy to get to know well.

When he was at Wrigley Field, it was so hard to ever talk to him other than just "Hey Ernie. How you doing?" Then he would ask, he would ask you about your wife or your mother, he would turn the conversations around. He was just so in demand. Everybody, everybody, wanted to say "hi" to him, and he had time for everybody. It was really, really hard to have a good, long conversation with him, but it was always a friendly face, and I never saw him push off anybody or not have time for anybody.

Ernie definitely sold Wrigley Field as the best place in baseball. When he would do a national interview, he would always talk about how great it is to play at Wrigley Field. That was when it wasn't always the nicest place in the world. It never had amenities. You can talk to people about when the crowds were so small that they would close off the upper deck. The first game Ernie played with the Cubs in 1953, the crowd at Wrigley Field was 2,793. Not very many people.

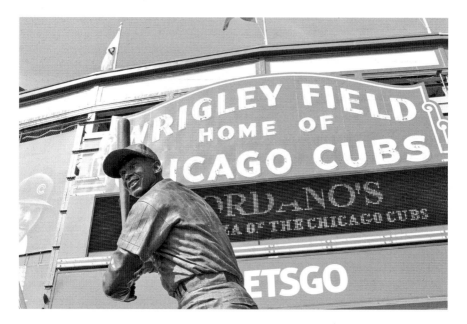

Mr. Cub Ernie Banks is immortalized with a statue outside Wrigley Field's main gate beneath the iconic marquee. Banks played his entire Major League career with the Cubs. *Rob Carroll photo.*

One of the things he used to say was that when he looked out on the field, the bleachers seemed so close. As legend has it, he homered on the first pitch that was thrown in batting practice using a bat he borrowed from one of his teammates, Ralph Kiner.

Ernie, one on one, engaged with all sorts of people at Wrigley Field in that era because the Cubs weren't very good and the games weren't very well attended. Ernie got to know people by name at the ballpark, and it was retail politics. He developed a genuine personal relationship with the Cubs' best fans. When his playing career ended, there was a short time when he was the first base coach, and he was a terrible first base coach because he couldn't stop talking to the fans in the first row of the seats over there by first base. His attention would always be divided between the game and his fans. There was a genuine conflict for him.

Ernie and Wrigley were definitely tied together because of the fact that it stayed in one straight line back to the day in 1953 when he walked in for the first time. If Ernie had been with a franchise that had different stadiums, new stadiums, like the Cincinnati Reds—they moved from Crosley to Riverfront and are now in the Great American Ball Park—I think he might have lost some enthusiasm for going to the ballpark.

He was never a self-promoter. He promoted the Cubs. He promoted baseball. He promoted Chicago. He promoted a lot of things, but he didn't promote Ernie Banks per se, and because of the hard-to-get-to-know-well part, he sort of eluded historians to a degree. Ernie had a three-year run when he won back-to-back MVPs. I don't think he's remembered necessarily as a great shortstop because he hit so many home runs as a first baseman. His role as a goodwill ambassador kind of overshadowed his great play. And you know, he was doing it when the National League was loaded with pitchers from Koufax to Drysdale, Gibson and Seaver. I don't know if there's ever been a tougher era for pitching. In 1969, that seminal Cubs season, he hit a hundred-plus RBIs that year at age thirty-eight, when Leo Durocher was trying to send him to the bench.

I think, to some degree, history has lost track of him as a player because he was so ever-present as the guy out promoting the Cubs and smiling and singing the seventh-inning stretch and the "Let's Play Two." If he had just been Ted Williams and had that personality, people might have looked back and really appreciated his play more than they did. But he just gave of himself with that smile and overshadowed a little bit just how great of a player he was and how he was one of the all-time greats.

One of the beautiful things about him was that he became an adult, but he was always the kid who marveled that he could hit a home run. When the

Banks, a baseball Hall of Famer, hit 290 of his 512 career home runs at Wrigley Field. His milestone 500th home run came on May 12, 1970. A year later, he slugged his final round-tripper before retirement. *National Baseball Hall of Fame Library, Cooperstown, New York.*

Cubs went to the National League Championship Series in '84 against the Padres, the first game of the series was played at Wrigley Field.

Ernie was in uniform on the field, as if he were a player or at the very least a coach, which he wasn't. He sat in the dugout and did interviews with reporters, national reporters, talking about the Cubs' mystique and how great it was to finally have a team in the playoffs because they didn't get there when he was a player. It's just so unusual that a guy, an adult, would go back and put a uniform on and put himself there when, other than the fact that he wanted to wear the uniform and sit in the dugout before a playoff game, there was no reason for him to be doing it. I just think that speaks kind of to the child in him. Still, he gave himself a moment that he wouldn't have ever had wearing a uniform at his beloved Wrigley Field.

15. MAKING BILL MURRAY LAUGH

JIMMY GREENFIELD, AUTHOR *100 THINGS EVERY CUB FAN SHOULD KNOW & DO BEFORE THEY DIE*; MANAGER OF CHICAGONOW, THE TRIBUNE-MEDIA-OWNED BLOG NETWORK

You know what? I'm going to begin by getting something off my chest: Screw Ozzie Guillen.

I get the former White Sox manager's hatred of Wrigley Field was gamesmanship, and I always took the bait by getting annoyed when he laughed about the "rats bigger than a pig" or said "I puke every time I go there." But it still bothered me because Wrigley is and always will be sacred ground, no matter how big the rats are.

The miraculous thing to me about Wrigley is that every time I go there, it's a replay of the first time I ever went. You come upon this ballpark sitting in the middle of a typical Chicago neighborhood, and aside from a few street signs alerting you to its impending presence, there's little reason to know what's coming. It all leads up to that first moment when you see the playing field, the ivy, the bleachers and the iconic scoreboard in the background. I swear the theme from *The Natural* starts playing in my head whenever I know I'm about to see it for the first time that day. That will never leave me.

I'm not one of those people who can recall their first game. I'm not even sure I went to all that many games as a little kid. What I remember very well is the amazement at realizing my parents would let me go to games alone, probably when I was around fifteen. All it took was one bus ride, one train ride, and there I was at Wrigley Field. But my favorite moment at Wrigley actually has very little to do with baseball.

I was covering the 1998 National League Wild Card tiebreaker game between the Cubs and the San Francisco Giants, and my job that night—keep in mind, these were the early days of the Internet—was to gather as much audio as possible and send it back to be posted to a very early iteration of chicagotribune.com. When the night ended and the Cubs had won a spot in the playoffs, I was one of several reporters to run alongside Sammy Sosa as he jogged back to right field following the team celebration to bask in the adulation of his fans.

It was an amazing moment. But not as amazing as one I'd experienced about an hour earlier.

Harry Caray's death just prior to the 1998 season had been a huge blow; the impact he'd had on Cubs fans during his sixteen seasons as the voice of the team can't be overstated. He was beloved. And then he was gone.

The shock of it led the Cubs to begin the tradition of having celebrities come into the broadcasting booth to lead Wrigley's faithful in singing "Take Me Out to the Ballgame." New generations may not realize it, but every time it's done it's an homage to Harry.

As the Cubs made clear they were planning to make celebs singing the stretch a tradition, the question "Who's singing the stretch?" joined "Who's pitching?" and "Is the wind blowing out?" as the key questions of the day.

I'm not sure when I realized Bill Murray was going to be doing the singing on the night of the Wild Card tiebreaker, but while I toiled in my makeshift work area in the cramped dining room in the press box, I suddenly noticed he was there.

Before I knew it, we were face to face in the hallway between the cafeteria and the broadcast booth. I have no idea if I was the only one talking to him or if others had also surrounded him. But there I was with my microphone out with an opportunity to ask Bill Murray a question.

"So, Bill, have you made your song selection for the seventh-inning stretch?"

He laughed. I'd made Bill Murray laugh. Not hard, not side splitting, not enough for him to make me an honorary Murray brother. It may even best be described as a chuckle. But for the sake of posterity, let's just call it a laugh.

"I'm going to do some new material," he replied.

And then he went out and sang "Take Me Out to the Ballgame" to forty thousand adoring Cubs fans.

Until I see the Cubs play in a World Series at Wrigley, I'm content to let that memory be my favorite.

16. MEMORIES FROM THE LEFT FIELD BLEACHERS

JOHN FRANZ, LADERA RANCH, CALIFORNIA; FORMERLY OF ORLAND PARK

I can remember coming to Wrigley since I was about four or five; my mom would bring me every summer. I was born in 1984, so I was probably here that year, too. We used to live in Orland Park, so we'd take the bus to come out to games.

The day of my first game, I remember, started when we met Mark Grace that morning at the bank. He was signing autographs for fans, and then we came to the game. In 1987, we were talking to Andre Dawson before the

By the end of July 2015, Wrigley's bleachers were once again bustling with fans. Despite changes to the entrance, fans still line up early to stake out their favorite spots in the bleachers, which remain general admission seating during the regular season. *Rob Carroll photo.*

For decades, fans could purchase bleacher tickets only on game days. Ticket windows long ago went dormant for such sales at the bleacher gate, located at the corner of Waveland and Sheffield, but some were included in the redesigned entrance. *Rob Carroll photo.*

game, and then he hit a home run to win it. We always sat in the left field bleachers in the back. They seem to be the same even after the renovations. It's different, but they kept it traditional.

Attending as an adult in 2005, there was a big rain delay the night of Greg Maddux's 3,000[th] strikeout. I wanted to leave because I didn't think that game was going to be played. It started at eleven thirty that night. My mom said, "Yeah, we have to stay. It's history." We ended up also seeing his 300th win on the road in San Francisco. That was cool to get to see both of them.

We were here in '08 against Houston when the tornado siren came on. It was a Monday Night Baseball game, and we were first in line for the bleachers. We had our "It's Gonna Happen" sign and were on ESPN. Then the lightning struck right behind us and the tornado siren went off. That was fun.

I was also in the bleachers for Game 6 of the 2003 NLCS, but I don't talk about that. It wasn't that fan's fault; I've said that since the time it happened.

17. Passing Along the Tradition

Jeff Gilmore, with daughter Alyssa, Evanston, Illinois

My dad brought me to my first game when I was about seven or eight years old; that was about thirty years ago. I went to games all the time as a teenager. It helped that my sister was the editor of *Vine Line* for several years, so she would get me tickets. Greg Maddux was one player I always came out to see. After he left, we came to the first game he came back to at Wrigley. Everyone was flashing dollar bills at him. He beat the Cubs that day. Kind of a bad memory, not having Maddux, but it's just part of the heartache we go through. Now we've actually got some real hope.

It meant a lot to take my daughter, Alyssa, to her first game a couple years ago when she was six. We were sitting in the front row of the bleachers, and during batting practice, Carlos Marmol came up and threw her a ball. It was significant to her. The next day, he got traded.

There's nothing else I'd rather do than take her to games. She watches every game on TV and gets really emotional with it. I assume that's how I was at her age. I know I cried in 1984. It's easy to get emotional because you get the feel of how the city's atmosphere kind of changes when the Cubs are good. When that happens, Wrigley kind of reminds me of Vegas, like everyone is on vacation having a good time.

18. Rounding the Bases of Life

Jeff Wilder, lifelong Cubs fan

Of the many unforgettable experiences I've had imprinted on me at Wrigley Field, there's always one game that somehow stands out above all the others.

I'm not even sure why, but this particular game and experience is the one I think of first. Oh, sure, there was the game with my wife when Sammy Sosa hit number sixty. The crowd had a party-like atmosphere before, during and especially after the game. We even got to shake Bill Murray's hand.

And of course, I'll never forget each first game for my two sons, Zach and Josh. A lifelong, diehard Cubs fan bringing his son to his first Major League game at Wrigley Field is a rite of passage I was privileged to share and pass on. For those games, I felt like I had fulfilled my responsibility as a father, ensuring that for each of them, their first Major League game would be at Wrigley Field. Anywhere else would be unacceptable to me. It becomes much more than a game. It's so emotional.

Why these games aren't the most memorable to me is a question I can't quite answer. Maybe it's because, as much as baseball is a kid's game, you still see it a little differently through the eyes of an adult, especially as a husband and father. But I go back to a time without all those adult responsibilities. You're just at Wrigley Field on a perfect summer day with your best friend. You're still a kid, but you're about to step out into the world and round the bases of life.

The date was August 10, 1989. The Cubs were shocking everyone in first place while becoming the "Boys of Zimmer." Did I mention it was a perfect summer day? The Cubs were playing the Phillies. As luck would have it—and I've come to believe it's fate when the Phillies visit Wrigley—the wind was blowing out. What better place to be than in the left field bleachers?

My best friend and I had just graduated from high school in early June. We were on our way to separate colleges in a couple weeks, so this was one of our last "hurrahs" together. We were, and still are, diehard Cubs fans who know the game of baseball really well. We could have our fun, be into the game and talk baseball—perhaps at a level most of our peers didn't know. As a true Cubs fan, you either "get it" or you don't. Fortunately, my best friend, Bill, and I got it and still get it.

That said, we got to Wrigley early. We wanted to win the race and get good seats in the left field bleachers. We wanted to catch home run balls during

batting practice. It was one of the exceptionally hot and humid, dog days of summer kind of days. It was hot in the bleachers well before the game even began.

Fortunately, the Phillies had Roger McDowell on the roster. MLB's class clown was in mid-season form and provided an abundance of pre-game entertainment. First, and perhaps most appreciated, he grabbed the grounds crew hose from below the left field bleachers and sprayed everyone to cool us down.

Equally as fun was when McDowell put a bucket out in deep left centerfield. He threw a ball into the crowd, and the game was on. The fan who had the ball had to toss it into the bucket from the bleachers. It was fun and challenging, but I didn't get a shot at it. One fan's throw did make it into the bucket, although it bounced first. Then McDowell drew up pass plays on his hand where the fan became quarterback, and he ran routes in the outfield like a wide receiver. It was so cool. That invisible wall that always seems to exist between an MLB player and the fans temporarily disappeared. It was a great way to get pumped for the game.

The game started true to form when the Cubs and Phillies meet with the wind blowing out. Hits were plentiful, and lots of runs were being scored. The Cubs got out to an early lead in the first inning, followed by an epic eight-run third inning. This game seemed like it was in the bag. But it was the Phillies at Wrigley. They scored seven runs in the fifth inning and six more over the next two innings.

The Boys of Zimmer knocked the ball all over the place that day. Grace, Girardi and Sandberg all doubled. Sandberg also went deep twice. Unfortunately, Lenny Dykstra, John Kruk and Darren Daulton also were hitting the ball all around the ballpark.

As the game went back and forth, we sat in the bleachers having the time of our lives. We laughed at silly things that kids laugh at, made jokes about things, cheered our heroes and playfully booed their rivals. We were about to make our way in the world, but for nine innings, we got to be kids one last time as we watched our favorite team play our favorite game in the greatest place on earth.

The more I thought about this game, I decided to check my memory against the box score. In my mind, I was positive I knew the final score was 16–13, a great Cubs-Phillies game I would never forget. What I was beyond surprised and amazed to learn was that the Cubs lost. In my mind, I was convinced the Cubs won, but there it was on Baseball-Reference.com—the Phillies won 16–13.

Every memory I have of that day was a win. Despite the final score, it was a win in my life. The weather, the setting, being with my best friend, interacting with Major Leaguers and the Bleacher Bums. That day was so quintessential in the life of a kid about to become an adult. A perfect summer day in the Wrigley Field bleachers will reverberate throughout your memories forever, reminding you of simpler times and why you love the game and the Cubs.

Looking back, it was such a rewarding experience. It meant so much more than I ever realized that day. And it has become something I'll always appreciate and be grateful for. There's really only one thing left to say, and that's thank you.

So thank you Wrigley Field for being there for me at that time, waving me on as I began to round the bases of life.

19. PAYING FOR A SHOT AT WRIGLEY'S FIRST NIGHT GAME

BOB HORSCH, PHOTOGRAPHER, BOB HORSCH GALLERY

Being a sports photographer, Wrigley has always been my favorite. I enjoy Wrigley and the excitement in the surrounding neighborhood.

My first recollection of visiting Wrigley was in the early 1970s. I recall being able to sit anywhere—unfortunately, this does not happen today—and that's when I started jumping over seats to get the right angle to capture either a wide angle of the park or down really low to capture a hitter at the plate. I always enjoyed taking wide angles of the park and always enjoy seeing the ivy and the iconic scoreboard.

My best memory from all the games I attended would probably be "8-8-88," the first night game. I got up on the Cubby Bear roof by dropping a few bucks to photograph the historic event alongside all of the press and other photographers. It was an awesome view with all of the lights, the crowd and traffic jam. Shortly after I went into the park, the heavens opened up with rain, and the historic event at Wrigley was postponed until the next evening.

I'll always remember that evening. I have also been anxious every Cubs season in anticipation that this might be "the year."

20. Up On the Roof(top)

Tom Browning, Cincinnati Reds pitcher, 1984–94;
Wrigleyville Rooftop visitor, 1993

One of my career highlights at Wrigley started when we were in Pittsburgh and Bob Walk, who was a pitcher for the Pirates at the time, said he was able to get into the scoreboard at Wrigley. Somebody allowed him into the scoreboard during the game, and he said it was awesome. So when we got there, that was the first thing I did; I went to the grounds crew guy and asked him if it would be a possibility. He said no because they had caught some flak for it with Bob Walk, so it wasn't going to happen.

During batting practice, Tim Belcher, who was a teammate of mine, and I were just looking around, and I said, "How about one of those buildings?" So we're in the clubhouse, and the manager for the visitor's clubhouse, Tom Hellman—we called him Otis—actually knew a guy who owned all the buildings. We got him on the phone and asked if it would be possible, and he said yeah.

I was supposed to meet him at Murphy's Bleachers on the corner across the street from Wrigley during the top of the third inning. I had a black shirt on, and we walked down three or four buildings. I went up three flights of stairs, took off my black sweatshirt and just got on the railing and started waving to my teammates down there in the bullpen.

They ended up turning the TV camera on me, and actually I got fined by the manager because I left the stadium in my uniform. That was the only thing they could pin on me. Obviously, it did work out great. I got a nice picture of it on my wall. I think more people will remember the Wrigley game than they do my perfect game. It ended up being one of my career highlights.

A funny thing is that it was the first year the Marlins came into the league. When we went to Miami for our first trip, Wayne Huizenga sent his personal secretary down to our clubhouse wanting to know if I'd sit in his restaurant in center field sometime during the game. I had to decline because I would have gotten into hot water with our general manager, who was Jim Bowden at the time. We didn't really see eye to eye.

21. June 3, 2003: Sammy's Corked Bat

Chad Anderson, Rockford, Illinois

The 2003 Cubs season will linger in Cubs fan memories for a long time. I have to admit that, eight years later, watching ESPN's 30 For 30 documentary *Catching Hell* on the Bartman debacle (more aptly named, the Alou, Gonzalez and Prior debacle, in my opinion) resulted in my shutting off the television mid-show and tossing my remote across the room. Too soon, I suppose. My story isn't about that game, though. Rather, my story is from a bleacher seat on June 3 of that infamous season.

It was the Devil Rays that came to Wrigley for the first of a three-game set on that June evening when I met an old college buddy from the 'burbs to head into the Friendly Confines. Tickets in hand, we strolled to the stadium, enjoying the sights and sounds of Wrigleyville. It wasn't long before we found a prime spot in the center field bleachers.

The way I recall it, it was just about dusk, and there was a strange overcast haze over Wrigley. The lights were on, seemingly reflecting off the thick air around them, casting an ominous tone. With Mark Prior on the mound, however, we were sure to see the "W" flag raised that night. Prior did make easy work of the Rays' top of the lineup, and Wrigley was excited to see our boys at bat. That half inning started off with action. Lead-off hitter Mark Grudzielanek was plunked by a pitch, followed by Alex Gonzalez doubling to right.

The place was abuzz with Corey Patterson coming to the plate with two runners in scoring position, but when he struck out swinging, nobody was concerned. Up trotted the man who would bring us to the Promised Land, or at least plant one onto Waveland. Local hero Slammin' Sammy Sosa worked a full count with some mighty hacks. This would be it. Although the anticlimactic at-bat only led to Sammy shattering his bat and dribbling into a second base ground out, the run scored, and an RBI was fine in our book.

The cheers quickly diminished, however. Rays catcher Toby Hall picked up the handle of the bat and briefly examined it before tossing it at the feet of the home plate umpire. With a chunk of Sosa's bat in his hand, the umpire gathered his comrades near the mound. What were cheers of excitement quickly turned to hushed murmurs and quizzical looks around the stadium.

Nobody was coming out of the dugout, nobody was arguing and everything that had happened so far appeared to be very run of the mill.

Scattered "What are they talking about?" and "Why are they taking so long?" predated smartphones and instant Twitter feeds. One fan a few rows in front of us had quickly tuned his handheld radio to WGN 720 and listened intently to his headphones with his hands cupped over his ears. "They're saying the umps might think that bat is corked!" the fan announced to our section. Stunned disbelief and headshakes resounded as Sosa was ejected without so much as a protest from the guilty party. The run was taken off the board, and the runners returned to their bases.

22. SEPTEMBER 28, 1998:
A BIG HOMER AND A BIG BALLOON

GARY GAETTI, CUBS THIRD BASEMAN, 1998–99

Playing in the World Series will always be at the top of my baseball memories, but that game against the Giants and that last month or so of the 1998 season was probably one of the greatest, most fun, most rewarding times of my entire baseball career. It's definitely in my top five moments.

I grew up a Cardinals fan, and I really wasn't into the rivalry between the Cards and the Cubs. I always liked going to Wrigley as a visiting player. It's just one of those places that you always hear about. I loved playing there but didn't really envision myself getting to the Cubs and Wrigley. Yet when it did happen, it was all in that McGwire-Sosa deal. The home run race kind of overshadowed things in St. Louis because we were out of the picture. Going from that to the Cubs to be part of the excitement was just really neat. We had a unique team with a bunch of characters.

Being an older player having come to the Cubs and Wrigley late in the season, I felt like I was at the top of my game and went through an unbelievable stretch of hitting. It really couldn't have come at a better time in a better place. It was a very satisfying time.

It was scoreless in the bottom of the fifth of the one-game playoff when I hit the home run to give us the lead. The moment just put everyone over the top. It's kind of weird because you could feel the mood of "That's what we needed. We're going to win this thing right now." It let everybody relax and have a feeling that we were in the driver's seat and were going to will this thing to happen.

Rod Beck got Joe Carter to pop out to end the game, but it's hard to describe that moment when the guys get together on the field to celebrate. You realize the hard work that you put in is paying off; you're going to the next level. You're congratulating everybody in this unguarded moment and are just really happy for everybody at the same time.

That night, there was a lot of excitement inside and outside the park. I remember somebody out there on Waveland had stitched together either some bedsheets or something to make this gigantic Harry Caray balloon, like a hot-air balloon. It had those glasses and Harry's face painted on it, and it floated high enough to see it above the bleachers in left field. I still laugh thinking about it. When it got closer to center field, something happened with the balloons inside of it; the whole thing just started taking off into the sky.

There I am in the dugout, and we're coming down the stretch going to the playoffs, and the one thing I remember about this game more than anything else was this giant Harry Caray bobble-head balloon walking across the outfield. It was perfect, so fitting.

23. A HALL OF FAMER FINDS HIS HOME

RYNE SANDBERG, HALL OF FAME CUBS SECOND BASEMAN, 1982–94, 1996–97

My first taste of Wrigley Field was a September call-up for the Philadelphia Phillies. I had just finished a season of Triple-A ball at Oklahoma City and started in the second game of a doubleheader at shortstop. I actually got my first hit in the Major Leagues at Wrigley Field as a Phillie. My first impression was that it was a very, very historic place—had a coziness about it with less of the commercial things going on. It felt more about just raw baseball when the game was going on without all of the hoopla and a lot of the fancy stuff. It was all about the game. And that's how I learned to know the Cubs fans. They're very knowledgeable fans, and the combination of that with the fact there's not a bad seat in the house at Wrigley makes for a pretty good atmosphere for a baseball game.

For me, it really kicked in in my third season in 1984, when Dallas Green put together a team that was going to be competitive, had veteran players and was going to give us a chance to win. That team we had in '84 was a very likable team with character. When you talk about Jody Davis, Leon Durham, Ron Cey, Keith Moreland, Rick Sutcliffe, myself

and Steve Trout—just to name a few—I think that was a group of guys who played well together.

As that summer went along, we started to creep up in the standings, and right around the middle of June or the end of June, we jumped into first place for the first time. Then came the excitement of the Cubs fans all across the country and at Wrigley Field to the point where seats and tickets were hard to come by.

Sometime in that late summer, probably early August or September, we were on the bench watching the view and the game, and we noticed two guys up on the rooftops across the street. Keith Moreland said, "Look at those two guys. You know, that's awesome. They're watching the game from across the street on the rooftop." After going away on a road trip, we came back to see twelve people up on a rooftop with a couple of folding chairs. Then, a month later, there were about thirty or forty people up on the rooftop with a barbecue and some more chairs. They started coming out of the woodwork toward the end of that year. And for me, that's when it really took off to another level.

Harry Caray broadcasting the games really brought all of us to life as…as players that the fans related to and got to know and really pulled for us. The popularity of the team nationwide came with WGN and Harry and Steve Stone broadcasting the games.

For me, personally, the first game at Wrigley that really comes to mind is June 23 that year against the St. Louis Cardinals, where I had the game with the two home runs against Bruce Sutter. It was nationally televised on NBC's *Saturday Game of the Week*, so I think that was the first moment I took my career to a different level.

Then, I'll never forget in '84 we had our last home series before the end of the season against the Cardinals. We won that Sunday day game and we're going on the road, I believe, for a week or ten days, and we had a chance to clinch on the road. Well, after that game, we're in the locker room getting undressed, and Jim Frey walked in and said, "Guys, we have to go out. The fans are not leaving." So we all went out, some of us in just a baseball shirt, cut-off shirts and our uniform bottoms and flip-flops. We went out, and nobody had left the ballpark. And they were cheering. This was ten minutes after the game, and we paraded across the field. It was like a send-off that we were going to clinch on the road, and the fans wanted to do something special. They just kind of made it up, and somehow it happened.

From '84 on, we had sellout crowds. There was a buzz going on, there was an excitement in the stadium and it almost didn't matter whether the

Cubs were in last place or first place. And I heard a lot from different visiting players, be it when they were runners out at second base or if I was on base talking to them. The opposing players said, "Wow. This is baseball. This is what it's supposed to sound like. This is what it's supposed to feel like." I think that spoke loud and clear of the atmosphere that went on for the rest of my career after the '84 season.

For me, it goes back to my first day there and my most recent days there. It all starts from blocks away, familiar territory, and then right out of a neighborhood pops up Wrigley Field. You see people walking to the game, and you just get a sense that people want to be there and something special is going to happen in a few hours. It's a baseball game, and everybody is excited to be there. I still get that sense going there, just because of the unique location of it and the signs that there's a baseball game happening that day, and you could feel it blocks and blocks away from the stadium.

I think Wrigley is a destination for baseball fans, not only Cubs fans, but baseball fans in general. The true baseball fan either has it on his bucket list or he's already been to Wrigley Field to watch, even if it's only one game, because it is that special of a place.

24. "Harry Caray Said Our Name!"

Ivan Lovegren, actor, Los Angeles, California, via Omaha, Nebraska

Wrigley's the best, the greatest place on earth. I was five years old in 1989, and my parents actually sent me and my brother to Chicago to visit our grandparents for a few days. It was our first time ever doing a vacation on our own. My dad was from Chicago—I lived in Omaha, Nebraska—so WGN and the Cubs were on every single day. That year, I would watch the Cubs every single day.

One of the things we did on the trip is we went to Wrigley. I was so small, and there was such a crowd, I don't remember a lot of the walking in the door. But I do remember seeing the field for the first time. They were warming up, and again, my sole focus was on finding out who was pitching because I wanted to see Maddux pitch so bad.

So I was looking all over the field, and then, you know, finally my grandpa bought a program, and back then they would actually put the insert in the program that had the day's roster, and we saw Mike Bielecki. We're

there, and Mike Bielecki pitched. I was so bummed, but I had his 1989 Topps baseball card, so that was kind of cool. I'm 90 percent certain the Cubs actually ended up losing, and I was bummed because I wanted Greg Maddux to pitch since he was my favorite. Still is.

The trip ends, we come back home and our parents are like, "Guess what. We got something. We taped the game on VHS." Should I translate that for readers nowadays? On the ancient system of communication. So we're watching the game, and you know back then, in the fifth inning, they would always be like, "Oh, we welcome so and so." I don't know how much you had to pay or how that process went, but bottom of the fifth inning Harry Caray says—and he is three sheets to the wind by now—of course, in classic Harry Caray fashion, he mispronounces it: "We like to welcome Curtis and Ivan Lovegreen from Omaha, Nebraska." And we're like freaking out—like, Harry Caray said our name. He's still the greatest broadcaster who ever lived.

Before I moved to Los Angeles, I did a bit of background work one summer here in Chicago, and there was a movie called *The Express*. It's the story of Ernie Davis, the first black Heisman Trophy winner. And one night when they called us in, they said, "Hey, guess what? We're going to Wrigley." We got to come through the ivy in the left field wall and stand on Wrigley for about four hours while they filmed under the lights that night. You can't really see me in the film because it's at night, and the silhouette is on him, but I'm one of the players who lined the path that he walked.

It was 100 percent magical. I didn't touch the ivy, though, because I respect it, but I definitely breathed in the scent of the ivy. It was lovely.

25. A Wrigley Ending Before His True Beginning

Tony La Russa, Hall of Fame manager

My last Major League appearance was as a Cub in 1973. You know you had a lousy career when you score the winning run on Opening Day—I was pinch running for Ron Santo and had nothing to do with it, so that was my introduction to the Cubs.

When I got to the White Sox, spent almost seven years there, you really got the flavor of baseball fans—South Side, North Side, the rivalry was very exciting. I got away to Oakland for a little while. I remember going into Wrigley Field when I got the chance to manage the 1990 All-Star Game

there. That was really my first chance there as a manager, and it's a difficult place to manage. You had trouble seeing because you were kind of sunken in the dugout. That day was cold and rainy. Later on, I found out that when the wind is blowing out, it's really nerve-wracking, man. It's a unique ballpark. The people are right there next to you, so you can hear them. I liked that up close and personal.

When I went to the Cardinals, that rivalry with the Cubs was very special. Half the crowd blue, half the crowd red. It was the best—real intense—but no cheap shots. The fans weren't punching one another. In 1998, the Cubs had Jim Riggleman as the manager, and they made the playoffs and had the individual home run chase between Sosa and McGwire—and I've had guys on that Cardinals team tell me the highlight of their career was to be there for Opening Day when McGwire hit a grand slam. When they played against each other, it was electric at Wrigley.

26. Bleacher Bums, Buttons and Mice

Larry Davis, Las Vegas, Nevada

Growing up in Skokie in the 1960s, I watched the Cubs on Channel 9. My next-door neighbor was a big fan, and he used to hook up his television in the backyard. My two brothers and I, along with my friends, would watch the games all summer. The night games we'd usually watch in my neighbor's backyard.

My first game at Wrigley was for a birthday party for a guy on my block. We saw the Cubs play the Milwaukee Braves with Hank Aaron and Joe Adcock. I remember the game itself, but I'll never forget when I walked up the steps and saw the vines and the brick wall. We had really great seats; they were called grandstand seats about six rows past the main aisle, right behind home plate. I'll never forget that.

Ten years later, in the summer of 1969, I didn't miss a day in the bleachers from after school let out until I went away to school at the very end of September. It was unique. It was electric there. It was really the place to be, and you realized you were involved in something special, something that would be historical: the Bleacher Bums.

I was a senior in high school in '69, so I was much younger than the main group. Those guys were drinking beer and meeting the players and going

The Cubs and the remaining fans left at Wrigley celebrate a walk-off win during the 1969 season. The team won ninety-two games yet faded down the stretch, with an 8-17 September that cost them a division title. *National Baseball Hall of Fame Library, Cooperstown, New York.*

out drinking with them. Those guys were over my head, to be honest. I knew who they were, but I was too young to hang out with those guys. At any rate, I went to the games and got caught up in the mania out in the left field bleachers.

I decided to try to make a little money off of it: I made Bleacher Bum buttons. It was a round button that said, "Official" on the top and "Bleacher Bum" underneath. In the middle, there was a little box to put your name. I made ten thousand of them; they cost me a dime a piece, so $1,000 total, and I sold them for fifty cents.

At that time, there were no reserved bleacher seats. People started coming to the games and getting in line because there was a real premium on getting the first two rows in the left field bleachers. They'd be there as early as six o'clock in the morning to get in line. And it wasn't unusual for half the bleacher people, just to get a seat, to be there three hours before the gates opened. It was unreserved grandstands and unreserved bleacher seats, which made it first come, first served. People got there early because they didn't want to end up in right field, and of course, they didn't want to end up in center field.

I'd sell buttons before the games. My friends would help me, and then they would go in when the gates opened at eleven o'clock to save me a seat. Pretty much everyone was in by eleven, so I'd hang out a little longer. I sold

them out, ten thousand of 'em. It took me about thirty games. They were a pretty easy sell. People just wanted some affiliation with the Bleacher Bums, so they bought a button that said, "Official Bleacher Bum," and they were part of the club—if there was a club. Anything they could do to attach themselves. People just wanted to be part of that group because it was an exciting group. It really made the games entertaining as a sideshow to the Cubs. You never knew what you could see there.

Probably the craziest thing I saw was when the Bums brought some white mice—a box of white mice, three or four of them—and put them on the field. They dumped the mice on the field. Lou Brock was in the outfield and couldn't take his eyes off the mice. They never stopped the game to get the mice off, but Lou Brock had half his mind on the game and half his mind on the mice. That was pretty funny.

When Kenny Holtzman pitched his no-hitter in '69, there were probably a couple hundred people who jumped out of the bleachers onto the field. At least a couple hundred. I was one of them. I really believe the basket was put on because of the Holtzman no-hitter.

27. Still Rooting for the Cubs in Arizona

Stanley Kuczek, Phoenix, Arizona

I was at Wrigley when Mark McGwire and Sammy Sosa were going down to the wire with the home run race in 1998.

McGwire hit two and Sammy hit one that day. I've never seen it any louder. Nobody would leave until the last inning after they batted. It's something I'll always remember. That and the first game I came to when I was nine years old in 1954, when Hank Sauer, Ralph Kiner and Frankie Baumholtz were playing.

I live in Phoenix now, but I keep coming back every year. I'm originally from Wheaton. I can still follow the Cubs out there with the MLB cable package. I also go to spring training and, of course, when they play the Diamondbacks.

I'll always be a Chicago fan. I won't root for any of the Arizona teams. It's just the way it is. It goes from generation to generation, from my grandfather to my father to my son and my daughter. It's an older crowd in Phoenix. They're all retired like me. During the Diamondbacks game, there are more Cubs fans than D-Backs fans. In spring training, it's like a scrimmage. Nobody pays attention. They just sleep.

28. Journey to Wrigley Is Part of the Fun

Kevin McCarthy, Rockford, Illinois

I grew up in the Norwood Park neighborhood on the northwest side of Chicago in the 1960s. There was no way to avoid being a Cubs fan living in that part of the city. I was just old enough to remember when Leo Durocher was trying to get his 1969 Cubs to the World Series. Unfortunately, we all know the outcome of that story.

Eventually, I started going to games without my family. My friends and I had to walk to Higgins Road to take the bus to the Jefferson Park CTA terminal. We would hop on the L and get off at the Addison Street station. From there, we would take the Addison bus to Wrigley.

We always used to get to the park early to walk around, get autographs and just make the most of our time. My father was a Chicago police officer. I was always very proud of Pops being a cop. So we used to talk to the police officers from time to time to see if they knew my dad. This was the beginning of name dropping in my life. We also conversed with the firemen at the firehouse on Waveland Avenue quite a bit.

The Waveland Avenue sidewalk has been the final path for baseball fans heading to Wrigley likely since the park opened in 1914. That stretch of pavement was closed in 2015 because of construction on the "triangle" property. Crews installed a makeshift bridge to run electrical cables across Waveland without disrupting foot or vehicle traffic. *Rob Carroll photo.*

Going there on Sundays, even on game days back then, the CTA had only weekend service, meaning limited times when the buses and trains run. There were times when we waited for the Addison Street bus to come and it seemed like it would never arrive. So we started walking east down Addison. From the Addison stop to Wrigley, as we learned later, was about three miles. Throughout our youth, we ended up doing this time and time again, sometimes catching the bus halfway. It was sixty cents to transfer at that time.

When we got to the ballpark, we usually bought either the bleacher seats or general admission right on game day for two or three dollars. It was never really a problem getting a ticket back then since the Cubs were regularly in last place. Sometimes, through a friend of a friend, we received reserved seating, which meant we were supposed to sit way in the back of the ballpark. Even though the tickets were free, we'd still walk around the park trying to find ways to move to the more desirable box seats that were closer to the front.

We would all have to agree and have enough guts to attempt this brave move to the box seats. We would find a group of unused seats just to get ejected after maybe a half inning due to the Andy Frain usher who saw us sneaking in or after someone, probably the true box seat ticket holder, turned us in. We were sometimes successful making the move. It was usually after the sixth inning. I was clueless at the time that Andy Frain was an actual person who started a company. As a kid, I thought Andy Frain was a job title like electrician, salesperson or manager.

29. LIFE OF A VISITING PITCHER

JOHN SMOLTZ, HALL OF FAME ATLANTA BRAVES PITCHER

You can sense a different feel in the Wrigley Field crowd during the playoffs. You can feel their hunger for something that hasn't happened in a very long time. The Cubs and Braves played in the 1998 and 2003 postseasons, and I remember being on the mound to close out Game 4 in the 2003 season.

My elbow is just screaming, and Sammy Sosa's coming up with two outs in the ninth with us up 6–4. Sammy's a dead-fastball hitter and that's all I can throw at this point. My manager came out and asked if I was done. I said yes but that I was man enough to take whatever came. I threw the full-count pitch, Sammy hopped and I just dropped my head. If he hopped, he

usually knew it was gone. This time, he flew out to the track in centerfield to end the game, and we sent it back to Atlanta for Game 5.

Wrigley can be a pitcher's park because the ratio shows the wind blows in more often. I was a fly ball pitcher, so when the wind blew in, you could attack more. Then there were days when the wind blew out. One time, I gave up eight runs, four in the first, but ended up winning. Overall, I liked the atmosphere at Wrigley with everything right there, so close. On the mound, I felt like I was right on top of the hitter.

But I wasn't a fan of the bullpen set up down the line. There was too much room, and I would end up throwing one in the dirt by the catcher, which would delay the game. The fans being so close wasn't too much of a concern because I'd stay in the dugout until about the time I might come into the pitch, which wouldn't be until the eighth inning. You'd get down there and some fans would get on you, but you can't really say anything back.

One of the things I enjoyed doing was shagging balls during batting practice. It wasn't the same at Wrigley because you couldn't try to rob home runs and you didn't want to run into the brick walls. And the fans are right there yelling for a ball. They would berate you for a ball. My trick was to stay in center where there were no seats. If I had to run into one of the gaps, I'd try to stay under the basket so they couldn't see. Usually, I'd give a ball to one of the younger players and have him decide what to do with it, let him take the heat.

30. Keys to the Game

Gary Pressy, Wrigley Field organist

I started playing the piano when I was five years old, and I switched to the organ like six months later. So I've been playing the organ for a long, long time. Over fifty years. I filled in for the Cubs at Wrigley Field for a few games in 1986. My first game was on Mother's Day 1986, so that was great because my mom is my biggest fan. But my first full season was in 1987.

At that time, you would send in a résumé. I was playing the organ for the Chicago Sting at Wrigley Field. So they did hear me, and that helped. They called me in March '87 for an audition, and I got the job on April Fool's Day.

Baseball has been my blood my whole life. It is an amazing trip that I'm on because I can remember, growing up, I'd be the one, like everybody else,

to run home, catch the final few innings of Jack Brickhouse and Lloyd Petit or Jim West on the TV and watch Ernie bat and Ron bat and Billy. So when you're there, you're kind of like "Wow."

It's been twenty-nine years that I've been behind the Lowrey organ at the ballpark. Even now, it's great. You've got a nice view, and the Cubs are certainly an exciting ball club. It's a dream.

You've got to always update your material because at Wrigley Field you've got your people who were going to the games in the '40s and '50s still going to the games. And then, of course, you've got the newcomers, the kids. And they like to hear Lady Gaga or Katy Perry and all of that. A lot of my music is spontaneous with what's happening on the field. Maybe you can put music with that situation.

When I first got the job, Harry Caray was singing during the seventh inning. He did that, of course, until he passed away in February '98. And then they got the idea of having guest conductors for "Take Me Out to the Ballgame," and then the fun really started. One of the craziest ones was Mike Ditka, who, on bad knees, charged up the ramp, grabbed the microphone from Steve Stone and did it in a polka tempo. I caught up to him halfway through. I call it the Knute Rockne of "Take Me Out to the Ballgames" because I think we scored six runs in the bottom of that inning. It was like "Rah, rah, rah, let's go, let's go." And then we had Ozzy Osbourne. To this day, I still think he sang it backward, but that's OK. Most of the people who sing, they do it in good taste. Harry wasn't Sinatra, you know what I'm saying? So we wouldn't want anybody who did it real well.

31. A LIFETIME OF APPRECIATION

FERGUSON JENKINS, HALL OF FAME CUBS PITCHER, 1966–73, 1982–83

Everything has to change in the sport of baseball, and Wrigley Field is probably the last stadium to do it. Boston did it a couple years ago with seats on top of the wall. Now, the Ricketts family is doing it here with new bleachers, a new clubhouse, office buildings, you name it—they are doing everything to improve the part of Wrigley Field that needed it.

People still recognize what I did as a player; there's a lot of respect from the fans, and I really enjoyed that part of being out there. It was exciting to see myself up on the video board pitching at Wrigley again. So that—it kind

of brings a tear to your eye, thinking, "Gee whiz, how long has it been? I haven't pitched since the '80s. That's a long time ago."

The fans, some of the older fans who are still big Cubs fans, still remember what "31" was able to do. They put some old footage of me pitching up on the video board. But I got an uproar from the fans when I went out there to throw out the first pitch before Game 3 of the series against the Mets. I wore a number 14 jersey out of respect to Ernie Banks.

It shows respect by a club to retire a number. I think that's unique. It doesn't happen to everybody. Two players who are now both in the Hall of Fame, Greg Maddux and I, wore 31 for a quite a few years and were able to win ballgames. That's the top of the mountain right there. The nice thing about it is I'm on the left field pole with Ernie and Ronnie. And the other pole is Maddux, Sandberg and Billy Williams.

That's all a long way from my beginnings at Wrigley. I got called up to the Phillies in 1965. The last road trip the Phillies took we had to go Chicago. We show up to Chicago, and the second game I got a chance to pitch in. We had a rain delay, so I come in the eighth inning, get somebody out. I come back to pitch the ninth, get Billy out and then Ron Santo's the next hitter. He hit a high fly ball to left field, and it fell into the first couple of seats in the bleachers.

After the ballgame, all the reporters are up there in the clubhouse—basically before you get there. And the microphone is right in front of my face asking what do I think of my first experience pitching at Wrigley Field. I said, "Well, I'd hate to pitch my whole career in this ballpark." Six months later, I'm traded to the Chicago Cubs. My dad always used to say be careful what you wish for.

The biggest thing in that era was every team had five or six pretty good hitters. You had to pitch to the hitter, especially at Wrigley Field; you had to make them hit it on the ground. Sure, I gave up a lot of home runs in Wrigley Field, a lot of them were solo. I tried not to walk anybody or give up a lot of hits before someone popped one on me. The most important thing was I already knew the ballpark was small, like Connie Mack Stadium small, so you got to minimize your mistakes and hold the other team to as few runs as possible and hope your team could score.

We started getting good crowds in '68, when we started to win under Leo Durocher. We were picked to win in '69 and stayed in first place for like five months. The only reason we didn't win the pennant that year was because we stopped scoring runs. There were just some teams we ran into that were buzz saws. We just couldn't score runs. The next year Pittsburgh got us, and the following year, in '71, it was the Cardinals.

Cubs legend and baseball Hall of Famer Ferguson Jenkins won ninety-five games at Wrigley in his career, which included ten years with the Cubs and a stretch of six consecutive twenty-win seasons between 1967 and 1972. *National Baseball Hall of Fame Library, Cooperstown, New York.*

In '68, '69, '70, people were camping out for the bleachers on Waveland and Sheffield. They had sleeping bags lying on the cement waiting for the ballpark to open so people could rush in and get good seats in the bleachers. They wanted to see the Cubs win a pennant.

32. DID HE OR DIDN'T HE?: BABE RUTH'S WRIGLEY WORLD SERIES MOMENT

ED SHERMAN, AUTHOR OF *BABE RUTH'S CALLED SHOT: THE MYTH AND MYSTERY OF BASEBALL'S GREATEST HOME RUN*

It is still unbelievable to think, eighty years later, here we are in the second decade of the twenty-first century, and you can still point to a spot in Chicago at Clark and Addison—a few hundred feet east—where Babe Ruth actually stood and hit one of the most famous home runs of his career. The idea that this spot is still there I think is significant. It speaks to the history of Wrigley Field and also to the history of the futility of the Cubs. The most famous moment in the history of that ballpark was done by a player on the opposing team in a World Series.

People forget about that. They lose sight of the fact that this wasn't just another home run. It really, effectively, ended the 1932 World Series. The Yankees were up 2-0 in the series, and it was coming back to Chicago. The Cubs were the favorites to win that World Series because of their pitching. There were still a lot of high hopes that with a couple games left in Chicago, the Cubs could still turn things around. But Ruth hit a three-run homer in the first inning. He almost hit another home run in the third inning. The Yankees were up like, bang, right out of the gate. Then the Cubs, for the first and only time in the whole series, actually mounted a rally and tied the score in the previous inning. Now, all of the sudden, there was momentum on the Cubs' side, and people were going crazy.

Ruth came up and, if he struck out or hit a weak popup, especially a strike out, the argument could have been made that the place would go nuts and the Cubs would be suddenly golden. Instead of striking out or hitting a ground single, not only did he hit this home run, but he also hit the longest homer in the history of Wrigley Field at that time. It was just this massive shot. That gets a little bit lost in the whole retelling of the story. Then, on the next pitch, Lou Gehrig hit another home run. Back-to-back home runs. Boom, the series was over.

I have said this many times, whether or not you think he called it is almost secondary to the idea that this was the most unique at-bat in baseball history when you consider that this happened in the middle of a World Series game. You're not talking about a situation where the closer was trying to get him out to end the game. It happened in the middle of the game. People are standing on their feet, taunting him. The other team's players are out on the field, taunting him. You can't even imagine that happening today. He is responding to them, obviously, he is clearly responding to them.

Because we don't know for sure if he really pointed—that does feed the lore. We didn't have the eighteen camera angles; we didn't have Ken Rosenthal asking him about it after the game. Nobody really asked him about it until two, three days later. It was kind of clear that he wasn't even sure what the reporter was talking about. Again, you don't even know how accurate that reporter was because back then they made up quotes—the writers did things to serve their own needs. This wasn't even

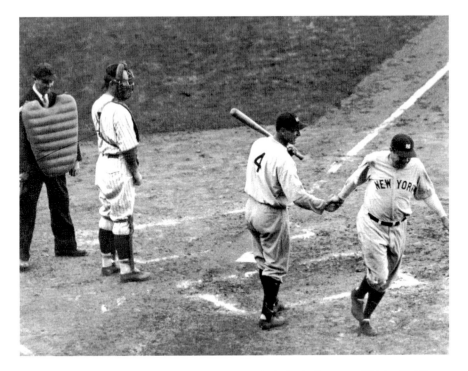

The legend of Babe Ruth's home run in the 1932 World Series is among Wrigley Field's greatest stories. Whether he pointed or not, it is one of the most talked-about moments in baseball history. *National Baseball Hall of Fame Library, Cooperstown, New York.*

an era when the writers went down to the locker room after the game. The stories were basically just retelling what happened. There wasn't any TV. There was radio, but this was early in the Depression, and many people didn't have radio. Basically, these stories were very glorified play-by-play versions with a lot of flourishes, and some of the writing was unbelievable, so that was part of it.

For all his greatness, Ruth didn't have the career-defining moment like Reggie Jackson or Hank Aaron. It was almost like his career demanded something larger than life, like a fable, something that was almost out of a storybook. That's why I think we still talk about it.

I think he was the greatest athlete in the twentieth century. If you're trying to describe someone, the essence of his greatness, well you can say, "This is a guy who pointed during the World Series game and hit a home run where he pointed." How many guys can do that? I think we keep retelling the story because it's Babe Ruth. How many athletes from the 1920s do we still talk about? How many athletes still seem as alive today? This guy has been gone for sixty-plus years. He played his last game over eighty years ago. He is the only athlete who really seems as current today as some of the guys who are still playing the game.

If he had done this in Cincinnati or in Brooklyn, I still think it would have been an unbelievable moment. What makes it relevant to the twenty-first century is that Sportsman's Park, Crosley Field and Ebbets Field aren't there anymore. I think it's really cool that you can still go to Wrigley Field. I can take my son and point to home plate and tell the story. You can visualize Ruth being there. You can see where he stood, and you can point out to center field and where he hit the ball. Even though center field was totally different back then; it was configured differently when the bleachers weren't there. There were no vines or anything like that. You can still say, "Here's where he hit the ball." You can even almost walk out to the spot. Your grandfather or great-grandfather did sit in the seats at Wrigley.

I think that is what makes the Wrigley element of this so compelling still, all these years later, is that you can do that. You don't have to imagine what the scene might have looked like; you can still see it.

33. August 9, 1988:
The First Official Wrigley Night Game

Tadd Swanson, Peoria, Illinois

Being a kid in the late 1980s out in the country three hours away from Chicago, we didn't have cable, but WGN still pushed hard on AM radio, so I grew up listening to a lot of Cubs baseball. Occasionally, we'd go to our grandparents' house in the bustling metropolis of Galesburg. They had cable. Anytime I was there, we'd always have the Cubs game on. I just kind of ended up being a third-generation Cubs fan. I really didn't have any say in the matter.

We'd generally go up to a game or two in the summer, but it was a pretty big production to go up there because you had to drive, and park, and walk and get the tickets. There wasn't any StubHub or any of that stuff. Sometimes I'd go with a friend's family or my grandfather would get a ticket with a men's or church group and we'd go up to Wrigley with a bunch of old guys on a bus.

At some point, I remember my dad said he was going to try to get some tickets for the first night game and then telling me he didn't get any for the first night but for the next night. I thought that was a great near-miss but that it was cool. Generally, you got tickets weeks in advance because there was no printing at home. I'm sure he had to call an 800 number and wait for them in the mail. So you did this kind of thing weeks in advance because you didn't want to get up there and mess around with will call.

Being eleven, I was old enough to know there were no lights at Wrigley and no night games. I remember sitting and watching the game the night before with the rainout and Greg Maddux being the instigator of the whole tarp-sliding thing. It occurred to me that if they didn't get the game in then, we'd be there for the first one, but part of me was a little sad about the whole tarp-sliding thing because I knew there wasn't much of a chance of it happening two nights in a row. They don't do it every rainout—it wouldn't be spontaneous.

We drove up there the next night and sat in the bleachers. I looked at the lights thinking it was very, very strange. At that point, it was awesome to be an eleven-year-old out in the evening in Chicago at Wrigley for a Cubs game. I was conflicted, wishing there was a rainout so I could see the whole tarp thing. I thought, "Well, that's dumb. You drove all the way here; you want to see a ballgame."

The visuals of the night stand out to me. It left me kind of awestruck. I'd never been to another Major League park other than Wrigley, so this was also my first night game. The visuals were striking: the pinstripes, the ivy, the flashbulbs from cameras because this was still a fairly spectacular event. I'd been under park lights for a baseball game before, but I never experienced that many lumens.

Then, after the game, you and forty thousand of your closest friends are all trying to spill out into the same eighteen-foot-wide street. You get out there, and it's darkness. Even though there are streetlights, it's nowhere near as bright as where you just came from. These are the pictures in my mind.

I don't remember game stats or anything you would see on Baseball Reference. Especially as a little kid, a lot of my memories are more visuals. They played the Mets and they won—those are the only two facts I remember from that day.

34. ALMOST ANOTHER LOU BROCK STEAL

JOHN ARCAND, BIG TEN NETWORK'S "BIG TEN TREASURE HUNTER"

We moved to the Rogers Park area of Chicago in 1969, which was obviously a formidable Chicago Cubs season. We'd take the super bus transfers for $1.75 right out to Wrigley Field and for four bucks get a bleacher or grandstand seat.

What we'd do at the end of the ballgame is lift up the seats and collect all the cups. Then we would get a great general admission pass from the Andy Frain usher for doing that after the game. So we would perpetually always have more tickets for upcoming games for that same $1.75 transfer and our eagerness to watch the Cubs play.

In those days, it was great because if you stood at the corner of Wrigley where the Captain Morgan Club was until recently, the bus would pull right in there, and the players would be hopping off and hitting the stairs. They used to go right upstairs, so all the ballplayers who were visiting would have to walk by you.

One of my favorite stories was when the Cardinals were in town. I was standing by the gate where these guys would go upstairs, change into their uniforms and come down. Lou Brock came down, and I showed him a 1964 Topps coin of him with a Cubs hat on.

I said, "Mr. Brock, I wanted to show you this." I also had an autograph book, and I said, "Could you sign this for me?" He grabbed the autograph book, grabbed the coin and said, "Son, it's amazing. You've got some real nice autographs. You know, I'm looking at Ralph Kiner. And you got this coin." Then he said, "Well, with all of these great autographs, which one of these would you like back?" I said, "Aw, I would like them both back. You're one of my favorite players."

Then he said, "Well, you know I can give you one of them back. I mean, look at this, you got Tony Scott, you got Joe Youngblood, you got Ralph Kiner. I mean, you got some great autographs."

And I said, "Mr. Brock, I really would appreciate both items."

He said, "I can't give you both. Which one do you want?"

I said, "Oh, I'd really like 'em both," and he goes, "I tell you what, kid. Let me hold on to this coin. I'm going to go show it to some of the guys in the dugout, and I'll get you a few more autographs for your autograph book."

So he took both of the items. I went down and met him downstairs probably ten minutes later, and he came out of the dugout and handed me the coin and the book back.

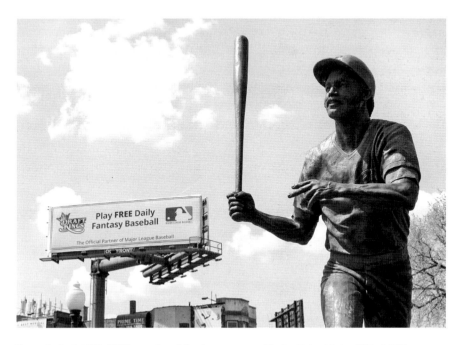

Sweet Swingin' Billy Williams played for sixteen years with the Cubs, hitting 231 of 392 career home runs at Wrigley Field. *Rob Carroll photo.*

No matter how much this game has changed or turned into a corporate entity, the dreams of a nine-year-old and a twelve-year-old kid are still the same. I was at Billy Williams's 400th home run game, and he signed my scorecard beforehand. After he hit his 400th home run, everyone threw everything they had up in the air as confetti, and I did the same thing, forgetting I had a scorecard signed by Billy Williams. That was a bittersweet day for me.

Your first love at Wrigley was your Cubbies. We went to forty games a year—it was like home to me. One day, seven of us all missed the first day of school to go see the Dodgers play because one of the girls personally knew

Ron Santo, one of the Cubs' most popular players and broadcasters of all time, spent fourteen years with the team as a stalwart at third base. *National Baseball Hall of Fame Library, Cooperstown, New York.*

Steve Garvey. All of a sudden, the game's about to start and they announce on the speaker system that the Jamieson School students at the game better report back to school or they would be suspended. We all went back to school right away. Steve Garvey called the principal to apologize.

That was the innocence of it in those days. It was so simple. When I go to Wrigley today, I'm reminded of forty years of Cubs. The Milt Pappases, the Rick Reuschels, the Rick Mondays, Santo, Banks—all these guys you got to really see up close.

35. WRIGLEY'S SECOND HOME

DENNY GARKEY, FOUNDER OF LITTLE CUBS FIELD, FREEPORT, ILLINOIS

My whole life I have been a baseball fan. I played baseball. I coached baseball. I watch baseball. I've been a fanatic of baseball. I've always loved the Cubs, and Wrigley Field, I thought, epitomized what's good about baseball. The atmosphere there. The old-school feel for baseball when you're there.

In 2005, I was in a place called Rookie's Sports Bar near Black Earth, Wisconsin, eating lunch with friends. I looked out behind the sports bar, and there's a Wiffle ball field for kids. It's fun for people who visit the sports bar to go out and hit some balls around. It was very generic. It was mostly plywood, and it had a little scoreboard. I thought, "It's too bad somebody doesn't build a replica of Wrigley Field and do it right. Trick it out with bricks and ivy, the scoreboard, the whole thing." I started obsessing over it. I thought, "Why hasn't this ever been done? Can it be done?" I Googled it and found out nobody had built a scale replica of Wrigley Field this size with the Cubs' permission. It had never been done.

The process started when I asked my wife if I could spend some time exploring the feasibility of getting this done. She said, "That's a great idea. It will get you out of the house." I still have a job, and I'm a good time manager. So I thought I could do this. I called the Chicago Cubs to get their permission to use their logo and the marquee from Wrigley Field. We needed their help to get this done.

The first person I talked to was a marketing person who happened to be John McDonough, now the president of the Blackhawks. He didn't know me from Adam, and we talked for fifteen to thirty minutes. I expressed how I wanted to do it. It was going to be in a park. We would form a nonprofit,

The Chicago Cubs provided some of the ivy that can be found along the outfield walls of Little Cubs Field in Freeport, Illinois. The field, occasionally used by youth teams, is open to the public. *Rob Carroll photo.*

and it would be for Little League. He said, "That's a great idea. What can we do to help you?" He said, "We'll run it by our legal department and our board of directors, and I'll get back to you to see if we can give you the green light." I heard "legal department" and "board of directors" and thought this was going to be the last thing on the agenda and I wouldn't hear from him for another six months.

He called me about ten days later. He said, "We just had a board meeting. Everybody loved it. The legal department said it was fine. What do you need?" I said, "That's easy. I need a private tour of Wrigley Field, a cutting of your ivy so we can grow our own ivy that matches and I need the phone number of Ron Santo." I wanted to get Ron Santo involved in promoting this to maybe give it some verbal attention when he was on the air. McDonough said, "Come to Wrigley any time. Just let us know when you are coming; we can give you a private tour. You can measure and go over everything. You can take pictures, and we'll give you a cutting of the ivy." We did that a couple months later.

In the meantime, I formed a nonprofit. We got some like-minded, crazy people involved in it. I talked to my good friend Mark Winter of Winter

Construction, who builds commercial and residential buildings. He's a big Cubs fan. At that point, everything was just falling together. We talked to construction people. We talked to the bricklayers' union, Local 6, out of Rockford. We figured we needed about twenty thousand bricks to build this, and we needed bricks to match Wrigley Field. They said they would do all of the labor for free. That was $170,000 worth of labor they said they would donate. The carpenters' union said they would build our gift shop right next to the field with no labor costs. The electrical workers' union said not only would they do all of the electrical work at the site for free, but they also would donate all of the fixtures. We had a plumber who said he would do all of the plumbing for free. We had smith finishers say they would do all of the smith finishing for free. We had a guy with a bulldozer who does civil engineering in Freeport. I had coached his son in baseball and basketball over the years. He said, "Yeah, we'll bring in the bulldozers and do all of the site work for free whenever you are ready to go."

It was amazing. None of these were written contracts. We shook hands, and that was the end of that. And they said when you're ready and you have materials, we'll be there and do whatever needs to be done. Then the architectural firm said they would write up the architectural drawings at no charge.

We had a press conference announcing we were going to do this. We got attention not only from local media but also Chicago media came out. At the time we made the announcement, it was early in the project. We had a website that was donated, and we had $100 in the bank. That was it. We had an idea and all of these handshakes. It went from there to becoming an out-of-control boulder that you roll down from the top of the hill. Everybody wanted to make it happen. Banks gave us money. The park district gave us the land on a lease for one dollar in the corner of the park. The park was being redone anyway to accommodate a quadplex of baseball diamonds. We were the fifth diamond. Ours would be an entry-level diamond for seven- and eight-year-olds, plus t-ball and Wiffle ball. It would be a tourist attraction.

Then the bricks were donated from a place in Lincoln, Nebraska. They were trucked up here for free by a trucking company. We had about $500,000 worth of donated labor and materials. We raised about $130,000 in cash, which was all we needed, to buy some materials and specialized labor. But 95 percent of the labor was free. We went to local banks. We went to service organizations, and they would donate some money. The park district gave us $50,000 that was from a matching fund program that was set up and had $1 million in it over the years. It was specifically for projects like this where grass-roots organizations wanted to do projects within the park district, and they

Little Cubs Field, a smaller version of Wrigley Field, opened in Freeport, Illinois, in 2008. Work on the field was mostly completed by volunteers. *Rob Carroll photo.*

would match whatever you raised. We only asked for $50,000. Technically, we raised a half million dollars in labor, but we didn't have the heart to ask for that much. We didn't need that much. So we asked for $50,000. They were getting something for five cents on the dollar that was going to put Freeport on the map. They bought into the whole idea.

For four and a half months, the bricklayers were here in town building the perimeter of the field. While they were here, some of them had to stay overnight. Hotels in town put them up for free, and every restaurant in town fed them for free. They just showed their bricklayers' union cards. That's an amazing story. You tell people about it and they never believe it. It happened.

We got Ron Santo's phone number soon after the original conversation with John McDonough. He came out and promoted what we were going to do. Then, two years later, when the field was completed, he came out for our grand opening. And then he continued to talk about it on the air. He thought it was the coolest thing.

I really thought it would help youth baseball and help our community. It would be something the entire community could take pride in for years to come. It's about getting kids to play baseball. Who wouldn't want to start his or her baseball career as a six-year-old hitting at a replica of Wrigley Field?

A lot of people say they can't believe it exists. A lot of people say this was in my mind for years. As a kid, they pretended they were at Wrigley Field. They say, "You just built something out of my imagination." It was in my imagination, too—and plenty of other people's—and we wanted to make it a real thing.

It's the loyalty of the fan base of the Cubs. The fans stay with them. There's something about Wrigley Field that makes people want to identify with it. It's all about replicating the feel that you might get at Wrigley Field. You're not allowed on the field at Wrigley without security tackling you. You can come to Little Cubs Field and wander wherever you want to go and hit some balls.

36. On the Beat at Wrigley

Fred Mitchell, longtime *Chicago Tribune* sportswriter; Cubs writer, 1983–88

Baseball is in my blood. I played a lot, from Little League to high school, while growing up in Gary, Indiana. I was also a big baseball fan, and my father was nice enough to bring me to a lot of Cub games at Wrigley from the time I was probably four or five years old.

I've been with the *Chicago Tribune* since 1974 and was the Cubs beat writer from 1983 to 1988. Beyond that, virtually every season after, I was helping to cover the games or write features. In recent years, I've covered weekend home games for the Cubs and the Sox.

It was quite nostalgic going to work there in the early days. Whenever I walked down around Clark and Addison, I'd flash back to memories of my father when he'd bring me down there, when I was six or seven, holding his hand walking along the sidewalk up to the gate. It brings back a lot of memories.

Like so many other Cubs fans of my era who speak of coming to the ballpark for the very first time, seeing it all in living color is shock to the system. From early childhood, watching the Cubs in black-and-white television on Channel 9, it was quite eye opening—obviously something I'll never forget.

I also enjoyed getting to see the players up close while they walked on the catwalk between the dugout to the locker room. Back then, it was wide open. They have draping covering it up now. Then you could stand underneath and yell up to the players. I didn't do it, but some people would throw peanut shells or programs at the players. That was a way to get up close and personal.

It doesn't get old going to Wrigley. I've had the chance to cover games in every park in the league. Most, if not all, of the other ones have more modern amenities for the media, as well as the players. Yet there's still something special about Wrigley Field that makes it unique.

Up until about 1986 or '87, the press box used to be located on a lower level than it is now. The vantage point was awesome; a lot of foul balls would come in there, which we didn't mind too much. It was just ideal. Now, those are the suites on that level. These days, when the press box windows are open, you feel like you're part of the crowd. You get a good sense of the atmosphere.

When I sit and look down at the field, I imagine seeing players in the '50s, '60s and '70s playing on that very same diamond. That will never change between the lines. I grew up a Cincinnati Reds fan, so I look at the field and I imagine when I was a kid and my dad would bring me there to see Ted Kluszewski, Johnny Temple, Ed Bailey and all the guys from that era.

When I first started in '83, the Cubs clubhouse was down in the left field corner. You talk about a bandbox; it was really tight quarters. It was difficult for us in the media to navigate over the duffle bags on the floor to try to talk with players. The teams weren't very good at that time. Typically, they weren't in very good moods, but they had nowhere to hide like they do now when they can go inside a lounge or a weight room to hide. It was an uncomfortable situation at times until they moved into what was considered then to be a state-of-the-art clubhouse, which is far from that now. The players who don't like the facilities now—believe me, it could be worse.

The managers back then would typically engage the media in their office, which was wide open, so a lot of times players could overhear the conversation. So if a manager like Jim Frey wanted to rip Ron Cey, a guy he was not a big fan of, he would say it loud enough for Cey to hear. That was a pretty common practice back then. Managers would go off. They said what they said, and they generally stuck by it, except for Lee Elia, who got in a little bit of trouble.

There were so many other colorful managers. Tommy Lasorda would hold court before and after the game when the Dodgers would come into town. I think the common thread of conversation with all these guys, managers and players, was the terrific stage that Wrigley Field presented, as far as the greatest baseball cathedral. It was the mecca just to be able to come to Chicago. Even though the Cubs have this long history of losing and not winning championships, it's still a privilege for all these teams to come to Chicago and play at Wrigley Field. It's even true for veteran players or guys who played most of their careers in the American League. Just having the chance to play for the first time at Wrigley after eight or nine years of being in the big leagues—these guys were still pretty wide eyed and excited about playing here.

Everyone who was around during my time on the beat will point to the Ryne Sandberg game on June 23, 1984. It was significant in a lot of ways.

A nationally televised game made it a much bigger deal than it is now. The game went back and forth, looked out of the Cubs' control. I remember leaving the press box and walking down to the lower box seats, which is a common practice of the beat writers, especially at that time because you would just walk onto the field and into the dugout at the end of the game. It was easier to navigate the crowd that way.

So when it looked like the game was going to be over, I left the press box with a writer from the Associated Press. We were just recording in our scorebooks what we thought were the final couple of outs, and then obviously it turns out Ryne Sandberg hit a couple of home runs to prolong the game before they went on to win it in extras. It was a surreal atmosphere for a regular season game in the middle of the season. It sticks in everybody's memory.

37. Meaningful Memories Span the Decades

Dennis Eckersley, Baseball Hall of Famer, Cubs pitcher 1984–86

There's nothing like Wrigley Field. Once you're a Cub, especially back in the days of WGN, you're always a Cubbie. It's hard to explain it unless you're in Chicago.

I had never been to Wrigley in my first ten years in the league. I had heard about it and saw it on TV and knew it played small. When I got there in late May 1984, it was still early in the season when the wind blows in a lot and it's a totally different ballpark to play in. When the wind blows in, it's horrible to hit in. Then there were days like when Ryne Sandberg hit two home runs off Bruce Sutter. What a day, huh? I'm thinking, "Oh, my, the ball's jumping." In the dugout, you could see the ivy, and you felt like you could see close up into the eyes of every person in the bleachers. It just seemed like a bandbox.

As time went on, as a starting pitcher there, I used to get up in the morning saying, "Which way is the wind blowing?" You've got to get lucky as a pitcher to pitch the right day. In the summer, the ball jumps. On the other side of it, they had the grass up high, so that helped you if you were a sinker baller. It made me want to throw more sinkers. Then it just became the luck of the draw on the day you were pitching there. I would take batting practice, and I'd hit balls out of the ballpark, so I'd say, "Oh my god, I'm hitting them out!" It's scary. You think it's cool until you think about it.

After getting traded to Oakland in 1987, I came back to Wrigley for the first time for the 1990 All-Star Game. To be honest, I was proud to come back a new man with a new career. It was meant to be. I was peaking right there in the middle of the best year I ever had in my life—1990 was the best year I ever played relief-wise.

It was electric at Wrigley, and then it rained and kind of doused things a bit. It's the little things I remember: my friend Richard Marx, who is from Chicago, sang the national anthem; Bill Murray was sitting right over the top of the dugout, and I made eye contact with him; Ryno was having a great year. There was a good feeling in the ballpark that night because the Cubs were coming off a playoff year in 1989.

Returning with the Cardinals in 1996–97, it had a totally different feel. The Cardinals were changing because La Russa just took over, but the Cubs didn't know who they were because it was before Sosa went off in 1998. The fans weren't so bad to me; if you've been a Cub, they're good to you, they don't rip into you. A lot gentler than back east. I was too busy trying to get people to worry about the Cubs-Cardinals relationship.

More recently, it was incredible to be at Wrigley broadcasting the last two games of the NLDS against the Cardinals. The fans were very tentative about celebrating; they were so excited, but they just couldn't burst because they didn't want to blow it. Right down to the last out, they had sort of that nervous anxiety—just don't do anything wrong—fingers crossed. I was feeling it for them. They've had so many disappointments.

After Game 4, when they clinched the series, I had to go through the stands to get where I wanted to go. I'm trying to get through the crowd, but you can't get out because everybody stayed. The people couldn't have been nicer—how could they not? They were so happy. That's what I took away from being there. I feel very fortunate to have shared the moment with them. Hopefully they have more.

38. Land of the Free, Home of the Brave

Wayne Messmer, longtime national anthem singer, former Cubs public address announcer

On September 27, 2001, after we had canceled a ten-game home stand because of the September 11 attacks, we were the last team to come home and start playing ball again. It was a big deal. It was a huge, huge deal. That

afternoon, I had been standing at O'Hare next to President Bush because he had just rolled in on Air Force One and made the announcement that it's time to start flying commercially. I sang there. That was an unbelievable moment. Then I came home, changed clothes; my wife, Kathy, was with me, and we went off to the ballpark that night to sing "America the Beautiful" and the national anthem.

To walk out there by the pitcher's mound and stand there with all of the ballplayers, firefighters, police officers and military standing there, arm in arm, up and down the foul lines was emotional as all get out. I remember coming home that night. And I'm sitting there like an old guy taking his shoes off, and I said to Kathy, "This was not your ordinary day." That was tremendously emotional.

It's been easily four thousand times that I've done the song, and I'm not sure I've ever done it perfectly yet. On the field, I am always thinking mechanics, technique. I'm always warmed up. When you get down there and it's show time and you have the mic, I think there's a responsibility of singing for some guy sitting on a barstool watching TV, some veteran guy whose life might not be going as well as he wished it would or somebody who is a singer who is just waiting for me to hopefully do it right. There are also those people in the stands who are going to elbow themselves after they say, "Oh, Wayne Messmer is singing. Really? Look at this guy." I don't want to let them down.

I take that approach from live theater, which is also a background of mine. When the curtain opens, people don't care that you have a headache. They don't care that you've had fifteen Cepacols because your throat is numb. They want it done right. My goal has always been to sing it so those who sing along have the opportunity. There are times to show you are a good singer and there are times to use that good singing ability to show you can sing something respectfully.

I'm looking around at people all the time as I'm singing, and I'll catch the eye of somebody. If some guy is wearing a cap, I will burn a hole through him. Show some respect by taking your cap off. Other things I think about are: "I've got a speech on Saturday that I need to work on" or "I forgot to send that e-mail" or "I've got to go to the bank tonight." It's weird how your mind can wander.

Opening Day is particularly challenging sometimes, too. I would be on the field...I would be down there reading endless commercials and crazy propaganda. Then there would be all of the introductions, and then on top of that, you're pretty well frozen. It's about an hours' worth of work in foul

weather, which is about the worst thing you can do as a singer. For me, I found the worst thing that can happen is having cold, wet feet. To me, that is just disaster. So what it does is really constrict the muscles in your throat, making it difficult to sing.

The national anthem itself is already a very taxing song. It's an octave and a fifth, and the average voice doesn't have that range. That's why people either bail on the top or the bottom of the song in terms of the melody. It was difficult. On cold opening days, I would take a couple Thermacare heat packs and wrap them around my back. I would take a small one and put it around my neck. If I had been strip-searched before I went on the field, they would say, "What is this guy trying to be?" But it worked. I'd have a couple thermal packs in my pockets so I could keep at least one hand warm. It was a challenge. Then, after singing—and some people even if they are right in front of you don't get the fact that you are the guy doing the announcing and singing. Singing is what gives you the spotlight. So it doesn't matter to someone else if you have already been reading for forty-five minutes and your voice is a little rough and the singing isn't great. It did put a lot of pressure on me, and I have the curse of being a perfectionist.

As I kid, I was always in the backyard doing the announcing. My brother and I would play home run derby. There would never be a guy who came up to bat without being announced. Generally, there would be play by play on top of that. We never did pause to do the national anthem. I've always loved announcing. I've been doing radio since 1976. Radio has always been in my blood. And having the good fortune of being given the gift of the voice to be able to speak and sing at a good level.

I'm probably the senior-most voice associated with Wrigley Field. In '83 and '84, I was with the White Sox as PA announcer and singer. Then I opted for free agency in the winter of '84. Opening Day of '85, I came on as the PA announcer with the Cubs. I did a guest shot out at Wrigley one day against the Expos, so I sang the Canadian and U.S. anthems. A lot of people noticed and said, "Wow, this is really good." Conversations began in the off season, and I ultimately made the switch to go to the Cubs. I grew up in the city on the South Side in Brighton Park. It was an ethnic neighborhood. A "dees, dem and dos" neighborhood. Most of the guys in my neighborhood were constant reminders of how I didn't want to speak when I grew up.

39. Learning from Rogers Hornsby

Allan Devitt, Bensenville, Illinois

There was a baseball school sponsored by the old *Chicago Daily News* in 1947. My dad had recently retired from the U.S. Navy. He was in the U.S. Navy during World War II. So he may have heard about it and took us there. It was either free or very inexpensive because we never had much money.

The school was right down on Wrigley Field. What I remember very much was how the infield was crowned. I was a kid then, and I thought I had died and gone to heaven. I was actually on the field! You had to bring your own mitt, and if you had spikes you could bring your spikes. If you didn't, you wore sneakers. You were just in your street clothes like your blue jeans. You got to run around the bases. It was just wonderful. It was absolute heaven.

Rogers Hornsby was out there. He was there, and he would pitch to you. I just remember how nice Mr. Hornsby was when he saw me holding the bat, which was probably as big as I was. He said, "Are you a good hitter, son?" I said, "No sir, I'm not very good." He said, "Well, put the bat down and come out to second base." I was all glove. I could catch pretty well and throw pretty well. So he took me out to second base, threw me some ground balls and worked with me. My brother was bigger than I was, so he worked with him hitting the ball.

I can still recite the 1945 pennant-winning team position by position. We were avid Cubs fans. We used to try to sneak into Wrigley Field with the Curtiss Candy Club people and try to climb over the wall. We'd do anything to try to get in. And it was inexpensive, too. My mother, when she was working, would give my brother and me two or three dollars. We'd go there at 10:00 a.m., when they opened, and we'd catch batting practice. We'd sit there all day. She'd pack us a lunch. We'd get into the bleachers. It was only like fifty cents or a dollar to get into the bleachers. And we'd stay there all day. It was the best babysitting you could get. Then we would walk home because we were within walking distance of the park.

And that's how the Cubs hook you. They get you when you're a youngster. I often tell people the Cubs are like dope. You know they're no good for you, but you can't help yourself.

40. The Pink Hat Guy

Jim Anixter, Cubs season ticket holder since 1967

On May 12, 1970, an overcast day, on a one-two pitch by Pat Jarvis, Ernie Banks hits a line-drive home run to left field for his 500th home run. As he's rounding first base, he shakes hands with Hank Aaron, who is playing first base that day, and trots around the bases. There were 5,338 people there that day. I was there. I went to nine straight games so I could see his 500th home run.

Opening Day 1969. It's the bottom of the ninth; the Cubs are losing 5–4. One on, one out and Leo Durocher motions for Willie Smith to pinch-hit for Jim Hickman. On a one-two-count pitch, Willie strokes a home run over the right field wall and they win 6–5. Hey, hey, holy mackerel, I slept ten feet above my pillow that night. It was one of the greatest games I ever went to.

I was sitting behind home plate in 1972, when Milt Pappas was one strike away from a perfect game with the Cubs, winning 8–0. Bruce Froemming

Leo Durocher managed the Cubs to 535 wins over seven years, including 92 victories during the 1969 season. The Cubs finished no worse than third for four straight seasons under Durocher. *National Baseball Hall of Fame Library, Cooperstown, New York.*

was the umpire that day. On a three-two count, he calls ball four on a close pitch. Froemming was a jerk for doing that. Then the next guy pops out, and Pappas finishes with a no-hitter.

I've seen all these games because I've had tickets since the 1967 season. I've been there for more bad times than good. After I got discharged from the Coast Guard in 1966, I walked into the Wrigley Field offices and said I'd like a half dozen seats in the front row for my company. The guy says come back just a second, someone had died and didn't will their tickets to anyone. They asked me if I minded sitting first row behind the screen. I didn't. After all these years and changes to the park, my firm has sixteen tickets: four in Row A and twelve seats in what used to be Row 1.

The Pink Hat Guy started when the 1990 All-Star Game was at Wrigley. Anyone who went to the home run–hitting contest the day before got a pink All-Star warm-up hat. My wife, Lesley, is a wonderful woman, but she is not a baseball fan. So I wore the pink all-star hat and a green shirt since 1990 on so my wife could see me in the first row and know that I'm really there and not playing games. And people recognize me. I'm a bit of a sex symbol, an icon. When I come into the ballpark, not a day goes by that someone doesn't ask me for my autograph or ask to take a picture with me. And even though I'm seventy years old, I get propositioned sometimes by women half my age to go out after the game. It's good for the ego, but I point to my wedding ring and say, that's nice, but I'm going on forty-five years of blissful boot camp, also known as marriage.

In 2004, my cousin said I should make a hat. So I did it with Pink Hat Guy on the front, trademarked, and with "Go Cubs!" on the back. If anyone wants the hat, I give it to them free around the country with the oral understanding that they make a minimum donation to the American Cancer Society or the cancer charity of their choice. My brother passed away of cancer, and my wife knew a few people who passed away from it. Maybe at the end of the year I generate a thousand hats. It's a small thing I can do. I tell them not to send the check to me, just say Jim Anixter, the Pink Hat Guy, asked me to make the donation.

A few years ago, I told Tom Ricketts that I spend thousands of dollars on tickets and should get a chance to sing the stretch and throw out a first pitch. I'm there more than Jon Lovitz and other celebrities who show up once a year. Next thing I know, the Cubs call me and say they had one night game left for me to do it. It was against the Astros during the first match-up between two teams with one hundred losses. I practiced for about a week so I wouldn't embarrass myself. Billy Williams told me to aim for the screen so

that I might hit the catcher. When I sang, and maybe I shouldn't have said this, but I said, "Let's get some runs. We don't want to be shut out two nights in a row!" Bob Brenly gave me a high five after that.

The FOJS, Friends of Jim, are the ushers and beer vendors. I don't drink and I don't smoke, but every beer vendor wants to buy me a beer. I say, you can buy me a beer when the Cubs play in the first game of the World Series at Wrigley. If the Cubs win the World Series, it'll be bigger than the '85 Bears, the six Bulls championships, the Blackhawks' three Stanley Cups and the White Sox World Series. It'll be the greatest story in the history of sports.

41. Wrigley Through the Lens

Jim Tianis, WGN cameraman, 1989–present

My first Cubs game with WGN was in 1989. They called me out of the blue because a neighbor who was a cameraman had put my name in. They called me and asked, "Do you want to do some Cubs games?" It's August 1989. I was, and still am, a huge Cubs fan, so I was like, "Yeah, I'd love to."

It was something I always wanted to do—in particular, Cubs baseball at Wrigley Field. I grew up watching the Cubs on good old Channel 9. As a kid, I knew that if I turned the TV on to Channel 9 after one o'clock on a weekday, I'd be sure to see green grass and Wrigley Field. So when they asked me to work a Cubs game, I wasn't even clear what they wanted me to do. I'm pretty sure they wanted me to run videotape as a replay operator. I said yes. I had no idea how to run the tape machine. Zero. I wasn't going to say no to my one chance to do work for WGN doing the Cubs games.

I went to a studio on North Avenue that had a machine to get a needed crash course. I show up that day, and I remember being between two staff guys—now it's pretty much all freelancers, then it was a mix of freelancers and staff—and boy, they didn't want anything to do with me because I didn't know anything.

I remember listening to Arne Harris for the first time, having him ask something about making an edit or something. And I'm just sweating because I haven't the slightest idea what I'm doing. I had no idea what I'm up against. I'm in there for about an hour when one of the managers came in and said, "Hey, Jim, aren't you usually a cameraman?" And I said yes.

They had an extra tape guy, and he was looking for something to do, and there was a camera available, so I said I'd grab it.

They sent me up to the scoreboard. At that time, Arne would use the scoreboard camera to go to breaks. Like a beauty shot. Arne would take a wide shot of downtown or the ballpark. It was kind of a misty day. The amazing thing to me is I walked in right in the middle of this Cubs playoff run, and I get to be running camera for WGN, which was my dream job as a kid. So I was just completely enamored the entire day. It was a whirlwind, where you try to soak in as much as possible hoping that you're going to come back. I had a wonderful job. I think they even put me on the air that very first day. It was kind of rainy, and I probably wasn't prepared for that clothing-wise. I remember they got a shot of me up on the scoreboard.

I'm spoiled now because I don't ever want to watch a Cubs game any other way than from behind my camera. It's a strange place to be because I love baseball—in particular, the Cubs and Wrigley Field—when you're there live and you can see everything. I can still be a fan when I'm a cameraman, but it's a little bit different. You don't sit there and actively root for the team; you've got other things going on. Still, I see everything that I want to see, and it's at my fingertips. I've got this huge lens that, from the dugout, I can zoom into the right field corner and shoot a couple of leaves of ivy on the wall. You're constantly checking on what other cameras are shooting. We all have our responsibilities, but you try not to double up efforts. You're listening to the director, the other camera operators and the game audio. If Len and J.D. are talking about the pitcher getting tired, you've got to look for the shot before the director asks for it.

For me, the scoreboard nostalgically is my favorite spot because it was the first place I was. You can see inside and outside the park. It's the only place you can still see people on the street outside after how they've changed the bleachers. There are stories all over—inside the park, in the dugout, on the field, in the stands. It's up to us to find those. We're always hunting and pecking and looking for stuff.

We found the guy who lost his seat once. And he was loaded with beer—he had like eight beers. Arne would cut to him between pitches. And we stuck with him for like an inning, five or ten minutes, until he finally found his seat, and it was pretty funny.

Then there's the story of the mailman delivering on Waveland that's been told many, many times. Andre Dawson hit this monster home run that went onto the street. Of course, all the Ballhawks converge on it. The mailman got caught up in the moment and decided he wanted the baseball, too, so he

Jim Tianis has watched Cubs baseball and Wrigley fans from every camera perch, including the third base dugout, in the ballpark over the years. *Jim Tianis photo.*

ran after it. And sure enough, the mailman came up with the ball. We had the shot of the guy holding the baseball up sort of toward the center field camera. I think they had him up in the booth, and then he got in his truck and went about delivering the mail. They fired him the next day and then reinstated him later on.

There's one thing that I happened across in the 2014 season that was so strange. And if I didn't pursue it, it wouldn't have gotten any notoriety at all. One of the new Cubs, maybe it was Jorge Soler, hit a home run into the left field bleachers, and I was on the high first base side camera. This guy catches the ball like any other home run that we've seen a thousand times. He goes crazy high-fiving his friends. In the middle of this jubilation—this guy was so excited that he caught this ball—you see his face completely sour. It was the strangest transformation.

I kind of tracked the ball in the sky and down as it landed, and I think they showed the replay, but I'm fixated on this guy because his face went from this incredible joy to complete panic. I'm like, "What happened? What is going on with this guy?" I see him say something to the guy he's with, and they're looking at each other and looking down and around. I'm still trying to piece together what the hell is happening.

Then I see them point to the field, and I see him grab his hand and that gave it away—he freaking lost his ring. He was high-fiving people, and he threw his ring off. Are you kidding me? It looked like they were pointing to the warning track. I took a chance and snapped in a two-times extender on my lens, and I just went to the warning track.

Sure enough, the light was just right where I found his ring. You could see it gleaming on the warning track. I'm trying to communicate to the truck

that he threw his ring onto the field; they don't know exactly how to deal with this. They rewound it and showed that moment of him high-fiving and then his face just completely losing it. We probably showed a couple angles of it. I remember ESPN using it, and some of the news people probably replayed it. I think the Cubs even went out there and interviewed him because it was just a crazy moment. And Len and J.D. had a field day with it because his wife was there. So they were like, "Oh, he's in trouble."

It was a good little bit. It's one of those moments that, if I had just done my thing and whipped off of there, I would have missed this. Obviously, something said just stay with this a little bit longer. I'm glad I did.

42. ALL THE SMALL THINGS

TIM SCHONTA, ELMHURST, ILLINOIS

Cubs fandom didn't come from my parents; neither were big sports fans. But I had older cousins. As the younger guy, you follow the cool older guys, and they were diehard Cub fans. That's where I was introduced and got the idea of rooting for the Cubs.

In fifth grade, 1969, my friend's dad had access to tickets, probably from work. So my friend, myself and another guy would just go down to Wrigley. Sometimes we'd get a ride to the Des Plaines L and take it down to Wrigley. In fifth, sixth and seventh grades, we just went to a boatload of games with these free tickets.

My favorite player in those days was Don Kessinger. I was just amazed at this guy, how he could go deep in the hole, get a backhand grounder, spin and then throw out the guy at first. Even though Ernie Banks, Billy Williams and Ron Santo were all there, Don Kessinger was my guy for all those years. Back in fifth grade, I had no idea this was some historic team that people would still be talking about fifty years later. Looking back on it, I consider myself fortunate that all of these things fell in place for me and I was able to see a lot of games in '69.

My all-time favorite Cub is Greg Maddux. He came up in the '80s, and from the get-go, there was something about Maddux that caught my eye. Whatever it was, he was my guy. I followed his career from start to finish, even those years when he was in Atlanta. Then, of course, he comes back to Wrigley for a stint, and that was just great. And he hit some milestones

Don Kessinger (right) earned All-Star honors six times during his twelve years with the Cubs. He also won two Gold Gloves manning the shortstop position at Wrigley. *National Baseball Hall of Fame Library, Cooperstown, New York.*

while he was back with the Cubs. When he came up, he was just another rookie. No one knew that he was going to have that kind of career. There was something about him that I just plain admired.

Over all these years, it's the little things that really stand out about being a Cubs fan at Wrigley. There's always something going on, and I have that sense of it being a family reunion. There are thirty thousand people here, but it feels like family.

When you come into the ballpark, you come into the underground. For a lot of years that was really a dingy place; it was dark and dirty. Then you come up those stairs and you see that beautiful, vivid imagery of the park. And that has always impressed me, and it still does. It is an absolutely unique place. First of all, it's just a beautiful place to be whether it's a day game or a night game. Even the night games are spectacular. At night, it's almost pitch black out there beyond the wall, and you've got this intense light illuminating the green of the field and the bricks. It's just a beautiful place to be.

There's the legacy experience of taking my boys at an early age. My older boy will analyze the food for you. My younger son is sitting on the edge of

his seat, analyzing every aspect of the game. They're both great fans and smart baseball guys.

I love when the fans chant in unison, like with Darryl Strawberry, "Darryl, Darryl!" And when there's some commotion because a fan won't throw back an opposing team's home run. One time, you could tell this guy was hearing it for hanging on to the ball. Eventually, everyone in left field started with the "Throw it back" chant. Then the whole ballpark is yelling at this one guy. It was the next inning when the ball comes sailing out of the seats back to the field. This guy finally gave in, and the whole place just went nuts. Stuff like that I love.

One thing I do is evaluate the odds of getting a foul ball based on where my seats are for a game. One time, we fell into some tickets at the last minute. I didn't know where the seats were until we got there. We were sitting on the third base line, a little off home plate, just under the upper deck. I thought there was no way to get a foul ball there. It would have to be high enough to clear the net and low enough to stay under the upper deck. Well, Mark Grace hits one through the eye of the needle. I took one step to my left and caught it belt high. It felt like God was throwing me a bone.

43. May 5, 1998:
Kerry Wood Strikes Out Twenty

George Castle, baseball writer/author

There's a 1949 movie, a comedy, where a professor mixing some substances accidentally stumbles on something that repels wood if applied to another substance. So he becomes the ace pitcher of the league because he goes and puts the substance on the ball, and it repels the bat. The movie was *It Happens Every Spring*.

The Kerry Wood game on May 5, 1998, was literally something out of Hollywood fiction. That ball was doing things I've never seen a ball do before. I've seen Bruce Sutter's splitter break straight down. I've seen Maddux's cut fastball bore in toward a left-handed hitter and just nick the inside corner. Wood's pitches were dancing all over the place like they were repelling wood. The Astros were like a Little League team trying to hit it.

I covered the Cubs, and Chicago sports, for the *Times of Northwest Indiana* for twenty years. I will make the statement that this game may have been

the most dominating game in Major League history. It was obvious that Wood was fulfilling all the hype and potential that surrounded him since he was drafted three years before. He could throw one hundred miles per hour. He had this unbelievable breaking pitch. For him to strike out his age—twenty—was absolutely sensational.

Wood had to pitch for his life in that game because Shane Reynolds struck out ten of his own, and the Cubs had only a 2–0 lead, so Wood had no room for a mistake. The dominant game started to bubble to the front in the eighth inning, which he finished with eighteen strikeouts to tie the rookie strikeout record of Bill Gullickson, who did it against the Cubs. As Wood racked up that eighteenth strikeout, the atmosphere was getting electric in the ballpark and tense in the press box because we were seeing something that hadn't been done before. At that point, he also tied the Wrigley Field strikeout record set by Mr. Koufax in 1962.

We were going into the ninth inning facing uncharted territory. Wood really stepped it up in the ninth inning. Those pitches to the Astros were unhittable. Look at the replays. You couldn't hit those pitches with a rolled-up Sunday newspaper, which were pretty substantial in those days. He got the twentieth strikeout against Derek Bell. If you watch the telecast, Chip Caray predicts he's going to throw that baffling curve. Sure enough, he did, and Bell was helpless; he swung through it for the twentieth strikeout.

For the Wood game, you knew you were going to have special coverage and need to rise to the occasion in what you write and how you construct a story. Your own adrenaline is pumping. You're thinking about what you're going to write, what you're going to ask Wood. It was total chaos going down to the locker room afterward. We just mobbed him at his locker, which was the closest to the entrance, so there was nowhere for him to run and hide.

It wasn't a no-hitter. The one hit, a dribbler off Kevin Orie's glove, was an infield hit, but this was better than most no-hitters. The one thing I wondered was whether it compared to the Koufax perfect game. I asked Billy Williams and Ron Santo if this was "Koufax"—that type of dominating performance. They both said yes.

44. APRIL 16, 1972:
NO-HITTER IN FOURTH CAREER START

BURT HOOTON, CUBS PITCHER, 1971–75

The old saying is that as soon as you get to Wrigley, the first thing you do is look to see which way the flags are blowing. People always ask me what it was like to pitch at Wrigley Field. Depending on which way the wind's blowing, you were either pitching in the best ballpark or the worst ballpark.

I was drafted by the Cubs in June '71. To that point, I had pretty much not ever been outside the state of Texas and not really been to a Major League ballpark other than the Astrodome a time or two. I first walked into Wrigley Field as a twenty-one-year-old kid in the big city of Chicago. I'd never seen anything like it in my life. I'm just in awe of the city of Chicago. You step back and try to take it all in, wondering am I really here? Is this really happening? Five, six days after seeing Wrigley for the first time on a visit with the scout who drafted me, I was throwing my first professional pitch there against the Cardinals.

All of this stuff is happening to you real fast. I remember getting to the ballpark on my first day of pro ball, and Yosh Kawano was the clubhouse guy. He became a real good friend. He got me fixed up, and I'm in my uniform, my pinstriped Cubs uniform with the Cubs patch on the left side of the chest, sitting on one of the trunks in the clubhouse, and nobody's there.

Next thing you know, the first guy through the door is Ernie Banks. I introduced myself to him, and he's like, "OK, welcome." Then in come the rest of them: Santo and Beckert and Kessinger and Billy Williams, just the whole slew of them. I'm twenty-one years old, and all these veteran Major League Baseball players I'd been watching just start flowing in. I think each time one of them walked in I looked down at that patch, thinking, "Is this really happening?"

It was a big thrill to pitch against the Cardinals, but I developed tendinitis, and they sent me to Triple-A for two months. I come back in September and pitch a complete game, struck out fifteen, against the Mets at Shea. Then I win my next game in Wrigley against the Mets pitching a shutout against them.

Take it over to 1972. We go through spring training, and as soon as it's over, we go on a thirteen-day strike. I'm a rookie. I don't know anything about strikes or labor relations. All I want to do is go play baseball, but we got put on hold for about two weeks. When we finally got started up again, we opened against the Phillies in Wrigley Field. Fergie pitched the first game,

then it's my turn. I'm pitching the second game of the season. That's when I threw my no-hitter.

I wasn't really sharp. I walked seven guys, but it was one of those cold days and the wind was blowing in.

There were a couple of balls hit that I was lucky on. You're going to throw a no-hitter, you gotta be lucky. Someone hit a line drive at Don Kessinger. He made a real good backhand play on him. Greg Luzinski hit a ball that on a normal day would have been out on the street, but the wind brought it back into the ballpark, and Rick Monday caught it. I remember striking Greg Luzinski out for the last out of the game.

Nobody said anything about the no-hitter, so the next thing you know it's the fourth inning, and I look up and I haven't given up a hit. I walked seven guys. I had other things on my mind than the hits. Usually when you walk seven, you're not pitching very well.

After a two-week layoff, you come back starting all over again; you're not real sharp. But you go out there and get outs, regardless of what the score is. If it's nothing-nothing, you go get three outs and keep your team in the game until they go out there and score you a run. There were a lot of pitching duels back in those days. I wasn't trying to pitch a no-hitter. I was pitching to get outs.

The next thing I got to deal with that I wasn't used to was all the press and the magnitude of what I had just done. I've always been a quiet individual. After I pitched a game, I was like let's get it over with and go home. That didn't happen that day. It was kind of a big introduction to the media, although it wasn't anything then like it is now, but still in a city like Chicago, where all your games are televised, with all the fans and players and everybody on the field, doing interviews wasn't something I was used to. I didn't really get a chance to absorb Wrigley Field in that moment. It was a bit of a whirlwind; you're left wondering if this is really happening.

Wrigley Field is a special place. The ballpark, the character and the fans. I remember Wrigley back then on some days in September when you were lucky to have two thousand people. Now, it seems like every day it's sold out now. A Cubs fan is always a Cubs fan. They're all over the place. Wrigley Field is the anchor—that's Cubdom right there.

Pitching there was a blessing, something you certainly remember.

45. MAY 17, 1979—PHILLIES 23, CUBS 22: A WILD, WINDY, WEIRD DAY AT WRIGLEY

JAYSON STARK, ESPN BASEBALL REPORTER

I started covering baseball in 1979 for the *Philadelphia Inquirer* and actually went right from the *Inquirer* to ESPN. My third game that I ever covered at Wrigley Field was that world-famous 23–22 game. So that was quite an introduction, right?

I had been there one time for one game, thought it was one of the coolest places I had ever visited in my life, like everybody does. But I mean, when you see something like what I saw that day, that becomes the defining memory, I think, for somebody like me. I'll never forget any of that. It happened a long time ago, but I'm still telling the stories about it.

Even in batting practice, you could see pop-ups just landing out there on the street, and that kind of gave us an idea. And you know, there was some just insane stuff that happened even early on. Randy Lerch, who was the starting pitcher for the Phillies that day, hit a home run in the first inning, and they got one out in the bottom of the first. As the story goes, Randy Lerch had said in the dugout, "Be sure and get me some runs." So all right, they go out and hit three homers in the first and score seven, and he hits one of them. He comes back to the dugout after the home, and Bowa says to him, "You've got enough runs?" And Randy looks at him, "That should be enough runs for two starts." He got one out, and he was gone. It was 7–6 after the first, and I think that right then I knew this had a chance to be something memorable. I didn't know it was going to be something historically memorable, though.

Even though it was an afternoon game, we had an early evening edition, so I did in fact write running on that game. God knows what kind of mess that was. But I still knew pretty early on what I was watching. I mean, I've never seen a team score twenty runs, and the Phillies had twenty runs by the fifth inning. It got so crazy in the fifth inning that Greg Luzinski pinch hit, got walked and he got hurt, so they had to take him out of the game. The Phillies put one of their pitchers in to run for him, Nino Espinosa. They wound up batting around, and Nino Espinosa's spot in the batting order came around again, and they were winning by twelve runs at the time, so they let him hit. Bases are loaded, and they let him hit. Because I'm sure they thought they had enough runs. So he hit in that game and never pitched in that game. That's how bizarre it was.

It's hard to keep your head from exploding when you're covering a game like that. But I am a guy who has always prided myself on attention to detail and making sure that I kept track—keep track—of all of the great numbers as they're unfolding. I have no idea how many pages of notes I took in that game. One of the things that some people do remember but I noticed at the time was in that fifth inning that I talked about, the Phillies scored a bunch of runs. At one point in that inning, Pete Rose was on second base, the next guy up hit a fly ball and he tagged up and went from second to third with his team winning 20–9. And then he winds up, scoring on a sacrifice fly. He never would have scored if he hadn't tagged up and gone from second to third. You know, it doesn't just sum up a day at Wrigley Field; it sums up the way Pete Rose played baseball. Even up eleven runs in the fifth inning, he knew then and there that that might not be enough because it was one of those days and every run mattered. I can still see him in my mind's eye tagging up and going from second to third and thinking, "What the heck is he doing?" But that was a huge run. They blew a twelve-run lead in that game and won it on a Schmidt homer in the tenth inning off of Bruce Sutter. Amazing.

My very favorite story of that game, and this is the perfect Wrigley Field story because this is one thing I've always noticed about Wrigley Field in the days when there was just a hand-operated scoreboard—they did not post a score. It was just inning by inning. The only way you knew the score was if you were keeping score or actually added it up. There was one point in the game where Mike Schmidt and Mick Kelleher are pointing up at the scoreboard like, "What's the score of this game?" and they're trying to count the score. Eventually, Mick Kelleher points to Mike Schmidt's number, and he points at his own number and you think, "What are they doing? Oh, wait; they both wore number 20." So they decided the score was 20–20 or something like that. The perfect Wrigley Field story.

Tug McGraw pitched in that game and was terrible. Gave up a grand slam to Bill Buckner and said afterward it was the worst game of his career. He said, "I'll tell you what happened. I wasn't warmed up properly, and that's because I was hiding so I wouldn't have to come into that game." There were a lot of quips after that one, that's for sure.

The ballpark becomes part of the story in a game like that, maybe the biggest part of the story in many ways. And so that's why I don't think of it as just another game. I think of that as a Wrigley Field game, a Wrigley Field phenomenon. And I'll never think of Wrigley Field in my life without thinking about that game. It was the third game I had ever covered there.

I knew this was a historic game, that there had not been a game with this many runs scored since 1922. So you know that these games don't come around real, real often, but I also felt like this was a game that you would only see at Wrigley Field. Where else could something like this happen? You know the winds only howled like that in places like Wrigley.

When I talk to people about Wrigley Field, I tell them about that joy people seem to have in just being there, walking through the gates and especially sitting there on a sunny afternoon just basking in Wrigley. You know they're just so happy to be in this place. That's the magic of Wrigley Field and the magic of the Cubs and how they go together. I don't know how you explain this, especially given it's been a little more than a century without a World Series. The ballpark allows the love affair to continue because the love affair isn't just with the team. The love affair is with the place, it's with the ambience, it's with the feeling, it's with everything about being there. There's so much to it beyond just a ballpark. To state "ballpark" doesn't even begin to describe what the place means.

46. WHEN MARC MET HARRY

MARC VILLASENOR, LIFELONG CHICAGO NORTH SIDER

It was 1987, and the Cubs were playing the Expos.

We arrived at the ballpark early to try to get some autographs when we ran into Steve Stone, who took a second to chat with me from where he was setting up to air the lead-off-man show. That was sweet. We also got his and a few ballplayers' autographs, including Tim Raines, on the Cubs visor that was the ballpark giveaway that day.

After walking around the ballpark for a while, which was OK for a twelve-year-old in those days, I bumped into a schoolmate and had a partner in crime. We ended up behind and underneath the press boxes and began to try to map a way up there visually.

Then we decided to give it a go. Not thinking about security or any other possible dangers, we began our venture. Sure enough, we—a pair of twelve-year-old boys—ended up on the very same catwalk where Harry Caray usually walked and waved. As we passed each door, we'd look in the one-foot-square window to see if the iconic announcer was behind that door. After about three or four doors, we came to the one

Harry Caray, WGN and the success of the 1984 Cubs are widely credited with the explosion in popularity of the team and Wrigley Field. Many consider Harry to be the ultimate salesman of Wrigley as a baseball and tourist destination. *National Baseball Hall of Fame Library, Cooperstown, New York.*

where, on the other side, sat a man with a big white head of hair. Our eyes about popped out of our heads as we immediately looked at each other in amazement.

"That's him!" I said before I told my buddy to try the door.

He said, "No way! Let's go back!" But I said no, I'll try it and if it's not locked we'll just ask for his autograph and go back.

I remember the feeling as I turned the knob because, in fact, it was not locked. I opened the door, stuck my head in and said, "Mr. Caray?" He turned in his chair, as he had been facing the field, and I'd never seen his eyes so wide on TV as they were at that moment.

He said, "How did you get here? You could have been shot!" I apologized and said we just wanted an autograph. He said, "Well, get in here, hurry up. Both of you."

So I sat in Steve Stone's chair while Harry signed everything we wanted him to sign. He spent a good five minutes talking to us about our shared love for the Cubs. When it was time to go, he walked us out to the catwalk, where he received a crowd roar and waved down to them all. He instructed security to make sure that my friend and I made it safely down to our seats and were not kicked out from the ballpark.

We were not done, though. After walking back down, we ended up in the first row directly behind the Cubs dugout. We saw two seats empty and figured, why not? We were a couple seats in from the aisle with a few people on both sides. After about five minutes, an usher came and asked to see our tickets. Within a second of my buddy and me looking at each other, a gentleman seated closest to the aisle told the usher that we were with him, and the usher quickly walked away. We quickly thanked him, and he asked us to enjoy the game. We made sure not to move the rest of the game.

From those seats, I got to look Ryno, the Hawk, the Sarge, in the eyes that day. It was the ultimate baseball day for a kid from Montrose and Kimball.

47. Cubbie Blue, Through and Through

Lonnie Davis, University Park, Illinois

I've been a fan since the days of Santo, Kessinger, Beckert and Banks. My sister and I rode the Howard Line train right past Comiskey Park on up to Wrigley. I couldn't have been more than twelve years old on that beautiful first day of summer, which was my birthday. I remember the vendor who sang out, "Peanuts taste good like peanuts should," the noise and energy level, the fan participation chanting, "We want a hit!" or "We want an out!" and wooden seats rapidly and loudly folded and opened again and again. I also remember gratitude toward a big sister.

Now, no less than forty-five years later, I'm faithfully holding on, respectful and appreciative of great competitors and organizations but bleeding Cubbie blue through and through. Last year, we waited through all of June, July, August and most of September, and our Cubbies were a playoff team again. No thirty-mile commute will keep us—the two teachers, one cable guy and one Burger King manager—away from Wrigley.

Ron Santo hit 342 career home runs but also won five Gold Gloves for his defensive work. *National Baseball Hall of Fame Library, Cooperstown, New York.*

So there we were at the final home game of the 2015 regular season, sitting in the midst of the Kansas City Royals faithful and loving their dumbfounded look as we were walking off singing, "Go Cubs Go!"

48. On the Mound with Kerry Wood

Adam Ceasar, cable TV producer

When I was a little guy growing up in Texas, one of my grandfathers always had a Yankees hat on, and that kind of left an impression on me. So I kind of gravitated toward the Yankees. Don Mattingly was my very first baseball player.

My other grandfather would always watch Cubs games on WGN when I would visit in the summertime. He worked on a golf course, so we would mow the greens, eat breakfast and, in the afternoon, sit around and watch Cubs baseball on WGN like a lot of people in the Chicago area and a lot of the country since the Cubs games were nationally broadcast.

I moved to the Chicago area in 2002 after graduating from the University of North Texas and have been at my current job in TV since 2005, but we didn't really start building relationships with the pro teams until 2009. It started with the Chicago Bears. Around that same time, the Cubs were going through transitions on the field and with ownership. Prior to the new regime, the Cubs weren't that easy to deal with, so we never really had an in to do anything with them. But when you're going through a transition with new ownership and the team's not very good, even the Chicago Cubs were looking to get good media.

Year by year, we've been cultivating it more and more. We started off covering some of Kerry Wood's foundation's events, and that's how we got in with the Cubs. Everything sort of came together, sort of like it did for the Cubs this season. We covered the Cubs Convention, Joe Maddon's event, and even before that, we did Anthony Rizzo's Cook for Cancer in 2014.

I also covered Jason Motte's corn hole event with our reporter Aaron Kirn, who is a big Cardinals fan. We were in the middle of the outfield and both were able to take it all in, which is honestly hard to do because Wrigley's one hundred years old and there's so much history there. It's almost a little overwhelming. You have to do it in retrospect, go home and think, "Oh my god, I was where Willie Mays played and where Babe Ruth hit a home

run." I don't think about it until later; I just feel the energy and enjoy those moments when I'm on the field.

One of those moments came during another Kerry Wood event, his home run derby this summer. I had been pretty much all over the field except for the diamond. The Cubs organization, like most, is pretty friendly about letting people run around the outfield or even the bases, but they're very particular about the home plate area and the infield grass. The Kerry Wood event was the first time I got to step on the infield grass and, actually, the first time I had been on the mound.

When you're doing your job, you're focused on it, so I didn't really quite realize it until afterward that the first time I was on the Wrigley Field pitcher's mound was with Kerry Wood because he was throwing BP for the derby at that time. It wasn't five minutes after that when it kind of hit me, and I was like, "Holy crap, I was on the mound, and it was just me and Kerry Wood."

That was kind of special; the coolest moment I've had on the field at Wrigley last year was getting to stand on the mound with Kerry Wood.

49. Building Communities at Wrigley

AL YELLON, MANAGING EDITOR, BLEEDCUBBIEBLUE.COM

My Cubs fandom dates to 1963, when my dad took me to a ballgame. Like a lot of people my age, and younger and older, I got hooked watching them on WGN because playing all day games, you could come home and watch them after school.

That was part of the genius of P.K. Wrigley, who wasn't a great owner in most ways, but he understood how television could promote his team. Back in the '50s and '60s, a lot of teams didn't televise games because they thought it would kill their attendance. Wrigley recognized that putting the games on TV would make people want to come to the ballpark. Even when the team was bad, that wound up happening. Obviously, they had to win to draw better, but it did make Wrigley Field a destination.

And of course, later, when they wound up on national cable with the consummate salesman Harry Caray as their announcer, that's when things really took off.

I was in middle school when the Cubs first started being a good team after a long time of being bad. That's an age when you really start developing

Ernie Banks and Billy Williams greet Ron Santo at home plate after one of his 212 home runs at Wrigley Field. The trio of Hall of Famers is still remembered fondly by Cubs fans of many generations, especially those who followed the team closely in the 1960s. *National Baseball Hall of Fame Library, Cooperstown, New York.*

loyalties and understanding what sports is all about. The 1969 team really captured the imagination of a lot of people my age. The Ernie Banks/Ron Santo/Billy Williams/Fergie Jenkins group, those people are still revered even though they never won anything.

When I got out of college around 1979, I started hanging out in the bleachers, just because it seemed like the thing to do at the time. It's where I ended up meeting a lot of people who would become lifelong friends. We created kind of a community out there. It's not just at the ballpark; we go to weddings and funerals together and hang outside of Wrigley. To me, that's kind of the best thing about all this since there hasn't been winning baseball—this community of people we've created.

The website has brought people together, as well. I started a personal blog in 2003, which quickly wound up being mostly about the Cubs. The people who run SB Nation came to me in 2005 to ask if I wanted to join their group, which I did. It kind of took off from there and became what I do on a full-time basis. At times, it's quite a bit of fun to go to a game and talk about it and write about it and know a lot of people are following you. On

the other hand, there are some times when I wish I could go to a game and not think about what I have to write after it's over and just enjoy the game for its own self. Having access has allowed me to meet people I wouldn't have otherwise met and provides me with a fuller understanding of the game and the bigger picture about the business side of it all. Still, I've got plenty of baseball memories over the years at Wrigley.

The 1984 season, the first playoff season in my lifetime, really came out of nowhere. The team had been bad for a couple of years before that. The last game of the regular season, they had already clinched and knew they were coming back for a playoff game. The Cubs won that game in walk-off fashion against the Cardinals, which is always a good thing. Nobody left after the game was over. A few minutes later, the whole team came back on the field, some of them dressed in their shower clogs. A lot of teams do victory laps after clinching and whatnot now. In 1984, this was not a typical thing to do, and it just felt like a real magical moment. I had recorded every game in September 1984, and I kept all the wins. I still have them. Every once in a while, I still pull that one out and watch it thirty-plus years later.

One hundred thousand people will tell you they were at Kerry Wood's twenty-strikeout game when fifteen thousand people were in the park on a kind of drizzly, rainy day. Here's this kid in his fifth Major League start, and all of a sudden, he's striking out everyone in sight. That was a real special moment. The whole 1998 season was. I can recite the home run chase between Sammy Sosa and Mark McGwire even though, years later, it was kind of tainted. I'll admit, at the time it was exciting.

The 2015 season was a magical ride with things happening that Cubs teams haven't done in eighty years, not to mention watching Jake Arrieta do things nobody has ever done.

Through all the good and the bad on the field, Wrigley Field has a different relationship with its team and its fans than any other ballpark, even Fenway, which is the closest comparable, because it's part of a neighborhood. Fenway is in more of a commercial area; it doesn't have residences literally across the street.

People have accepted Wrigley as part of the neighborhood. In general, people want to live near Wrigley Field because it's there and because it's so intimately connected with its surroundings. Because of its small footprint, it feels more intimate than a stadium in a downtown area. That's why it has become such a special place for every Cubs fan and why it has become a tourist attraction.

For me, personally, it's the people I've met there, such close friends, that make it feel like home. It's really so unique that it can't be replicated anywhere else.

Within days of the 2014 season ending, construction crews began to descend on Wrigley for the bleacher renovation project. The first step involved stabilizing the iconic ivy-covered brick walls prior to the seating area demolition in right and left field. *Rob Carroll photo.*

The view from Clark and Waveland as the left field video board began to take shape during construction in March 2015 shortly before Opening Night of the 2015 season at Wrigley. *Dan Campana photo.*

Fences, cranes and construction workers were the new normal throughout the 2015 season around the ballpark. Even the picture-worthy bleacher entrance was obscured early on as the revamped outfield seating area did not fully reopen to fans until June. *Rob Carroll photo.*

Rob Carroll photo.

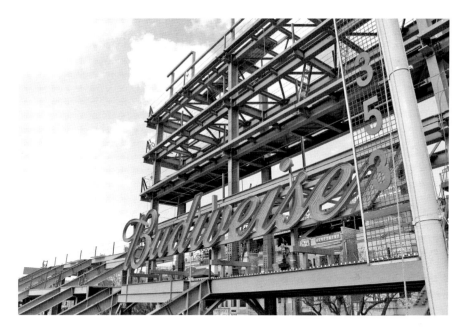

Smaller in size compared to its left field counterpart, the right field video board was primarily used for game-related information, such as lineups and stats. Upon completion, the Budweiser signage was placed atop the board. *Rob Carroll photo.*

Rob Carroll photo.

Rob Carroll photo.

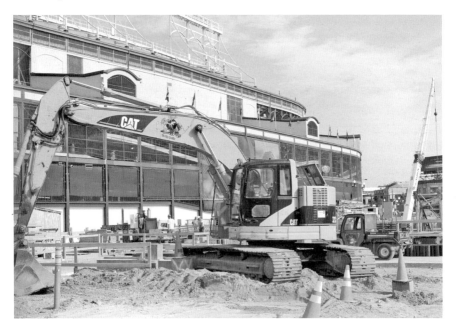

Heavy machinery replaced player cars and SUVs along Wrigley's west end as the "triangle" area was excavated as part of the work to construct new team facilities and a parking deck, among other things, in the place where a car wash and player parking lot previously existed. *Rob Carroll photo.*

The modern-day Wrigley Field grounds crew clears the field after batting practice and keeps the infield smooth during a 2015 game. *Rob Carroll photo.*

Wrigley's outfield panorama took on a new look in 2015 as the video boards became the focal point of the ballpark, while the classic, hand-operated scoreboard remains a fixture in center field. *Rob Carroll photo.*

From the uniforms to the field itself—check out the old-school second base—being a Wrigley groundskeeper years ago was a much different situation than it is today. *National Baseball Hall of Fame Library, Cooperstown, New York.*

Gloves and scorecards in hand, fans get excited during a late 1950s game at the Friendly Confines. *National Baseball Hall of Fame Library, Cooperstown, New York.*

The grounds crew prepares to roll out the tarp during a game in 1969. Much of the space along the first and third base lines has been reconfigured over the years to add additional seating. One such revamp required the tarp to be moved to the first base side of the field. *National Baseball Hall of Fame Library, Cooperstown, New York.*

Above and next page: Less than two weeks before Opening Day 2015, snow on the ground and construction all around made it hard to believe baseball would soon be played at Wrigley. *Dan Campana photo.*

Dan Campana photos.

Dan Campana photo.

Wrigley's main entrance and marquee were cordoned off through much of the offseason leading up to the 2015 season as construction stirred around the entire ballpark. *Dan Campana photo.*

Only twelve days before the 2015 season began with a Cubs-Cardinals game on national TV, workers use massive steel beams to form the skeleton that would become Wrigley's left field video board. *Dan Campana photo.*

Crews clear snow off the Wrigley Field tarp in late March as preparations for Opening Day 2015 got into full swing. Also visible is a section of the right field wall, with basket attached, that was fully exposed during the bleacher renovation project. *Dan Campana photo.*

50. A WRIGLEY FIELD SALUTE

ALEC GONZALEZ, U.S. AIR FORCE SENIOR AIRMAN,
PEORIA, ILLINOIS

At twenty-two, I've spent three years in the Air Force National Guard based in my hometown of Peoria. I'm a computer specialist and a diehard Cubs fan. I've got Cubs stuff hanging all over the office. It's all I talk about—I even drink out of my Cubs coffee mug every morning.

Four days before Game 3 of the National League Championship Series against the Mets, the USO contacted one of the high colonels at our base. They asked him to pick out a couple of good workers deserving of recognition on the field during the game. He came up to me—he knows I'm a Cubs fan—to talk about it. Since I'm such a big Cubs fan and had been to five or six homes games during the season, I kind of knew where this was going before he asked. I was like, "Yeah, of course I would go. It'll be awesome."

It became a rushed thing on Friday to get everything put together for the USO. They didn't know if it was going to be Game 3, Game 4 or Game 5. We finally found out on the Sunday before the first home game of the NLCS on that Tuesday.

Over the years, I've never sat real close to the field, usually in the bleachers or terrace reserved. When I was eleven or twelve, we did a Wrigley Field tour, which obviously doesn't happen under the same type of conditions. We sat in Aisle 213 that night, about ten rows up, right on the aisle. They were actually pretty good seats. Because we were on the aisle, a lot of people would stop and thank us for our service. I'd say thank you in return. The guy I was with, another airman, is a diehard Cubs fan, too. We wanted to get rowdy but knew we were in uniform, so we kept it under control when deep down inside we really wanted to blow up during the game.

When there was one out in the top of the fourth, we crept down to the camera well. On our way down, everyone was shaking our hands, patting us on the back and telling us thank you. All the guys in the camera well were pretty cool. It was awesome to be watching the game right next to the field and the third base coach.

In the middle of the inning, you go out there. Kyle Schwarber ran right by; he was a big dude. Dexter Fowler ran in from center. I kind of pointed at him, and he nodded with a kind of a "What's up?" look. David Ross and Jason Motte were standing at the top of the dugout. Once the announcer got

done saying our bios, Ross and Motte were looking at me, so I just pointed at Ross and he smiled.

My thought was to just take it all in. The USO guy who accompanied me said to look around the whole stadium and wave to all corners. It was so loud I couldn't even think. I was out there trying to take a photo memory in my head. You could see people's faces in the crowd—it was pretty incredible. The umpires came over and shook our hands, gave us a game-used ball with the postseason mark on it.

It would have been way more nerve-wracking if I had known about it more in advance. That day I almost couldn't eat because I was excited-nervous for this whole situation. Once I got out there, it was all good. Leading up to that moment, I was trying to figure out what I was going to do and how was I going to remember the moment. Just a lot of thoughts made me nervous. I'm glad that we had that moment; otherwise, the loss could have been more disappointing.

As a lifetime Cubs fan, I don't know, besides winning a World Series, how much better it could get?

51. Finally Got Smart When He Became a Cubs Fan

Frank Mallek, Chicago's far Southeast Side

Growing up on the South Side as a Sox fan, I could name all the players when I was twelve years old. And I remember the magic of going to Comiskey Park. But what happened with me begins with visits to my busia's house, where I'd see my grandpa watching baseball on the little black-and-white TV set up in the corner. He was glued to the Cubs. It was foreign to me.

I would go to Sox games with my uncle and enjoyed a lot about that culture growing up on the South Side, but what hit me was going to a couple of games at Cubs park with my dad and my uncle in the early '60s. Some of my memories are of the size of the park; the very, very sparse attendance. As a kid, I listened to the cowbells and some little old ladies ringing hand bells. Pat Pieper would sit on his little stool and say, "Attention, attention please. Grab your pencils and scorecards." Those were the days of Dick Ellsworth, Larry Jackson, Joey Amalfitano and George Altman, but none of them really impressed me. One day, listening to my transistor radio when

Santo, Banks and Williams went back-to-back-to-back with home runs, I said to my brother, "Hey, Paulie, I'm going to start going to more games at Wrigley." So, starting in 1967 and ever since, I averaged thirty to forty games a year at Wrigley.

As a teenager, I'd take the L train up there. Sometimes I'd be standing outside by myself waiting for the gates to open so I could run anyplace to find a seat up to those poles in the grandstand. The upstairs was always closed. Over time, I went from watching these home run hitters to paying more attention to guys like Kenny Holtzman, Ferguson Jenkins and, later, Lee Smith.

In 1969, I really made my separation from the Sox. I followed the Cubs closely, hung out with the Bleacher Bums in their construction helmets and watched the young girls dancing to "Zorba the Greek" in center field. I was going to school to be a teacher at the time, and I got my college degree in 1970. I joke around that I became a Cubs fan when I finally got my smarts. That year, when they kind of blew it, was to me the turning point in the culture compared to what you had in the '50s and early '60s, when maybe you had more retired people who went there for fifty cents a game. Instead, I saw a lot of young people, and it was the place to be. It was just cool.

Being a South Side Cubs fan got me teased a little bit here and there. I taught for forty-three years in the Catholic school system on the South Side, and when I'd mention something about the Cubs, some student would tell me how dumb it was.

Just as I changed my allegiance, the Cubs and Wrigley have changed. I remember parking my little '72 Malibu on Cornelia and walking four or five blocks to the park. Now, because I've never paid for parking, I'll go farther out, west of Racine,

Billy Williams is among six Cubs to have his number retired by the team. Williams, Ron Santo, Ernie Banks, Fergie Jenkins, Ryne Sandberg and Greg Maddux each are recognized with flags bearing their numbers that fly from the left and right field foul poles. *National Baseball Hall of Fame Library, Cooperstown, New York.*

The right field video board, shown here while still under construction in April 2015, became a part of Cubs playoff legend during the National League Division Series when rookie Kyle Schwarber launched a home run ball that came to rest beneath the Budweiser sign that now sits on top of the board. *Rob Carroll photo.*

south of Belmont. At Wrigley itself, I was excited to have these new video boards come in, but the first couple weeks of going there this year, I found myself just looking at them and thinking I can't see where Dave Kingman hit that home run to Kenmore and hitting those trees. I remember seeing Ernie Banks hit a line drive to left field and clearing the entire park. In 2015, Bryant hit that home run off the left field board, and of course, Schwarber put one on top of the right field board.

We as fans have roots looking back at how it used to be. I'm pretty slow and conservative as far as change, but I think part of that real magic of wanting to go to Wrigley, whether they were winning or losing, was you could sit there and just look at the park and be transfixed and rejuvenated by it. It's kind of a warm feeling back to my twenties and thirties. Wrigley gives us a chance to reflect back on our lives and remember when Santo did this or Banks did that.

With the renovations and new parking and hotel, I think this generation coming up won't know too much about what Wrigley used to be. Hopefully, those stories are not going to be lost.

52. A WRIGLEY WEDDING

LIZ GUMPRECHT, HAWTHORN WOODS, ILLINOIS

You could say our relationship sort of centers on sports. My husband, Kris, and I got engaged at Neyland Stadium at the University of Tennessee. We've also been Cubs fans our whole lives. While saving up for our wedding, we happened to be watching a Cubs game and saw the commercial that said, "Have your event at Wrigley Field." We had been to a few banquet halls, and they were all the same, so after the commercial, without saying a word, we both looked at each other and I said, "I'm on it."

I looked it up online, and there was no pricing. This is going to be an arm and leg, I thought, so I didn't even want to find out and be disappointed. About a week later, Kris asked if I ever found out anything about it. He convinced me to just e-mail and see what happened. So I did.

To our surprise, it was more than reasonable. It would be a buffet-style instead of a sit-down dinner, but we were fine with that. I mean, really, we're going to have our wedding at Wrigley Field. At the Art Institute and other museums, it's $5,000 to walk in the door, a donation, even before you start picking out tables. We were surprised there wasn't that kind of fee when the Cubs rented out Wrigley on non-game days.

They put us on a waiting list until the next season's schedule came out. You pick three consecutive weekends with the idea that the Cubs are going to be out of town one of those weekends. So, as long as your heart isn't set on a particular day, you're fine. We originally picked June but then decided on September. We were married on September 26, 2009.

We kept it a secret until we had a date. For a long time, we had people asking us what we were doing, and we're playing dumb. For the "Save the Date," we took a picture of our "W" flag. It said Kris and Liz's wedding, here's the date, location to be determined, but you could kind of figure it out with the Cubs "W" on it. But people didn't officially know until they got the invitation. We had 100 percent response to the invites, with 135 people there.

We were married in the bleachers—our ceremony got interrupted by a train—and then our reception was in what, at the time, they called the Stadium Club, so we didn't have to worry about a church. That was cool. We got to dress up, park in the players' lot and just stroll right up to the bleacher entrance for a wedding. How awesome is that? We could take the elevator up or walk the ramp; we took the elevator being all dressed up. You're standing

An expanded bleacher patio area now overlooks the neighborhood from behind the historic center field scoreboard. The mid-2000s bleacher renovation included a concourse, which wraps behind the bleacher seating area, but the 2014–15 project expanded the width of the concourse as the ballpark's footprint pushed farther out. Waveland and Sheffield Avenues were actually downsized as part of the process. *Rob Carroll photo.*

in the bleachers looking at the ivy, wondering if it's real. It turned out to be a beautiful day.

After the ceremony, we walked from the bleachers onto the field to take pictures while our guests went to the batter's eye. You couldn't go on the infield, and we were supposed to go back by the ivy, but someone ruined it for others by pulling some out a few weeks before us.

The food. Oh my god, the food was probably better than any banquet hall. You're getting married at a ballpark, you think you're getting hot dogs and macaroni and cheese and fries—but no, the food was delicious. Being in a landmark like Wrigley, you'd think you're going be restricted to these little areas, but we weren't. It was a very open and relaxed atmosphere, and we had the whole place to ourselves, so we walked the concourse and into the seating area.

We actually still hear from people about how much they enjoyed our wedding because it was very different and very memorable. We went to my stepsister's wedding two years after ours. My husband was in line waiting for a drink when two people in front of him that he wasn't sure who they were said, "Man, this wedding is nice, but I went to this wedding two years ago at Wrigley Field, and it was incredible."

He just stood there smiling because they didn't know he was there.

53. MAY 12, 1955: SAM JONES NO-HITTER

ERIK GODVIK, LONGTIME CUBS FAN, CHICAGO, ILLINOIS

Living on the North Side in Logan Square, I could go to more Cubs games than White Sox games. After the seventh inning, you could get in for free. So even if you had no money as a kid—and back then we had no money—you could have a good time.

A bunch of us young guys would go to the end of the left field bleachers and pick a row in the grandstands. Then, when everybody left, you would raise all the seats because they weren't spring loaded. You'd end up with a free pass so you could come back for another game. Then, the next time, in the seventh inning, you'd pick a row and do it all over again. You had to go around and lift seats, it wasn't exactly a killer.

One of those games was a walk-laden no-hitter by Sam Jones. You were and you weren't aware of what was happening because there wasn't much

hoopla like you see today, and I didn't have a radio with me to listen to Vince Lloyd. I remember Jones even loaded the bases in the ninth inning with no one out, but he got the no-hitter, and he won the game. There were hardly any fans that day. There were never many fans back then. The upstairs was never open. If the Cubs drew 1 million, it was a big deal, but they usually drew about 700,000. Today, they're around 3 million.

54. Fan from Down Under Gets a Wrigley Close Up

Dallas Kilponen, photographer, Sydney, Australia

Living in Sydney, Australia, I discovered the Cubs simply through my love for the game and the team's rich history. All that and the beauty of Wrigley Field made the Cubs the perfect team for me to follow.

Chicago is fourteen hours behind Sydney, which means day games at Wrigley are early morning Sydney time. The best games for me are night games as they are mid-morning. I'll either watch the game on MLB TV or listen to it in my car while I'm at work, which is usually driving around Sydney as a news photographer. I rarely miss a game, and if I do, I'll watch the condensed version online and read the game report.

My first visit to Wrigley in July 2006 was incredible. It was not only my first trip to watch the Cubs but also my first Major League game. They played Houston and won 4–1, and it was such an experience to be standing there among the crowd cheering on the Cubs.

I returned to Chicago for the next seven summers to do the Chicago-to-Mackinac yacht race and always checked the Cubs schedule as soon as I knew I was flying up. One year, the Cubs were on the road, so I ended up doing the Wrigley Field tour and watched some games at bars in Wrigleyville just to enjoy the experience of being near the Cubs.

In 2010, I was fortunate enough to gain a photo pass through Stephen Green, the Cubs photographer. I work as a staff photographer with the *Sydney Morning Herald* and have photographed sports for more than twenty years, so this was a dream for me.

It was a memorable night being on the field for batting practice and then riding up the "secret" Harry Caray lift out back of the stands up to the media dining room to visit the press box. Very cool. It was a beautiful evening

A photographer from Sydney, Australia, Dallas Kilponen relished the opportunity to get access to shoot Wrigley Field during a summer visit in 2010. *Dallas Kilponen photo.*

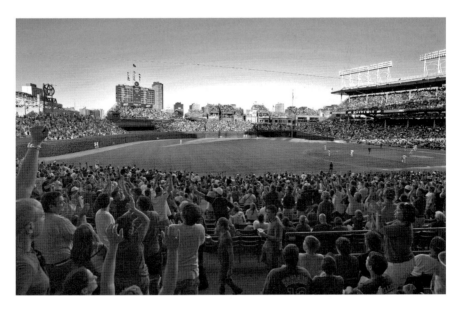

With a fresh eye for photographing Wrigley, Kilponen worked to incorporate the fans into pictures that captured the ballpark's atmosphere on a perfect summer night. *Dallas Kilponen photo.*

as the Cubs played the Phillies. I mainly took wide atmospheric shots throughout the game, with some beautiful results, while Ryan Dempster pitched the Cubs to a great 12–6 win with sixteen hits. Stephen was fantastic, as were the other photographers. I even got a game ball as a treasured souvenir.

I'm really stoked to again be flying up to Chicago in August 2016 to see some more games at Wrigley against the Cards and Brewers. I look forward to catching up with Cubs friends and sharing some beers in the bleachers.

55. Coming Full Circle at Wrigley

Tom Dreesen, comedian/lifelong Cubs fan

My introduction to Wrigley was as a little boy; I shined shoes in taverns, set pins in bowling alleys, caddied in the summertime and sold newspapers on the corner in Harvey, Illinois, where I grew up. Everyone there were White Sox fans, but my dad was a Cubs fan and would listen to the Cubs on the radio. As a little boy, I got hooked on them.

We were really poor, so I would bring my money home to help feed my brothers and sisters. My mother would put a nickel out of my earnings in a cup up in the cupboard, and when it got filled with nickels, I could then take the Illinois Central downtown and then take the L, the elevated, to Wrigley Field and go sit in the bleachers for like fifty cents. And sometimes, if you helped clean up after the game, you could get a free pass for the next day. My favorite players in those days were Andy Pafko and Phil Cavarretta, and when I got a little older, of course, Ernie Banks.

I always described Wrigley this way: You're driving through a neighborhood and you come to a stop sign. You look to your right and there's a ballpark. And you go in that ballpark, and you walk up those stairs and you're going to sit in a seat that your great-great-grandfather sat in, your great-grandfather sat in, your grandfather sat in, your father sat in, that you sat in, that your son will sit in, that your son's son will sit in...and you're all going to watch the same game in the same place. We all have this fantasy that we wish time would stand still. Well, it does at Wrigley Field, which is why it is such a special place—because of what preceded you.

I once told Jim Frey about when I was younger and sat in the bleachers. I used to fantasize about the bat boy. I thought the bat boys were rich kids who

came from rich homes. A raggedy kid like me with holes in my shoes would never be a bat boy. He called me later that day and said I was the bat boy for a week. For the next four days, as a grown man, I became the bat boy at Wrigley Field. Jim Frey made that childhood dream come true.

So now I'm the bat boy for the Cubs. David Letterman would rag the hell out of me: "I can't believe you run out there and pick up the bats. That's so stupid, you're a grown man!" I didn't expect him to understand.

I was bat boy for four days, and they lost the first three, but when Andre Dawson hit his 400th home run, he came around the plate and high-fived me. I was hanging out in the dugout with Rick Sutcliffe, and they played tricks on me all the time. He would put a bubble gum bubble on my helmet, and the crowd was laughing at me. I think they're pointing at me and laughing because I'm Tom Dreesen the comedian, and I'm waving at them with this stupid bubble on my head.

It's hard to describe going into that ballpark. I get that same wonderful feeling every time I walk up those stairs. While I'm talking about it, I'm getting that feeling—wow—of the first time I ever saw it. And all the smells, the hot dogs. Then you walk up those stairs, and oh my god, this is a Major League ballpark. This is the ballpark where Babe Ruth pointed. You go out to that ballpark and time stands still. And if you're lucky, the Cubs win that day.

Now, I've opened for Frank Sinatra in front of twenty thousand people in huge arenas. That's intimidating in itself. But when you go up there to sing "Take Me Out to the Ballgame"—I'm not a singer, I'm a comedian—and you look out over thousands of people in the ballpark, you go, "Oh, shit, I'm out of my element here." But I've done it fifteen years in a row. The wonderful thing is Harry set the pace for us. We don't have to be good because he didn't sing it that good either.

This all started because I shined shoes for weeks to have that opportunity to go to Wrigley. It was like going to heaven, from Harvey and the shack we lived in to Wrigley Field. When you're born a rich kid and your mom and dad have box seats behind the Cubs dugout, you'll never really appreciate it as much as I do. When I go there now, and the Cubs are always so nice to me and I'm sitting in box seats behind the Cubs dugout, I still appreciate it so much. Even to this day, when I'm sitting there, I'm looking out to the bleachers and I'm seeing that little boy from Harvey who paid fifty cents to sit in those bleachers.

56. Watching a Game with Fergie

Wes Jameson, Oklahoma City, Oklahoma

How did me and my family end up sitting at a Cubs game at Wrigley with Fergie Jenkins? Funny story.

My wife was four or five months pregnant when we went to a sports museum in Guthrie, Oklahoma. The old man showing us around was asking about the baby—boy or girl, what's the name—and we said it was a boy, and we tell him we're naming him Jenkins, after Fergie.

The guy got so excited and walked away. He comes back five minutes later and hands me a phone. He said someone wants to talk with you: it was Fergie Jenkins. We spoke for a while, and he told me he'd be in Oklahoma City in two months for the Warren Spahn Awards. He wanted us to be his guests at these awards. Imagine my excitement when the awards roll around and I'm having dinner while sitting between Fergie Jenkins and Clayton Kershaw.

As the night went on, Fergie asked me for my number so he could keep up with the pregnancy. I'm thinking, "Yeah, right. I'll never hear from this guy again." Well, he did keep with us. He would ask how things were going and was one of the first to congratulate me when little Jenkins was born in March 2015. We've pretty much talked weekly or every other week since. He even flew to Oklahoma City to meet Jenkins when he was two months old.

Then Fergie invited us to a Cubs game over Labor Day weekend so Jenkins could be at Wrigley with him. That experience was surreal. It was a 12:05 p.m. game against the Diamondbacks, but we got to Wrigley at eight thirty in the morning. We walk in, and as you know, you walk up from the concourse to the stands and get that first glimpse of the ivy and the grass, which just takes your breath away. But this was even better because it was only my wife, Amy; Jenkins; me; a few of my family members; and Fergie and his daughter. Other than that, Wrigley was empty. We just kind of walked around. It was the first time there for some of my family members, so I kind of went over some stuff I learned by taking a Wrigley Field tour.

Then, out walks Kris Bryant, which all of the girls in my family went crazy about. He came over and talked to us, and thirty minutes later, the rest of the team came out. Most walked over and chatted since it was only us in the ballpark.

As for the game, we sat in 218 because the size of our group was too big for a suite or to sit down with the players' families. The seats were amazing. We got to see KB hit the longest home run of the season off the video board

and sing "Go Cubs Go" with Ferg when the Cubs won 2–0. Then, after the game, I got to run the bases with my little niece—talk about floating on air. Growing up seeing your heroes round those very bases and now I'm getting that chance.

We walked out with Fergie and watched all these fans come up to him and ask for photos and autographs; he doesn't turn anyone down. He talks with the people, and you can see in their eyes that him taking that minute to interact made their whole days complete. He's just been an amazing guy.

57. WILL THERE BE A GAME 5?

KEVIN KANE, CUBS FAN FROM DENVER, OUTSIDE WRIGLEY FOR GAME 4 OF THE 2015 NLCS

My brother, Mike, got some tickets for tomorrow's Game 5, so we don't know if we're going to get to see the Cubs play. We just decided: let's do it. We got to see them in '69, '84, '89, 2003—you know, the feast and famine, the agony and ecstasy.

We don't have tickets for Game 4. We've been to Murphy's, walked all the way around the ballpark. Had a hot dog and an Italian beef, kind of doing the obligatory tour thing. We plan on hitting a couple of bars. We're just going to soak up the experience and hopefully end up watching the game in a bar somewhere they have a big screen.

It would be really disappointing not to see a Game 5, but the way the series is right now, it's like, you know, they overachieved this year, and they're young, so we anticipate they'll have good teams for years to come.

We've just got to soak in the moment. It's good to be a Cubs fan, just hanging out here, even if they don't get a win and we don't get to sit in a game tomorrow, which I really hope we do.

We moved to Denver about thirty-five years ago. It's kind of a sister city with Chicago. They had WGN, so we watched all the games all the time. We really haven't missed a beat in a lot of ways.

In 1968, we moved to the Chicago area. The Cubs were starting to get good. They were having a dogfight with the Cardinals that year, and of course, we experienced the '69 season. That kind of cemented it. We keep coming back because of that hope that they'll improve and they'll win. Because they haven't won for so long, maybe that's a part of it. As you can see, this is a part of me.

58. September 2, 1972: The Imperfect No-Hitter

Milt Pappas, Cubs pitcher, 1970–73

The year 1972 was pretty good for me. I ended up winning seventeen games. I topped it off in September with the almost-perfect-game no-hitter, no thanks to Bruce Froemming.

When you warm up, you're obviously not thinking of pitching a no-hitter at that point. You're concentrating on how you're feeling. I warmed up and wasn't feeling all that great, like I was coming down with a cold. I knew I needed to do something. When you throw pretty hard and you're not doing it the way you should, that's when I became a pitcher instead of a thrower. That day, I concentrated on pitching and what to do with certain hitters.

It was a good defensive day, with some plays where I thought there it goes. There was a ground ball between third and short, and Kessinger, being a former basketball player, backhanded the ball, jumped up, twirled, threw to first base and got him. I don't know if a normal shortstop could have made that play.

There was a ball hit a bit earlier in the game over my head on the mound, and I said to myself, "You better move because that's gonna be a base hit being that it's such a slow bouncer that no one's going to get to it fast enough." So with my back to home plate, I saw the ball, which was just into the grass behind the pitcher's mound. I ran back, got the ball and, like Don Kessinger, turned around and fired it. That could have very easily gone up into the tenth row down the right field line, but I threw a perfect strike to first base, and we got him out. That was a big play, but no one really said much about it. That was the play of the game for me.

And then, starting the ninth inning, here comes the test of what's going to happen, what's going to set the table for the next three guys coming up. First guy up hit a medium pop fly into center field. Billy North all of a sudden slipped and fell, and I'm thinking, "Oh, here we go. That's the end of everything." Billy Williams came out of nowhere out of left field on his white charger and made a darn good play. Billy wasn't exactly the fastest man in the world. When North went down, Billy wasn't even in the picture. Then, there he was, and he caught the ball.

Cubs fans are the greatest, and they sensed from the sixth inning on that something was going on with the pitcher. Each inning it becomes louder and louder; they're standing up and clapping with each out in the inning. You go out for the next inning and the same thing happens over again. You might

realize the fact you have a no-hitter through the fourth, fifth, sixth inning. In the seventh, you start thinking hard about it, and your teammates all of a sudden clam up and don't say a word.

At that point, it was up to me to break the barrier, so when I came down the dugout stairs after the eighth inning, I said, "Oh, by the way guys, I got a no-hitter going." Oh my god, everybody opened up. Started clapping and talking. So the pressure was off of them, but it was still with me. So I went down the stairs to get away from the dugout craziness.

I could see the game and the opposing pitcher from the bottom stair, and all of a sudden there was so much clatter and noise underneath the stadium. The police were there; the ushers were there. Everybody was talking. They were driving me absolutely crazy, worse than my teammates were. So I finally yelled out, "People, can you please zip it up? I've got three more outs to go on a no-hitter. Could you just let me concentrate?" They all stopped, and you could hear a pin drop.

Then I walk out; there we are, ninth inning, perfect game. The first guy was the one that Billy North fell down on and Billy Williams made the catch. The second guy hit a ground ball to Kessinger. So Larry Stahl comes up with two outs after twenty-six in a row. Fastball, Stahl swings and misses. I guess he was going to try to get a base hit on his first pitch. He never swung at another pitch.

I had him 1-2 and threw him three straight sliders on the outside corner that Mr. Froemming deemed to call balls. I was so upset. I was yelling and screaming at Froemming. I knew he didn't have the guts to throw me out after the way he screwed up that play.

All of a sudden, Santo comes over and says, "Hey, dummy, don't forget, you know, you do have a no-hitter going."

When the brouhaha was over with Froemming, all the yelling and screaming, I faced Garry Jestadt. He popped up to second base. Carmen Fanzone, who took the place of Glenn Beckert, caught the pop up. As they say, the rest is history.

Froemming never said anything. He's too ornery. It's just a shame that here's a chance for all of us to go down in history and he doesn't realize what he has, or if he did he's really stupid. He apparently told someone later that he didn't realize I had a perfect game going. That's the dumbest thing I've ever heard. How could an umpire not know there's a perfect game?

This bum knows we're playing in Chicago winning 8–0 and decides I'm not going to call them even if they're close. Nobody would have faulted him if he would have called strike three. Randy Hundley was barking at

Ten years before his no-hitter, Milt Pappas, then of the Baltimore Orioles, finished off the second All-Star Game of the 1962 season for an American League win. Wrigley Field played host to it on July 30, 1962. The lineups featured several future Baseball Hall of Famers, including Mickey Mantle, Hank Aaron and Willie Mays. *National Baseball Hall of Fame Library, Cooperstown, New York.*

him. Froemming came halfway to the mound, and I was saying things to him that normally during a game you'd be tossed for. Knowing the fact of how bad he screwed up, he just turned around and walked back toward home plate.

It was in September, so the season's almost over. I asked veteran umpires after the game what they would have done. One said his hand would have gone up so fast it would have been pathetic. These guys knew history was being made, and they can go the rest of their lives saying they called a perfect game. Not this idiot. It's a shame it had to go down like that.

59. HARRY HELPED HOOK HIM

JASON HILL, MICRO, NORTH CAROLINA

We're originally from Lafayette, Indiana, so my parents got me watching the Cubs. I also credit WGN due to the availability to watch the Cubs and good old Harry Caray for being such a fun and entertaining announcer. I could probably list one hundred of my favorite players, but the tops would have to be Jody Davis and the "Penguin" Ron Cey.

It was roughly a three-hour drive from where we lived to get to Wrigley, so we went to about ten games or so a year with my parents, or sometimes just my dad would take me. We did that for about eight years beginning with my first game in 1985. It was the end of June, I believe, and the Cubs beat the Mets to end a big losing streak. Being eight years old, I thought I had something to do with them winning just by being there. There was nothing "special" to the game other than seeing the Cubs play and watching Harry lean out of the booth to sing, "Take Me Out to the Ballgame." It didn't matter, I was truly hooked.

We did those trips to games until 1993. I haven't been to Wrigley since because of how life kept my busy during and after high school and hasn't slowed down in the last fifteen years I've been down in North Carolina.

But I've never stopped being a Cubs fan, and I'll never forget my first visit to Wrigley because it's the most memorable game to me.

60. IN IT FOR THE CUBS, NOT WRIGLEY

DAN SCHMIDT, ITASCA, ILLINOIS

My dad was a Cubs fan. We used to come to Wrigley when we were younger. I have four siblings. We'd get in because my dad knew an Andy Frain usher. It was miserable, about a thousand people only. We used to park at the church where the nuns were. My dad would give her a dollar, and we'd walk over here with our bag lunch. That was in the '80s, late '70s. It's more commercial now.

You had '84 when you thought something was going to happen; you had '89. There's always the next one. I think this is the first time that we didn't just go out and get Andre Dawson, who is a great player; Sammy Sosa, that's

a really great player, we didn't go out and do that. We got rid of that one great superstar and started over.

It used to be just baseball, simple bunt the runner over and stuff. Now there's just so much. You have to go an hour before the game because there's so much going on—which, I guess, is good because that's the world we live in.

For me, the Cubs are the top; Bears are second. I love the Bulls and the Blackhawks, but there's nobody bigger.

We traveled for the last twenty years. I have three kids and my wife; we traveled pretty much coast to coast to see the Cubs. Every year we go somewhere: Toronto, Washington, New York. We went to Baltimore before; we didn't see the Cubs game because they didn't play there yet. Atlanta, Miami, Pittsburgh, Cincinnati, St. Louis, Milwaukee, Minnesota, Colorado, you name it.

I love the Cubs, and I love Wrigley Field, but I just like the team. The team's more important than Wrigley Field is to me.

You look at Rizzo. People say he's a veteran, but he's been in the league really only five years. You look at that, and then you say you have a great player in Addison Russell; if he gets hurt, next thing you know, you have Baez to jump in. Defensively, he's a liability, but offensively, he's been a superstar, at least in the playoffs. They finally built up. It's not corporate-owned. Now, Ricketts, he's a fan, but he wants to win, so he goes out and gets Theo, and they get Maddon. It's remarkable.

61. That Koufax Game Stunk

Gary Linden, River Grove, Illinois

Dad had his vacation time in the summer, so we'd go down to Wrigley Field. Usually once a summer. We'd park on Racine and walk the two or three blocks to the ballpark. We would always sit on the third base side; we didn't get box seats because we didn't have that kind of money but in the lower grandstand behind the box seats.

Where we sat, I could see Jack Brickhouse walking across the catwalk going to the broadcast booth. Every time he walked by, I would yell out, "Hey, Jack!" to try to get him to wave. Not once did he turn his head. He either didn't hear me or he tuned out everybody yelling.

One year, when I was nine, my dad tells me we're going to see Sandy Koufax pitch today. Well, the first thing I thought when I heard the word "Sandy" was that the only Sandys I knew were girls. I thought, "Why do I want to watch a girl pitch?"

We get there, and Dad says we're going to be in for a treat because this guy's a real good pitcher. That was an understatement. Koufax pitched a complete game two-hit shutout—and he struck out fourteen Cubs. The Cubs didn't get a hit until an Ernie Banks single in the seventh inning. Billy Williams walked twice, and Don Zimmer had a single in the ninth. I did not enjoy the game at all. When we came home, my mom asked how the game was, and I told her it stunk.

I'm a kid. I wanted to see base hits. I wanted to see runs. I wanted to see the Cubs win, and I got none of that. It felt like a waste to sit there and watch almost everybody make an out. Koufax was just unbelievable. And my father told me before the game he was a real good pitcher. The Cubs didn't get any runs, and I didn't know if I wanted to ever see them again.

It was a really good pitcher's duel, just not for a kid.

62. THE BIRTH OF *BLEACHER BUMS*

JOE MANTEGNA, ACTOR

I grew up on the West Side of Chicago around Homan and Arthington. The thing about growing up on the West Side is it's a jump ball as to who you are going to follow. If you're a North Sider, you're a Cubs fan; if you're a South Sider, you're a Sox fan, obviously. The kid next door was a Sox fan. You get put on that by your father, mother or whoever happens to have influence in your life.

My dad was a Cubs fan. I remember going when I was pretty young, and Hank Sauer was one of my favorite players. I was a Cubs fan in the '50s. Especially back then, once that mantle of being a Cubs fan was laid on you, that's like saying do you want to fight for the Americans or the Nazis? I had a cousin Donny who was a Sox fan, and there would be endless arguments with my brother and me and him and his dad. That's just the way it was.

This has all been tempered as I'm in my late sixties now. Over the years, White Sox fans seem to hold the grudge a little stronger. They're a little more bitter. I think Sox fans hate Cubs fans more than Cubs fans hate Sox fans.

When you've got that ballpark in that part of town, why wouldn't you hate the Cubs? We're in Disneyland with Wrigley Field.

Bleacher Bums, the play I conceived, was based on the Cubs. I had been going to the ballpark from age five and on. There was a stretch as a kid when I went to ten straight games with my dad and they lost all ten. I remember when he asked me to go to that eleventh game, I turned him down because I thought it was all my fault. I remember thinking, "We've lost ten times this season, and I've been there every time. It must be me."

I started sitting in the bleachers as I got older. My dad would sit in the grandstands; he didn't want to sit in the bleachers. But I sat out there as I eventually got into acting because it was cheap. I would sit in this one section, and the people around me were amazing to me. It was like its own little world. There were gamblers and the girls who were coming to get suntans. Then there were the knuckleheads in left field who were just crazed. They'd get drunk and do anything to stir up the teams. You had all of these characters.

Since I was hoping to be a successful actor, it started to occur to me as I would look around, it was really hard to get people to come to the theater. You would have to have a really great show with rave reviews to fill up like a two-hundred-seat theater. I would look around and say to myself, "There's almost thirty thousand people here to watch an, at best, mediocre ball club. What's the secret?" I thought if I could capture what is going on here, theatrically, I'm on to something.

All of the characters are based on people I used to sit with. We changed the names. Some are combinations of people. Some represent whole sections of people, but some were actually one-on-one duplications of people I sat with. You had this one gambler who was very successful. He actually owned a clothing store up on Clark Street. Once the shop was open and the Cubs had a home stand, he would ride his bike over to Wrigley and chain it to the pole right outside the bleachers entrance. His name was Len Becker. We changed the name to Decker—that's the part I played.

What is it about the diversity of these people that brings them together? During the time of the game, they are united in their love and fanaticism for the Cubs. It didn't matter that they are from different walks of life, different economic groups, different ethnic groups, different ages. It didn't matter. Once the game ended, they all went their separate ways back to their own little worlds, and they never intersected one another. Yet they would come back again the next day to start all over again.

I presented it to the theater company and said I've got this idea for a play. They agreed to it after sitting in the bleachers with me. That was 1977 we

did that, and it is one of the most gratifying things of my career that this idea I had turned into a part of theater history.

For years, people would say my play becomes obsolete if the Cubs win because it is all based on them losing. I remember them saying that in 1977, and I said, "Well, we'll cross that bridge when we come to it." I would be the happiest guy in the world to cross that bridge. The play has been good to me since 1977. I could have written this play in 1909, and it would have been relevant.

Part of it lies in our American spirit. This country has always embraced the underdog. We are the epitome, the compilation, the mutt of all of these people who said we are going to do it our own way. This is who we are. The Cubs, in a way, exemplify that. It's mutt baseball. Every year, they try to put these teams together with old players and young players and horrendous trades. But every year, there's that optimism to be the little engine that could. I've always said it's easy to be a Yankee fan. A one-cell paramecium could be a Yankee fan because, yeah, they're winners. They've got tons of championships.

I'm often asked what's going to happen when the Cubs do win it all. I always say I would be one of the people who would support the idea of abolishing baseball and then embracing soccer like the rest of the world. That might ensure world peace because the whole rest of the world will go, "Oh my god, they've actually given up baseball to embrace the game the rest of us consider the best sport in the world."

And how fitting would it be to do that because why go on? If the Cubs win, there is no reason to go on.

63. One Long Drive, Zero Hits

Clayton Riley, Medford, Minnesota

I'm twenty-four years old, but I was born and raised to be a Cubs fan. My dad is a Cubs fan, and his dad was a Cubs fan and so on. I order the MLB package on DirectTV and watch the games whenever I am available. My dad and I enjoy listening to the XM radio broadcast with Pat Hughes and Ron Coomer.

We make it a habit to get to at least two or three games a year down in Chicago. It is one hell of a drive. It is pretty straight-up boring. As soon as we get to the outskirts of Chicago, my eyes just brighten up, my palms get

sweaty and I get nervous because I am getting to go to Wrigleyville again. I absolutely love it down there.

Me, my mom and my dad and a buddy of mine saw Cole Hamels throw his no-hitter last year. It was pretty amazing. I was well aware of the no-hitter during the game because I follow @CubsNoHitStreak on Twitter. The Cubs hadn't been no hit in over 7,500 games. The Cubs are like a religion. The only thing he posted on Twitter was: "The streak has died." That was more heartbreaking for me than actually seeing the Cubs lose that game.

I was still watching the game as a Cubs fan. I was rooting for them to get a hit the entire game. It got to the fifth inning, and I was like, "OK, I don't even care about runs anymore. Just get a hit, please."

We were sitting in the lower concourse between home and third base. After the final out, there was a lot of respect. I respect history. That will probably be the only no-hitter I ever see live. There were a couple Phillies fan sitting in front of us. I gave them high-fives. I said, "Congratulations, guys. You made the trip to Chicago, and you saw Cole Hamels throw a no-hitter." One of the guys said to me, "Good luck in the playoffs." I can't be mad at him for that.

It took a while for it to set in with me that they had been no-hit. I was a little dumbfounded by it. After the game, we got into the Full Shilling. We had a beer in there, and the place was packed. All everyone talked about was the no-hitter.

64. THE FINAL MOMENTS OF BILL'S PINK HAT

ROD PETERSEN, ISLAND LAKE, ILLINOIS

We used to have a group of eight guys who would come to Cubs games. The tickets got so expensive, we don't go very often now. This was about ten, twelve years ago, a group of us went. My buddy Bill was wearing a pink Cubs cap. We were giving him a hard time about it, like "What are you doing wearing a pink Cubs hat?" It was one of those neon pink Cubs hats.

It was a day game, a very windy day. We were sitting in the left field bleachers, and he's like, "That's it, I'm done. I'm getting rid of this." He took the hat—his back facing the field—and threw it toward the fence, trying to get it over. The wind picked it up and blew it onto the field. The Andy Frain ushers were there instantly, and they're like, "You're out."

"What are you doing? You can't kick him out; it was a mistake," we were pleading with them. They didn't want to hear it. We're like, "We'll tell you what, we'll see you at Murphy's after the game. We aren't going to leave, but we'll see you at Murphy's after the game."

So the game goes on. I think the Cubs won that day. We meet him after the game, and he says, "Aw, man, you'll never guess what happened. First, I was bummed because I got kicked out of the game, so I went over to Murphy's. I had a beer. I'm thinking, maybe I can get back into the ballpark."

He went and got a ticket, but they didn't have any bleacher tickets left, so he got a ticket for a seat. He goes into the ballpark, not knowing where his seat was, and his seat is one seat by itself next to a pole. He's sitting in a seat by himself next to a pole. He's like, "I see you guys out there in the bleachers having a great time, and I'm sitting here by a pole."

I went to the first night game in '88. It got rained out. The Cubs players are sliding on the tarp as the rain delay was going on. After the game, my buddy Bill, he has a couple too many cocktails. We're all bummed out, and we're leaving the ballpark. We come outside the ballpark, and the street was flooded. He gets on all fours and starts acting like he's swimming in his clothes. He's doing the crawl; he's doing the backstroke. He's doing the breaststroke. My buddy Bill's a great guy, but he'd had a few too many cocktails.

65. Finally Getting It Right with Fukudome

Marty McCaffrey, Chicago, Illinois

I am a season ticket holder in the bleachers and have been going to the bleachers since college. I loved that I could sit anywhere whether I wanted to sit in right, left or center. Plus, you could just go and buy one ticket and meet all of your friends who were already there. Over time, I just got hooked. I loved sitting in the bleachers, so that's where I ended up. I haven't had to sit in the grandstand except for (2015) when the bleachers weren't open yet.

I sit in dead center field, in front of the concessions, right by the batter's eye with a couple of bleacher season ticket holders who have been sitting out there as long I have been alive. It's fun because I get to sit next to people who are huge fans. You get a lot of knowledge and history from them.

There have definitely been players who have had good relationships with the bleachers. Alfonso Soriano loved being out there in front of everybody.

I know Sammy Sosa did. Those two guys were emphatic about loving being out there.

In terms of me, when Kosuke Fukudome was out manning center field for two years, those were probably the two years I went to the most games. I went to between forty and fifty home games each of those two years, and I always sat in the same spot. I was almost always wearing one of the same two shirts. He started to recognize me and tried to throw me a baseball so many different times, and he always missed. We had this eye-to-eye connection where we were laughing about it all the time.

The year after, when we got Marlon Byrd, Fukudome went over into right. There was a day game we went and sat in right field. I screamed, "Fukudome!" He literally laughed and threw a strike right to me. He knew who I was and could finally throw me a baseball and not worry about hitting the concession stand.

It's definitely a party atmosphere in the bleachers. The only time I ever see any fights or belligerence is when the White Sox are on our side of town. I just find that our fans and their fans don't get along, and a lot of their fans come looking to start fights. That's being very generalistic, but that's most of the fights I've seen. The rest of the time it's a belligerent Cardinals fan or a belligerent Cubs fan yelling at Cardinals fans.

66. WHAT ABOUT THE OTHER GAMES IN THE 2003 PLAYOFFS?

TIM CONNORS, FREEPORT, ILLINOIS

I am a teacher at Freeport High School. I have lived in Freeport all of my life. When I started to talk, the first word I said was "mommy." The second word I said was "daddy," and the third word I said was "Cubbie."

My favorite game, for many reasons, was during the 2003 playoffs. I teach speech. A former student of mine many, many years ago, when I asked kids what they wanted to do, he was a sophomore and said he wanted to work for the Cubs. His name is Lucus Luecke, and he is now a front-office member for technology for the Chicago Cubs. Lucus helped my dad and me—my dad has since passed away—get tickets to a lot of the playoff games in 2003.

My favorite was when Mark Prior beat Greg Maddux in Game 1 of the National League Division Series. The streets were so crowded. What stood

out to me about that game was there was electricity. I had been to so many games, but there was electricity in that game because Prior was pitching. I get chills talking about it now.

We were going to win. We're playing Greg Maddux. He left us, and we're going to beat him. Prior was just on fire that game. He couldn't miss wherever he threw. The young kid that you knew was going to pitch for ten to twelve more years, and get you all of these World Series. He was in control. He was going to beat Maddux.

I went to Game 1 of the NLCS against the Marlins. Nobody ever talks about that game. We're up 6–0, and Carlos Zambrano gives up six runs. We win that game, and there's no Bartman. Nobody ever talks about it, and I don't get it. It drives me nuts.

I direct musicals at the high school. We had a big rehearsal, and I couldn't go to Game 6. I remember driving home, watching the game and they're winning. Then Alex Gonzalez blows that play. I'm basically in the fetal position in my bed. My phone rings, and it's a friend of mine who had just won two tickets to Game 7. I said, "I'm not going. Screw it." He goes, "You're the biggest Cubs fan I know. You're going to this Game 7."

It was standing-room only, and so many people had decided "Well, screw this." We were walking, and there were two seats probably twelve rows behind the Cubs dugout. We just sit down. We were two seats away from Digger Phelps. We sat there and watched the rest of Game 7. The thing that I will never forget about Game 7 was, when Florida won it, how quiet it was. It was dead silent. You could hear the Marlins talking on the field. You could listen to their conversations. It was just crazy.

67. Sending the Cardinals Packing with Help from Dad

Miriam Romain, journalist/longtime Cubs fan

Dad and I used to come out to Wrigley a lot. He had season tickets in the upper deck in the first row of 416, right over the Cubs' on-deck circle. My first visit to Wrigley was in 1968, and I later lived in Atlanta for twenty years, but I'd always come back when the Cubs were in town to go to games with my dad.

When we'd go to a game, he'd tell me stories from when he was a kid. He was twelve when the Cubs were in the 1945 World Series. He waited in line,

and the guy in front of him got the last ticket. My dad cried on the streetcar ride home, but I'm not sure if it was because he didn't get into the game or because he was going to get into trouble for not telling his mother where he was going.

I kind of fell into writing about the Cubs, and it was kind of weird timing in 2008 after the Cubs lost the second game to the Dodgers in the NLDS. We were supposed to go to Los Angeles but thought maybe we didn't want to make the trip. It was pretty quiet around Wrigley after the game, and no one was really into it. My dad was supposed to pick us up and drive us to the airport. Then I got a call from my brother that Dad had a fatal heart attack. It kind of summed up that season for me: my dad died, the Cubs died.

It's really difficult separating the fan and the journalist when I'm at games. I can get too caught up in it.

But this is my dream job, so I just do what I would always do—asking questions and talking to people at games—and apply my professional skills to write about what the fans were thinking. It's not about what I think, it's not a blog, it's always newsy. And it's enjoyable being able to write about the team when things are going well, like in 2015. Win or lose, this year was a nice gift for all of us.

Being at the front of the line for the bleachers before the two games during the Cardinals series was important to me. First, to find a parking spot, but I wanted to watch as people came up to the ballpark and hear what they're saying and feel the excitement building. Sometimes I feel a duty to some fans to explain what they're about to experience. I tell them to go with the flow, cheer on the team, enjoy it and hope for the best.

The Game 4 series clincher against St. Louis wasn't crazy; it was amazing. I got a bit weepy. I had a Cubs sweatshirt that belonged to my dad with me, and I put it on when the Cardinals tied the game 4–4. Once the sweatshirt was on, I knew we were going to win. It was just such a strong feeling. Then Rizzo homered in the sixth to take the lead. Then Schwarber homered in the seventh. Then it was over. The crowd awed me. I loved seeing all the "W" flags and towels. When they won it, I wept a bit because it seemed so unfair that my dad wasn't there to see and experience it.

I stayed until the guys left the field because I didn't want to leave. It all made me realize I'll be a blubbering mess when we win the World Series.

68. Cubs Fan in a House of Mets Fans

Joe Hyer, Egg Harbor City, New Jersey

When I was six, my dad was a grocery store manager. He wouldn't go on a lot of business trips, but there was a food show in Chicago twice a year. Every time he would bring something home for me, as parents do when they are on work trips. One of the times, he brought me a Cubs hat. I remember wearing the hat, and a family member told me I looked cute in the hat. From that point on, I kept wearing the hat.

At six, I really didn't understand that it meant a lifetime of being an out-of-town fan, which is a pain to put up with. And I also didn't realize it meant a lifetime of watching every other team advance except for the Cubs. I was nine when I went to Wrigley for the first time in 1999. My brother and I went on a summer trip to visit a relative who lived in Indiana. One of the weekends we went over to Chicago. At the time, I don't think I understood the history of Wrigley. At nine, I don't think I appreciated it quite as much as I should have.

The game lasted almost five hours. It was a thirteen-inning game between the Cubs and Mets. The Cubs ended up losing 5–4. By that time, my brother was already a Mets fan. I grew up in a Mets house.

My mom tried to get into baseball last year. I guess her routine was my dad would have the games on and my mom would play her slot games on her laptop. She started watching all of the games last summer and considered herself the Mets' good luck charm. What was most surprising last season was when I started to hear it from my mom. My one brother would text a little bit leading up to the National League Championship Series.

We all thought, on paper, the Mets would be an easier team for the Cubs to beat. But we all know how this team operates, so there was part of me that thought this is just going to be another nail in the family coffin. Of course, the team we are going to lose to was going to be the Mets.

I heard about the guy who was playing "Go Cubs Go" on all of the juke boxes in St. Louis and Pittsburgh as the Cubs were knocking teams out of the playoffs. When they clinched, I saw he had done it in New York City after the Mets advanced. That Saturday before Game 1, I was working as a DJ at a radio station in New Jersey. During two on-air breaks, I made the decision to play "Go Cubs Go" for about fifteen seconds each. I talked about how I thought it would pretty much be an easy series for the Cubs. I got a

few comments on the station's website. It was basically just people who like to hear themselves think.

If I went out of my way to text my mom during the series, it was one time the Cubs came back and tied the game. Every time the Mets scored a run after that, my mom would text me. I made it a point to stop communicating with the family pretty quickly. My mom and brother even sent my dog a Mets collar at some point during the series. It's now packed away.

69. A HISTORIC INTRODUCTION TO WRIGLEY AND BASEBALL

BELLA MUNARI, CUBS FAN SINCE 1969

Since my father died when my sisters and I were sixteen, four and two, sports was not a part of my life growing up. In 1968, my sister and guardian met her husband, a great guy and a huge sports fan. His favorite team, the Detroit Tigers, won the World Series that year, and my younger sister and I took an interest in the game of baseball.

The following year, the Chicago Cubs were on their way, or so it seemed, to the postseason. My brother-in-law decided it was time for us to see a live baseball game, so he bought tickets for a game at Wrigley Field on August 19, 1969, against the Atlanta Braves.

It was a beautiful day for a baseball game, and we had great seats—box seats on the third base line—and we felt close to the action on the field. Ken Holtzman was the pitcher that day, with Phil Niekro pitching for Atlanta. Ron Santo hit a three-run homer in the first inning, and that was all the scoring during the game. Since my younger sister and I were just learning about baseball, we weren't aware of some baseball "facts."

When the game ended, the Cubs had beaten the Braves by a score of 3–0. The yelling, cheering and applause by the exuberant fans was deafening, and then the fans started jumping onto the field. I had never seen anything like it. I asked my brother-in-law if this happened after every game. "No," he said excitedly. "You've just witnessed a no-hitter."

It took some time before I realized the magic of that game. But one thing I do know is if I had known then what I do now, I would have been one of those crazy, excited, exuberant fans jumping on the field that day. I have

been a diehard Cubs fan since 1969 and was lucky enough to spend twenty years living less than a mile from Wrigley Field and attend many games there, including during the postseason, but none has been as magical as that game back on August 19, 1969.

70. Joey's First Pitch

Frank Mattucci, Illinois Hall of Fame Basketball coach at Stevenson High School

I had a long, wonderful career teaching history at Stevenson High School from 1987 to 2008. I was also the girls' varsity basketball head coach from 1991 to 2006. In 1995, we won the first team state championship for women's basketball in Lake County. The following year, everyone was predicting doom for us, but we ended up going 34-1 and won the second of back-to-back state titles. That's when the Cubs called me and said they'd like me to throw out the first pitch.

I guess I had some notoriety for being named national coach of the year twice and being chosen as one of the coaches for the McDonald's All-American Game. But I loved baseball, and the Cubs knew I was a baseball fanatic, so I thought, yeah, I'd do it.

The funny thing the week before was the kids, with whom I had a good rapport, were teasing me about throwing out the first pitch: "Coach, don't bounce it. Don't throw it over the backstop." I actually started practicing in the gym because I was sort of scared of screwing up. Then I thought why should I do this? I'm just the lucky guy who had a great team, and one of the players should do it. We spent a week trying to iron it out among three players. They were driving me nuts, so I went home and decided I would do it.

Then I looked at my son, who was nine and playing spring baseball at the time, and said, "Joey, how would you like to throw out the first pitch?" And he said, "Yeah, that would be cool." I brought it up to the team, and they loved Joey, so they were on board.

It was May 5, 1996, a rainy, drizzly day. We thought we were going to get rained out. The whole team, coaching staff and everyone else was excited. Being a Yankees fan, I was thrilled the Cubs asked us, but it wasn't as exciting for me as if you were a Cubs nut. The Cubs were playing the Mets—and I can't stand the Mets, being a Yankees fan—so that was fun. The Cubs won 5–4.

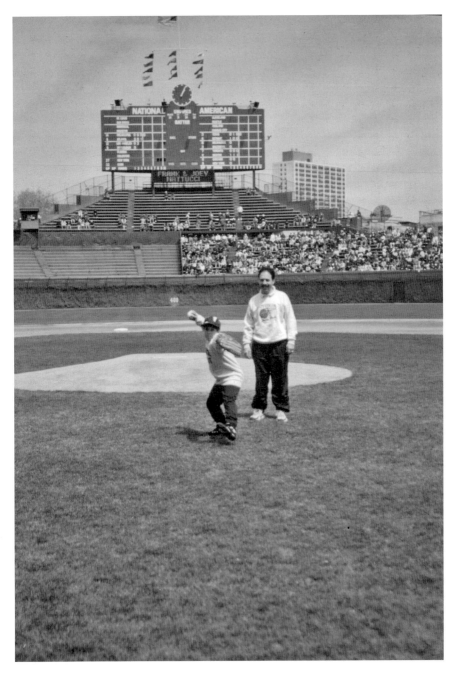

Legendary girls' high school basketball coach Frank Mattucci joins his son Joey on Wrigley Field to throw out a ceremonial first pitch in 1996. Mattucci and his two-time state champion Stevenson Patriots were honored before the game, but Mattucci's son was chosen by the team to toss the pitch to Cubs first baseman Mark Grace. *Mattucci family photo.*

The Cubs were good with Joey throwing out the pitch; they just moved him in front of the pitcher's mound. Mark Grace, Gracie, must have drawn the short straw to go out there and honor the girls' basketball state championship team. He was nice. He congratulated all the players, coaches and staff. He took a picture with us. Cubs Manager Jim Riggleman did, too.

I had been to a ton of stadiums before, but never on a Major League field like a guest, but I was more caught up in the moment for my boy, making sure he didn't fall on his face. He was nervous—he didn't want to bounce anything up there. I said, "Son, you're nine years old. They're not going to boo you. They don't boo very much here at Wrigley unless you're wearing a Cardinals uniform."

If he didn't want to do it, I would have stepped in. But he threw a nice little fastball right over the heart of the plate. Grace, who was catching, made it look good and then came out, gave Joe the ball and hugged him. That was cool. Joey enjoyed it. It was fun, an honor, and I think Joey appreciated it.

71. Now, I Cry Out of Joy

Carol Haddon, longest season ticket holder

My first year as a season ticket holder was 1971. I'm going to tell you something I have not said to anyone, not once in this world. I am seventy-one years old. Anyone who has asked me in the past, I have not given them a number. I've decided it's time to get over it—actually, it's seventy-three.

I started in '41. My mother brought me to Wrigley as a young child, and my first game was at the age of four. By the age of seven, I could keep a scorecard. To this day, every game I attend I have a glove, a score book and a radio. That's only at Wrigley. I do not carry my glove and radio if I go out of town. My seats are directly above the Cubs dugout, where I have been hit twice over the last ten years. But I have a glove so I can protect my face. I have comfort. Both times I've been hit, even though I have been told to watch for the lefties, the fact of the matter is I have been hit by two Cub right-handers—Aramis Ramirez and Wellington Castillo. Both of them were very nice to me the next day and asked how I was.

When I was a special ed schoolteacher in Wheeling, I would go to the ballpark on the weekends. During the summer when I had a summer job,

The 2001 Cubs held a six-game lead in the National League Central in mid-June and remained in first until early August, which prompted Major League Baseball to print playoff tickets, such as these "phantom" tickets for the World Series. The team collapsed in the final two months to finish five games out of first. *Photo courtesy of Michelle and Steve Cucchiaro.*

I would go to the ballpark on the weekends. I would sit in the right field bleachers near the same people. I was actually in the right field bleachers during my ninth month of pregnancy.

As soon as my husband passed the bar exam and my two infants were able to be babysat, I began my season ticket holder life. In the beginning, I would take the kids on the Skokie Swift because at that time we lived in Morton Grove. I would feed them throughout the game. As adults, they are lukewarm, October Cubs fans. They didn't go to too many games with me, but they're cheering for me after all these years. I'm also a season ticket holder in Arizona for spring training. I've been going out there for what was initially a week as some time away from my children. I've been going out there since the early '80s. I'm in my third ballpark in Mesa.

When I began attending games at Wrigley Field as a season ticket holder, people didn't follow the Cubs with the enthusiasm of today. In 1971, they never, ever would have drawn a million fans. I was likely to be sitting in my

front row seat as one of only ten thousand fans. So I really got to know a lot of people at Wrigley, from ushers to the broadcasters. The visiting players would stop and chat with me before going to bat because I sat right by that on-deck circle. I was right next to Cubs ball girl Marla Collins, who got me a lot of attention from Harry Caray. He loved Marla Collins, and we would always be chatting.

Then ten years ago, the Cubs added more rows from dugout to dugout. And my first row became a third row seat. At that point, at my request, the Cubs moved me to the seats I now have, which are directly in the middle of the Cubs dugout. They were available because there is a slant at my feet where part of my legroom was lessened to make more headroom for the players going from the dugout into the clubhouse; I'm very short, so it makes no difference. I see only the Cubs players, but I know them well.

Bill Madlock celebrated my daughter's birthday when she was twelve. I took a group of her friends to the game, and Bill Madlock came out and met all of them personally. I don't know that people would do that today. He gave them each a signed eight-by-ten photo. It was so nice.

Carmen Fanzone was Ron Santo's backup at third. We are still friends to this day. We started playing tennis together. We played competitively against each other or against others. We were pretty good. He still plays. He was a trumpet player and would play during the evenings on Rush Street.

Garry Maddox, who was a Gold Glove outfielder for the Philadelphia Phillies, once came to New Trier High School and watched my daughter Julie's softball game. The players used to hang out in the neighborhood. I remain to this day good friends with Randy Myers. He had a strong personality. During his time in Chicago, he would hang out at local bars in the neighborhood. A small group of us would go bowling together.

I do think my attendance at ballgames over these last forty-plus years has included more games than anyone else. Because a lot of others with season tickets split them, or share them with others or, unfortunately for them, don't get to attend as many games as I have been able to. Since 1971, I believe I have been inside Wrigley more than anyone else.

There was a season when I tore my knee up and needed major knee reconstruction. I was in a full-length leg cast for four months. I still went to every game. I extended my leg cast out into the aisle. I carried a little stool. My cast would rest on the stool. I didn't miss any games. So you could say that's courageous or stupid, I'm not sure.

We got lucky in '84 and went to the playoffs. That year marked the only year I ever cried in baseball. I went to San Diego, and the Padres

beat us three in a row. We had a two-game lead going in, and I really thought I was going to the World Series. They beat us three in a row. I got home to the airport, my husband picked me up and I cried. It was silly. Now, I cry out of joy.

72. ERNIE AND MY GRANDFATHER'S RADIO

TONY MOTON, SCREENWRITER, LOS ANGELES, CALIFORNIA

My earliest recollections of Ernie Banks are directly connected to my grandfather's old transistor radio. I started hearing Cubs games broadcast in our South Side home before I could walk. It seemed as if the volume would magically turn up when Banks got to the plate. Later, when I started accompanying my grandfather to games at Wrigley Field, the radio came with us. My grandfather would point to Banks in the field—Mr. Cub was playing first base in the latter part of his career—and he would keep the radio to his ear the whole game.

Holding on to that radio was my grandfather's way of passing down a tradition. If he liked or enjoyed something, he would share it with me. Thus, Ernie Banks became one of the most cherished of shared experiences I had with my grandfather. When I was seven, my grandfather took me to a sporting goods store to get fitted for a Cubs road uniform, and he made sure that it was personalized with our last name and Banks's number 14. I can still feel the sense of pride I had walking around Wrigley in that uniform. People looked at me like I was the star of the game. Or maybe it was the fact I was wearing black, wing-tip dress shoes instead of tennis shoes or cleats. No matter, I was "Little Ernie Banks," and "Big Ernie" was forever cast as my sports idol.

In the spring of 1972, the season after Banks retired, my grandfather's radio went silent. On Saturday, May 6, of that year, I was planning to join my grandfather at Arlington Park racetrack. He worked at the track as a restroom attendant, and I had been joining him for several years as his assistant. My main responsibility was helping pass out towels to men after they washed their hands. That Saturday was supposed to be a special one, too, because it was Kentucky Derby Day.

About the time I was expecting us to leave for the track, my grandfather told me that we weren't going to work that day. He said nothing more.

Within minutes, I watched him walk out the front door, stunned for quite some time until I awakened other members of my family to let them know what had transpired. Sadly, those final moments I had with my grandfather were the last anyone in our family ever had with him. His whereabouts have yet to be discovered. But I remember going into his room and claiming his radio as mine. The radio was special because it was the instrument that first introduced me to Ernie Banks and, more significant, sparked my burning interest in a career as a sportswriter and broadcast professional.

Over the years, the disappearance of my grandfather inspired me to write a screenplay about our relationship. Called *All Bets Are On*, the script wound up winning a Samuel Goldwyn Writing Award—Francis Ford Coppola is a previous winner—while I was earning a master's degree in screenwriting at UCLA in the mid-2000s. In the script, just as in real life, the grandfather character is attached to his radio, and Ernie Banks serves as a role model for a young boy who aspires to become a writer. The script's theme involves the notion that a person can overcome loss with positivity, something Banks knew all too well.

The night of January 23, 2015, I was polishing up the script for a table read with some Los Angeles–area actors to help in the development of the piece as a feature film project. I had the TV playing a basketball game on ESPN in the background when they announced Ernie Banks had passed away earlier that day. I literally was reading pages in which the grandfather was toting around his transistor radio and listening to Cubs games at the racetrack. Magically, the volume on the TV sounded as if it went up a few decibels at the news of Banks's passing. At that moment, I began to reflect on the one time I actually shared a room with Mr. Cub.

Early in my career as a sportswriter, I had the opportunity to interview Banks one-on-one in 1981, when he appeared at a PGA pro-am event for the former Quad Cities Open golf tournament in Coal Valley, Illinois. I was waiting near the clubhouse when Banks was driven toward me in a golf cart. He immediately recognized me as a journalist and broke the ice by jesting in reference to black-owned publications: "You from *Ebony* or *Jet*?! *Ebony* or *Jet*?!"

For the record, I was a sportswriter at the *Moline Daily Dispatch*, a local daily newspaper that served as my first home as a professional journalist. Banks was gracious and effusive, as you might expect, during the interview I had with him, though I'm not sure how I was able to hold the pen and take notes at the same time. Believe me, there is nothing quite like making contact with the athlete you grew up idolizing, especially

someone who was introduced by way of a grandfather's transistor radio. I have no doubt Willie Moton heard everything said between me and my source that day in Coal Valley. My grandfather was always tuned in to Ernie Banks on high volume.

73. THE MOST MISERABLE DAY OF MY ENTIRE LIFE

LIN BREHMER, WXRT RADIO HOST

I grew up in New York City. I was originally a New York Yankees fan. I thought the World Series meant the Yankees played another team. I was six in 1960. The Yankees went to the World Series in '60, '61, '62, '63 and '64. So I just thought it was funny there was any talk of a pennant race.

In the mid-'60s, a family moved into my neighborhood that was related to family friends of my parents. The family was named Keehn. It was two missionaries, and most of their kids had been born in India, but they grew up in Chicago. My life in New York was to play stick ball, or fast pitch, or baseball or softball every day of my life. When I played stick ball with the Keehns, we would take turns—one day I would be the Cubs, the 1966 Cubs, and they would be the Yankees. Then the next day they would be the Cubs, and I would be the Yankees. The next day, I would be the Cubs, and they would be the Yankees. So probably forty times a summer I was the Chicago Cubs. So you put that in your brain and you park it.

Many years later, you continue being a baseball fan, and you start to drift away from the Yankees because they're not very good. Then you flirt with them again in the late '70s, when Reggie Jackson had three home runs in the World Series. But you move to Chicago in '84 with the promise from my new boss, Norm Winer, that if I accepted the job, because I had dueling offers in the summer of 1984, he would take me to see the Cubs play in the World Series. Because the Cubs were going to go to the World Series in 1984. It was a guarantee. It was something everybody knew was going to happen. They were a team of destiny. Now that's a promise I am still waiting to collect on some thirty-one years later.

I came to Chicago. I looked for a place to live, and there at 3756 North Wayne was a two-flat and the upper floor was available. I was amazed walking down the street to find a Major League baseball park five blocks

from my apartment. I was pretty much a goner. I was so excited about the 1984 Cubs. I was moving to Chicago, taking a job at WXRT and the Cubs were going to go to the World Series. I actually moved the week the Cubs played the Padres. I was still at home (in New York) for Games 1 and 2 when the Cubs beat the Padres. Then my brother John and I loaded up the U-Haul truck in Albany, New York, and we drove to Chicago, stopping in Cleveland. The night we spent in Cleveland was Game 4, and they lost on that Saturday night. Now it was 2-2, and I said, "John, we've got to get to Chicago because the Cubs are going to beat the Padres, and we have to be there when that happens." We drove through a driving rainstorm on Sunday to get to Chicago. We arrived in like the third inning. My new landlord let us into her apartment downstairs so we could watch the game. Everybody on the North Side of Chicago was watching the game, and there we were five blocks from Wrigley Field. The Cubs were certainly going to beat the Padres in Game 5.

My first afternoon as a new Chicago resident was watching a ball go through Leon Durham's legs and then going upstairs and unpacking. It turned into the most miserable day of my entire life. The Cubs lost. I opened up the U-Haul truck. I had seventy boxes of record albums; thirty of them were on the floor of the truck that had leaked for five hours during the rainstorm. Now they were sitting in two-inch puddles. My brother and I had to run up the stairs to the second floor and unpack the boxes of records to get the wet ones spread out to dry before they disintegrated. That took hours into hours. We were stripped to the waist, sweating like dogs.

We finished up around ten o'clock at night. I didn't even have a bed. I just had a mattress on the floor. We threw ourselves down on the mattress. I said I don't know if we can find a place to eat around here. It's Sunday night. It's 10:00 p.m. We're probably screwed. Then I looked down at my socks, and they had little black specks on them. They were dusted with fleas because the former owner had a dog before they left. We walked down to Clark Street and saw a light in the distance. It was a sushi bar named Matsuya, which was open for many years in Wrigleyville. I would like to say that sushi bar saved our lives. We had some warm sake and some sushi. We slept on the floor covered in fleas. That's how I started my life in Chicago and my romance with the Chicago Cubs.

It's like a bad addiction. You get just enough Cubs to keep you from going into withdrawal, having a fever and chills. You get just enough Cubs without them winning to keep you going. Just like any addict and any pursuit they

have, I always think the next hit will take them some place better. It's in my blood, it's under my skin. Even in the fallow years when the Cubs were nothing more than an embarrassment, when they won, it changed my mood for the better.

My outlook on life is interwoven with the prospects of the Chicago Cubs. I've been to twenty-eight out of the last twenty-nine opening days. I spent the middle to late '80s in the bleachers with a sign in my apartment that said, "No lights in Wrigley Field." As soon as they installed lights in Wrigley Field, I said, "Hey, you know I could get a night game/weekend package." So I took the sign out of my window. In 1989, myself and three friends each got pairs of tickets for their families together in aisle 239. Over the years, two dropped out. I have since moved to aisle 229, where I have been for well over twenty years.

74. Playoff Energy Unmatched at Wrigley

Sean Brennan, Chicago Heights, Illinois

My mom and dad were both Cubs fans from before I was born, so this was handed down to me. One of my earliest memories at three or four years old was of watching on this little black-and-white TV. It was the game that Dave Kingman hit the ball down Kenmore. I wore number 10 in Little League because of Kingman.

I remember coming to Wrigley in the early '80s, before Harry Caray was here and the upper deck was closed, which is a weird thought today. I've been there in April, when there are barely fifteen thousand people in the stands, and it's nice, you can move around. It's more of a hanging-out-with-friends kind of thing.

My dad and I were there for the game that Pete Rose tied Ty Cobb. The seats we initially had weren't all that great. I think we sat in the low 200s, but my dad knew somebody, and we moved to the third row behind home plate. It was just a little bit of a nice upgrade. Pete Rose tied him early in the game, but unfortunately he didn't break Ty Cobb that day.

But playoff baseball is insane.

One visit to Wrigley that stands out to me was Game 2 of the 2003 NLCS. It was my first playoff game and, obviously, insane around here. I had seats in 203, up in the corner, and I could see Waveland from there. It was shoulder to

shoulder down the whole street. You just don't get that in a regular season game. The energy the crowd had at that time, you can't really put that into words.

We're just not used to playoff baseball. It is amazing how into it Cubs fans, even in the face of despair, still are. Until you come here and experience it, you just really don't know what it's like.

75. Stay as Long as You Want

Kyle Trusty, Des Moines, Iowa

My grandfather, the one who was a diehard Cardinals fan, took me and my brother to our first Cubs game at Wrigley in 1989 against the Dodgers. He did it because he lived in Waukesha, Wisconsin, and loved the game of baseball. To this day, all my aunts and uncles are Cardinals fans. They used to tease my grandpa, saying if he would have only driven south to St. Louis, then maybe I would have been a Cardinals fan, but he took me to Wrigley, and I'll never like any team other than the Cubs.

Oddly, that game was the only one I've seen at Wrigley that the Cubs won. Damon Berryhill hit a home run. My brother, who was five or six at the time, always says, "We won that first game, right?" because of the losing streak ever since. My dad and my other grandfather were also Cubs fans, so over the years, we made several trips to Wrigley. The memory of those trips always stuck with me even though the Cubs didn't win when we were at Wrigley.

I converted my wife into a Cubs fan, and we have two kids. I always wanted to take my son, who is now eight, to Wrigley to have that moment just like my dad and grandfather did with me. We also have a little girl who wants to do everything we're doing, so we waited until she got a little older to make their first trip to Wrigley in 2015. And because the Cubs had played the Dodgers for my first game, we planned the trip to see the Dodgers.

We were so early, among the first ones standing outside waiting to get in. Once inside, my favorite picture was when they walked up ahead of me and just froze looking at the field. My son turned and said, "This is so much bigger than the one I play on."

An usher had handed out stickers that let the kids get onto the field in that little roped-off area by the Dodgers dugout. They didn't have batting

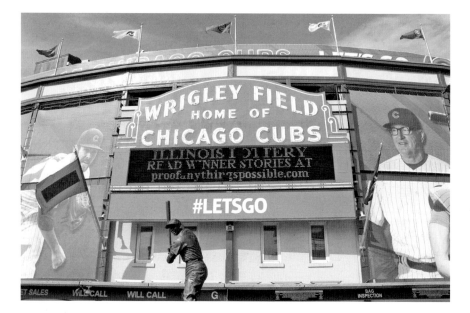

Wrigley Field's marquee at Clark and Addison has remained largely unchanged over the years, while in recent years large player banners have helped dress up the park's concrete exterior. *Rob Carroll photo.*

practice that day. I told my son that it would be OK and said to him, "Do you know what you're doing? You are standing on the infield at Wrigley Field. Dad's never done it." He was like, "Wow." He didn't want to get off. He didn't care there was no live hitting. He was locked in watching these guys playing catch in the outfield or stretching. Some of the Cubs were walking to the outfield to go to the cage.

My daughter, who's five, was on the field, off the field, back on the field—the people from the Cubs were really nice letting her go back and forth. My son didn't want to leave. He said, "Can we stay here until they get ready to start the game?" My wife and daughter already wanted to go back to our seats and get something to eat, but I told him, "You stay there as long as you want until they tell us we've got to go."

He's in third grade, and he had to give a speech, three to five minutes, and their choices were their favorite author or what they did on their summer vacation. He talked about his first trip to Wrigley Field.

To me, even though they lost to the Dodgers that day, it was worth it because my son got something from it. He remembers that experience, and it's something he'll probably never forget. That is what it should feel like every time you walk into Wrigley Field.

I've got friends who have never been to Wrigley. My mother-in-law is a Cubs fan, and she's never been. She said it's on her bucket list. I tell her you just got to do it, and if you want someone to go with, I'm your man.

You'll never have another experience like going to Wrigley for the first time.

76. Mongo Gets the Save

Steve McMichael, former Chicago Bears player; one-time guest conductor of the seventh inning stretch

It was the first and only time that Major League Baseball would let me sing during the seventh inning. This was right after my wrestling career was over, and I was coming to work for ESPN radio in Chicago in 2001. It was like advertising the radio show that was coming up, so I was more than happy to go and do it.

I didn't know that this umpire, Angel Hernandez, would get summarily booed up until the time I quieted the crowd down. It was the top of the seventh inning, and the Rockies were winning 3–1. A Cub slides home, clearly safe, and Angel Hernandez says, "You're out."

The crowd starts unmercifully booing him from that time up until I got up to do the seventh inning stretch. So I said, "Don't worry. I'll speak with him after the game." I'm smart enough to know if I threaten to whip his ass, there will be charges on me. I didn't know that he could get me kicked out of the stadium at the time.

He went to the Cubbies dugout and said if this guy doesn't leave the stadium, you guys forfeit the game. That's a pretty strong seventh inning stretch right there. They said I was inciting the crowd, but I was trying to get them to quiet down.

I talked to Ron Coomer at Mike Ditka's Restaurant years later, and he said, "You know, that all fired us up in the dugout." They came back out and tied it up 3–3. In the bottom of the ninth, it was a closer play than Hernandez called out in the seventh. "Safe!" The Cubs win the game. The paper should have read, "Mongo gets the save" the next day.

I left, and there was no security guard who ever came up to me. I had already left and was at Ditka's before I heard about what an uproar it was. I had just come off my wrestling career, and you know you got to grab the mic and cut a promo, baby. So after that happened, I was going to entertain the crowd. Nobody remembers how I sang the song. You can't sing it. You've

got to slow down and rap it, and you have to keep up with the beat and the crowd. If anybody wants some advice from an old seventh inning stretcher, write me.

I've been to the rooftops, but I haven't been inside the stadium since. John McDonough told me, "We would have had you back because of the uproar," but I guess Major League Baseball said you need to sift through your applicants a little better than that.

77. The Greatest Two Years of My Career

Mark DeRosa, Cubs second baseman, 2007–08

Before I came to the Cubs in 2007, I thought of Wrigley Field was an absolutely awesome place to play. So different than every other place to play in the big leagues. My story starts with BP in Atlanta during the 2003 NLDS with all the crazy Cubs fans at Turner Field. I remember saying to myself, "If I ever get the opportunity, I'm putting that uni on."

I'll never forget the day I signed there. A lot of people in Chicago didn't know who I was or what team I was coming from. It was the year they brought in Lou and Soriano and Ted Lilly, making a lot of splashes in the off season. I remember getting on the plane to spring training thinking I had a once-in-a-lifetime opportunity to be the second baseman for the Chicago Cubs and get a chance to play in front of those fans.

Cub fans only want a couple things: they want you to represent the city the right way, and they want you to post up every day and hustle, play hard and do the little things. If you're capable of doing that, they get on board. I think of some of my teammates like Ryan Theriot, who became beloved that way until he went over to St. Louis. The fans really rallied around who I was and how much I cared about playing there.

But it took a couple months. I didn't get off to the best start in '07. I remember that I struggled through the better part of the first half, and so did the team. I can remember when I knew this team was special was a game against Milwaukee in '07 when Aramis Ramirez hit a gigantic, gigantic home run, and it just lit that place up. We were losing. I was putting my shin guard on and had my back turned to the field when I just heard the roar of the crowd. That, for me, is a moment that will last for a long time. It catapulted us, and we went on to win the Central. I got my one and only curtain call at

Wrigley. Special stuff and a special time. For me, it was the greatest two years of my career. I was absolutely devastated when I got traded.

I couldn't believe the reception when I came back the following year in 2009 with Cleveland for interleague. I was totally taken aback and completely humbled by it. I only played two years there, and I got just a rousing ovation that made me wonder if had been here another ten years I wasn't aware of. I think the fans knew how much I loved being a part of that team and loved putting that uniform on.

It's funny, though, as much as they gave me that ovation on the first game back, by about the third game, when I was out in left field, they were like enough loving on you, you don't play for us anymore. It went right back to where it used to be as a visitor.

The thing for me is that win, lose or draw, the fans are always there. They cared. They showed up. The toughest thing to do in baseball when it gets monotonous over the course of 162 games is get up for a day game. I can remember driving to the field every day at eight thirty, nine o'clock, with Starbucks in hand, telling myself you've got to find a way to grind and get the body going. You don't have until seven to get loosened up. When you come out after BP around twelve thirty for a one o'clock start and the place is just jumping, it was just instant adrenaline.

78. THE MOST FAMOUS TATTOOED HEAD IN WRIGLEY

DAVID EAGAN, CHICAGO HEIGHTS, ILLINOIS

It all started with the Cubs bear logo that's on the back of my head. In a barroom one night, one of my buddies said, "You don't have the balls to do it," and I said, "Oh, really?" Everyone at the bar said, "You just lost a bet, get ready to pay for a tattoo."

A couple of months went by, and they said, "Hey you haven't made an appointment yet." I said, "I'm working on it. I'm kind of deciding what I want to do. It's going to be on the back of my head; everyone's going to see it. I want to make sure it's what I really want."

One of my Cubs flags is the Cub bear with the red circle around it. I was looking at it, and I'm like, well, I don't want to put the red circle around it because I don't want to hear all the Sox fans making jokes about having this target so they can shoot the Cubs fan in the back of the head. I went to my

tattoo artist, and I asked how would this look right here? He drew it up, and he stuck it on the back of my head. I liked it, he liked it. It's what we ended up going with.

The Ron Santo tattoo came about not too long after the Cubbie bear. The Ricketts family had just bought the team when I got these tattoos. Tom Ricketts was walking around; he was handing out baseballs to the kids. We were by the broadcast booths, just off to the left. I'm watching the game, and my buddy spots Tom Ricketts. He's like, "Mr. Ricketts, you want to see the biggest Cubs fan and the greatest tattoo in the world?" My buddy pushes me around. I didn't know Tom Ricketts was standing right there. He was like, "Oh, my." I just said hello and asked how he was doing. He said, "That's dedication. I like it." I told him it would mean a lot to get Ron Santo's autograph. I would like to put it right above the Cubbie bear. He goes, "Well, give me your address, and I'll see what I can do." I said I appreciated it and gave him my address.

About five weeks later, in the mail, I actually get an eight- by ten-inch photo of Ron Santo. It said, "To David, Go Cubs, Ron Santo." I knew it would be a couple hundred dollars to get this tattoo done, so I started saving money for it. Unfortunately, Ron Santo had passed away. That's when it hit me that I was going to put the number 10 on my head, with his autograph underneath it and a halo on top. That's how that came about. It wasn't too long after that I went with Billy's and Ernie's signatures on the sides. Eventually, I put their numbers up there, too.

My whole back is coming along. From the bottom of my back to the top of my neck is a Wrigley Field overview, and then on the top of my shoulder blades is a couple of Cubs logos, wall logos like "368" and "400" and seats. It's kind of a collage going on my back and neck. On the top of my neck, I have the logo there that they used for the one-hundred-year anniversary of Wrigley Field.

At the Cubs Convention in 2013, the Cubs wanted true fans for a commercial. They weren't looking to pay somebody; they could pay anyone to tell a Cubs story, you know? What they were aiming for was just honest fans. I was given a little thing by the guys shooting the commercial. We went in and did the pre-interview. I got a phone call in February, a couple weeks after the Cubs Convention. They came out to Chicago Heights, and we shot the commercial.

I do get a lot of attention, especially after my commercial aired in 2013. I didn't expect it, to be honest with you. The first game I went to after the commercial aired, it was horrendous. I couldn't get to the bleachers. They

call us Bleacher Bums, but I call us Brickheads because our heads are as hard as bricks and we don't give a damn, we're not moving from our seats. We've got traditions out there.

I like to get to my seat, and I'm standing in line for an hour before they start letting people in and all of a sudden people are like, "Hey, do you mind if I get a picture with my kid?" I'm like, "Not at all." I actually got asked for a couple of autographs, which really blew my mind. I thought people were messing around with me. "No, my kid just watched your commercial. It would just mean the world if you'd sign something for him." I thought he was joking with me. But he said his kid just laughs and giggles every time he sees the commercial. So I signed something for him and thought the only people I've ever had asking me for my signature are judges.

It got to the point where, when me and my friends got off the train, I'd tell them to just go to the bleachers and save our seats in right field because I might get mobbed again. My buddy started laughing about it so bad that my one friend, he would come with me and he would walk a few feet ahead. One day, he said he'd go get the seats and all of the sudden he starts yelling, "Hey, look, it's the guy from the commercial!" Everyone's turning and looking, and he's laughing. I'm standing there, and I'm getting mobbed. It's fun; I don't mind it.

I always tell people it was my birthright to be a Cubs fan. It wasn't too long ago that my mother told me she actually was a Cardinals fan. I said, "Wait, I thought you were a Cubs fan. You're always going to Cubs games with me." It just hit home. She said, "You're my son, I love you. If it meant taking you to a game you love, I dealt with it."

79. BEING A CUBS FAN IS A FAMILY THING

RUSS KLIMOWSKI, EVERGREEN PARK, ILLINOIS

I grew up on the South Side. My mother indoctrinated me to be a Cubs fan. Her father was a telegraph operator and worked with Jack Brickhouse when he did radio. He did the telegraph and sent the information about what was going on at the game over the wires. That was in the 1930s.

I love Wrigley Field. I used to come up here a lot with my parents. We would bring picnic baskets. My brother and I would bring our gloves.

We would sit on the first base side. I just remember going to double headers and all that.

When my kids were growing up—I have five kids—we would bring them all up there. We would just make a day of it. We would stand in line and just get whatever tickets we could get.

One time it was the last game of the season, and we got standing-room-only tickets. It was still great even though one of the kids got stung by a bee. It's a family activity, and you see a lot of families out there. Other places aren't like that.

We're season ticket holders now. It's just for the love of the game, win or lose. The guys are out there giving it their all. You like to see them win, but then you'd also see Santo out there clicking his heels and all that. You would just see them go out there and have fun in the '50s and '60s when I was a kid.

I made it to Game 1 in 1984. That game really stands out for me. I got to see them win 13–0, but then there was a lot of disappointment after that.

80. Dodging Dodgers Behind the Bullpen

Steve Nidetz, longtime season ticket holder

A Cubs fan my entire life, I've been a season ticket holder since '85. In '84, I was working on the sports copy desk at the *Chicago Tribune* and going to the games before going into work with no problem until late in the season. I could sit in the bleachers, not get there until 12:30 or 1:00 p.m. and still get a seat.

For the playoffs, I had talked to the sports editor to make sure I could get tickets. He said, "No problem. They know you are a longtime Cubs fan." This was after the *Tribune* had bought the team. I was feeling pretty good about it until about a week before the playoffs when he says, "You know, it turns out I'm not going to have that many tickets available. I'm not going to be able to get them for you."

I decided I never wanted to be in this position ever again where I had to ask somebody. So I put money together and figured out I could get a nice season ticket in the grandstand. I did that for a couple years along with another friend from the *Tribune*. We had two seats. He got reassigned and couldn't do it after a couple years. I figured I would take the money I had saved up, move up to the box seats and get a really good seat. I went to the

Cubs and asked what was available, and they directed me to the section down by the visitor's bullpen. I've been there ever since.

The person I usually sit with, Chris Simek, couldn't go the night the Dodgers came into the stands. She had given me her ticket, so I brought my wife, Wynne Delacoma, who maybe goes to one or two games a year with me. She's not a real big fan. At the time, she was a music critic for the *Sun-Times*.

It's a nice night. She's there, I'm there and before we know it, some idiot is running down the stairs and he grabs Chad Kreuter's cap. All hell breaks loose, including these huge athletes leaping over the wall and frightening her to death. What I found out is those guys are strong. I tried to hold a couple of them back. I said, "You don't want to do this. You could get suspended for this." Nothing would stop them. I remember just grabbing John Shelby, who was a coach at the time for the Dodgers, and just trying to hold him and feeling how strong he was. He just brushed me aside and went after somebody. It was ridiculous.

It was over in like an instant. My wife, she just left. She just turned on her heel, went out, hailed a cab and went home. She swore she would never come back. She did get a nice front-page story out of it the next day. After her story ran in the *Sun-Times*, I got a call from Mark McGuire, one of the executives for the Cubs, asking if there was anything they could do. They wound up sending her flowers, which was nice.

I never found out what happened to the guy who took the hat. I know they definitely tightened security down there. For about a year or two, they would have a security guard sitting at the bottom of the staircase, by the bullpen, to guard people coming down the stairs there. After a couple years, they decided that was just a once-in-a-million thing, so they did away with it.

81. Advice from Alou on How to Drink from the Stanley Cup

Kristen Taylor, Newbury Park, California

Being raised on the Cubs and having my love for them grow every year, it was only fitting I spend my twenty-first birthday at Wrigley with thirty thousand of my closest friends. It was 2002, and the Cubs were set to play the Brewers. My dad and I, along with a couple friends, arrived in

time for BP, per our usual routine. We enjoyed watching balls fly out on to Waveland and being fouled off into the seats from our spot along the third base line.

I spotted Robert Machado, who was no longer a Cub, but I loved getting pictures with different players to add to my collection, so we waved him over and I asked if he would take a picture. His response was a hearty, "Yes!" and he proceeded to grab the camera and start snapping pictures of my dad and I and the crowd behind us. This, followed by a ball from Alex Gonzalez and a beer or two, made for a great start to the night.

We headed to our seats, which were about six rows back from the on-deck circle. About this time, we noticed a lot of commotion near the dugout only to find out that Chris Chelios was there to throw out the first pitch with none other than the Stanley Cup. Even though he won it with the Red Wings, he still chose to come to Wrigley and be with the best fans in the world. And this was before Chicago had seen Lord Stanley in quite some time, so the buzz in the park was definitely elevated with his presence. The game itself was great, we enjoyed much beer, many hot dogs, the camaraderie that is Wrigley and did I mention beer? It was my twenty-first, after all.

After watching the Cubs win, we were pumped and ready to go hang out by the players' parking lot to try to get a few autographs. We saw the Cubs make their way out to their cars; most waved, and some stopped to say hello, most notably Moises Alou on his way to his motorcycle. He chatted with us, shook hands—only later did I learn of his tradition before games, which might have made me reconsider the handshake. I told him it was my twenty-first birthday; he wished me well, wrote me a nice greeting on a baseball and encouraged us to go "drink more beer!" Who were we to argue?

At this time, a few people rushed by us and said, "Chelios is at Murphy's! With the Cup!" My dad and I looked at each other and dashed down Waveland to check out the situation. Our friends had since succumbed to hot dog overload and too much beer, so it was down to the two of us. We walked into Murphy's into a huge crowd of people, who seemed to be headed the same way and milling around one section. We finally wormed our way through to see, in the middle of this mayhem, Chris Chelios pouring beer into the Stanley Cup for all to drink.

At this point, I've lost my dad, but I get my turn to take a swig out of the Stanley Cup. Many have asked why I would drink out of something that hundreds of others did, or asked if I knew where it has been or if I knew how unsanitary it could be. They must not have heard that it was BEER. Out of the STANLEY CUP. Served by CHRIS CHELIOS.

I finally found my dad as he was getting in line for his second helping when, like the fairy godmother, Chelios and the Cup were whisked away, leaving us all with a memory we will never forget. The car ride home started down Irving Park, windows down, screaming out the window to anyone who would listen that we just drank from the Stanley Cup. We keep the memories in our heads, as there are no pictures to accompany this great night, thanks to Robert Machado acting as paparazzi and using up all our film.

82. A Super Fan by Accident

Stewart McVicar, Club 400 owner, Lake in the Hills, Illinois

I didn't grow up in a sports-minded family, so I found the Cubs by accident. One day, I turned on WGN looking for the Superman cartoon I'd usually watch; instead, there was a baseball game. I tuned in at the right second to hear this old guy, which I'd learn was Harry Caray, yelling, "One run is in, two runs are in!" I was like, "Man, what is this old guy getting all excited about?" Right there, I was sucked in.

From that point on, I started watching baseball and wanted to play baseball. It became a family thing where we'd take family trips to see the Cubs play. We'd stay in the team hotel and meet players and get autographs. The Cubs also gave me something to talk about with my grandmother.

It's been all Cubs ever since. That's one thing about Club 400—my massive man cave dedicated to everything Cubs—so much of what's down there is stuff I've collected since I was eight years old. It all has stories behind it. I've got quite a few stories, too.

Back in 1998, when Kerry Wood just started out, we came up with the "We Got Wood" T-shirts. We originated it, patented it and everything. People wanted to buy them off our backs for fifty or sixty bucks. There was even a picture of them in *Sports Illustrated*. We had a peddler's license in Chicago and started selling the hottest shirts in Wrigleyville as suburban kids not knowing what's going on. We missed a lot of Sammy Sosa home runs that year selling shirts in the first three and last three innings of games.

Later in the year, there was the playoff game against the Giants, with Gary Gaetti hitting the home run, Steve Trachsel pitched like six scoreless innings and Rod Beck got the last out. We went down there with

no tickets, so we snuck in. We basically paid a Cubs person fifty dollars to get us in—there were six of us, and I was the ringleader.

I was there for Games 6 and 7 against the Marlins in 2003. Everyone says when Kerry Wood hit the home run, it was the loudest Wrigley had ever been. Well, I was at both 2015 NLDS games against the Cardinals, and when Baez hit his home run, that was exciting—the place lit up.

What I've learned is being a Cubs fan is not just about baseball. It's about believing in something with blind faith, almost like religion in some ways. Not everyone can be a Cubs fan. It takes character. I get a lot of questions like, "Are you the biggest Cubs fan?" I always say no, I'm just a crazy guy who built a man cave.

83. My First Playoff Game

Pat Donovan, Elburn, Illinois

Walking into Wrigley Field for Game 3 of the 2015 NLDS against the Cardinals, I could immediately tell it had a totally different feel than any other game I've ever been to. This was my first playoff game. I met my friend A.J. about fourteen years ago, and his dad always had tickets. He just calls me whenever there are tickets and didn't even question who he was going to bring when these playoff tickets came up a few days before the series would come to Chicago. There was no guarantee of a Game 4, so we picked Game 3. I'm not complaining.

We always have fun, especially going to a game with someone so many times because you know where to park and what each other wants to do. Neither of us feels like we have to impress the other. All the other games we've gone to have been a fun time at Wrigley and a good baseball game. You could tell right away this time was different.

For Game 3, we got down there three hours early. I just wanted to get down there to prepare ourselves for what was about to happen. You could hear the people as we walked a block from where we parked. There were four helicopters flying overhead. Everyone was just ready to go, either focused, nervous or scared. All the usual Cubs fan emotions.

The game started, and it just seemed like home run after home run after home run. It was the loudest I've ever heard it there; it gave you goose bumps all the time and chills with how far they've come and how good they're doing.

Going to regular season games in the past, you get people watching the game, talking, getting hammered. This game, I kept looking around to see what people were doing. Everyone's eyes were on the field. Every single pitch—it didn't matter who was pitching for the Cubs—everyone got loud every time it got to two strikes. Everyone stood, everyone cheered the entire game. Of course, with the home runs, the place went nuts.

My second playoff experience wasn't as great. I ended up going to Game 3 against the Mets. A totally different game than against the Cardinals—the two different sides of the playoffs. I liked the Cardinals game a lot more.

84. October 2, 1984: First Postseason Game in Thirty-nine Years Starts with a Bang

Bob Dernier, Cubs outfielder, 1984–87

It's a memory of a lifetime for me—I remember every detail. First off, I didn't sleep but an hour the night before because I was so jacked about the first Cubs playoff game since the 1945 World Series.

The Padres knew from my reputation that I would jump a fastball early in the count if it was a good pitch to hit, so Eric Show started me with a breaking ball that stayed inside for ball one. The count was 1-0, which increased my hunt for the fastball as an aggressive leadoff hitter to start a game. Now I really had a chance to get a good pitch to hit. It was a good pitch up and over the plate, probably a little too much up for me to attack early in the count, but I was so jacked I got on top of it and hit it out there—even I couldn't believe I hit it that far.

One thing that stands out: I was the first one to clap. When I hit it and dropped the bat, I just naturally clapped my hands because I knew I crushed it. I came out of the box hauling ass with my version of the Sammy Sosa hop, had a little wider turn than usual and looked at John Vukovich for a second. I got down there quick enough going into the turn that I could see the ball hit the back fence of the bleachers. As I made the turn at second, I knew where my family members were sitting up above third base, so I looked up there. I didn't point or do anything weird—we didn't do that back then, for the most part—I just looked up there and thought, "You guys must be really, really freaking out right now." They interviewed my wife. Even on that video, you could see the shock on her face.

That was my role, like if you were in a movie or a play. My role was to be on base when the badasses came up, and there were six of them behind me on that team. Every one of them could hurt you: Sandberg, Matthews, Moreland, Durham, Cey and Jody. For Game 1 of that series, I knew if I could do damage early in that role, then we've got Sutcliffe on the mound, we're at home and we just steamrolled to a 13–0 win. That was just our personality.

The moment made me feel accomplished as a pro, but more than anything, I felt like that ten-year-old kid playing baseball in the backyard.

85. First Pitch for the Opening Course

Graham Elliot, celebrity chef

My dad was in the U.S. Navy, so I was born into that nomadic lifestyle and traveled all over. I've been to all fifty states, and I also just love baseball. I loved playing it. I loved the history of the game, the romance of the game and how it brings people together, especially that father/son dynamic.

Cooking is something that my life revolves around, and I had the opportunity to come to Chicago and work for the great, late Charlie Trotter. That's what brought me out here. I was twenty-one years old in 1998. Being in Chicago, it was the first time I had lived on my own and the first time I had lived in a big city. I had nothing to do with the Midwest at all. No friends, no family or anything here. I just fell in love with the place, and it has kind of become my adopted home.

Having a team that is as storied as the Cubs and Wrigley Field, it's like a sports shrine, a baseball cathedral. You have to pay it respect. I think one of the first things I did when I drove into Chicago was go find Wrigley Field. You just stand in awe of it. I think that is how I decided the Cubs were going to be my team to cheer for. I think the draw is there is always next year, and they might not be the best team, but they're trying their hardest. There's just something about that "aw shucks" feel that the team kind of embodies.

You come season after season, but it's not because they have the most incredible star player or because they're like the Yankees where they couldn't not win if they tried because they've got so much money behind them. It's just the whole package of being so approachable and the fact that the ballpark is right there in the middle of everything going on. You don't have

to drive forty-five minutes out of the city and pay a million dollars to get into this huge skybox suite looking over the game.

It's the same raw feeling people have had for a century now of going, paying cash, getting a hot dog, drinking a beer, sitting on the bleachers and watching baseball. I think that purity lends itself to wanting to be a fan. Really, Fenway is the only thing that is close to that because the city has grown up around it. And when you have something like that—like your favorite athlete, favorite team, favorite band—that you grow up with, you hold it more dear than most other things in your life. That's when you get into that other touchy subject of change and modernization and where do you go with that. You can see why people weave so many different things into their Cubs experience.

The first game I ever went to was in '99. I went with a chef I worked with at Charlie Trotter's; his name was Homaro Cantu. We went and saw the Cubs versus the Cardinals. Since I have been able to come into my own as a chef and do TV stuff, I have been able to throw out a first pitch, and I have been able to sing the seventh inning stretch. Those are just lifelong dreams like touring the clubhouse and seeing the players. They're things that you pinch yourself when you get to do them. I practiced throwing out the first pitch for thirty years. I used to draw baseball cards with me on it and forge people's autographs and pretend to be them. It's literally not a joke when I say it's a lifelong dream. I bought three dozen balls and pitched for a month in my backyard. You speak to people, and all you get told is to just get it over the plate. That's the golden rule. I was back there trying sidearm and trying curveballs. But I was like, don't be an idiot, just get up there and throw the ball.

A lot of people don't realize how far the mound is back there from home plate. You go and you get up on the mound—they call it a mound for a reason. With the dimensions and the trajectory, it's a lot harder to dial in on the spot that you have to hit. You have that much more respect for Greg Maddux when you're up there and how he could surgically put it in certain spots. I did get it over the plate. That was the main goal. You're very stressed out while you're doing it—at least I was. It was still amazing to look back and see your name written on the scoreboard.

When you're alone on the mound, pretty much 99 percent of every guy who is sitting out there at the ballpark is watching and wanting to be in the same spot—we all thought we were good enough to play or loved playing when we grew up—or saying, "I wish my dad could see me right now." Those kinds of things. When you walk out there, it's like *The Natural*. You've got your hat pulled down, and you've got your glove. It's like it's the bottom

of the ninth and you've got to strike the guy out. You do feel the many thousands of people staring at you, even if those people are on their phones, eating hot dogs or whatever they're doing. They're not there to watch you throw out a first pitch, but you still feel that stress for sure.

I'm a huge baseball card nerd and collector. When I threw out the first pitch this year, Topps did a set of inserts of celebrity first pitches, and it included different actors and sports people and I have my own card. So I have my official Cubs baseball card of me throwing out the first pitch, which I then went on eBay and bought like two hundred of them so I could give them to friends and family and my kids. Then someone was like, "You know, you could probably contact Topps and they would give you some," which in hindsight was probably better. I had people on Twitter going, "Hey, Graham Elliot just bought a bunch of his own cards from me on eBay." I need to cover my tracks better. I don't care what people say. TV, being a celebrity or whatever you want to call it, that could all be gone tomorrow, but you can't say it's not cool to have your own baseball card. That's the coolest thing ever. At least it is for me. Even Gordon Ramsay thought it was awesome.

I can't wait to do the seventh inning stretch again. I want to do a reggae version, a lounge singer version. I think you can go so many different ways with it. It's super cool because by that time, everybody just wants to sing along and drink and have fun. As a Chicagoan, you do get it when you're there. You want to kind of channel your inner Harry Caray, but there's also the pride that comes with it and the responsibility. You've got to know the words. You need to know the cadence and how it goes. You need to be able to sing it so everyone can sing along. It's like doing great karaoke. If you go up and do some obscure and weird version of something, people feel awkward and no one enjoys it. That's why everyone loves "Don't Stop Believin'" and "Livin' on a Prayer" and "Sweet Caroline" when you go to the bar and do karaoke because everyone can partake in it.

86. Mr. Inside and His Baseball Collection

Moe Mullins, Original Ballhawk, kingballhawk.com

Catching baseballs outside of Wrigley is a long-standing tradition. I've been doing it since I was eight years old in 1958. I grew up there on Kenmore, right down the street from Wrigley, and went to Lemoyne

School. You had a big ballpark right there. Back in those days, the price was right to go constantly.

At eight years old, I was selling the balls for as little as fifty cents each, and then I'd go grab a hamburger for a quarter. That went pretty OK: go to the ballpark, you get a ballgame, you catch baseballs and you make a little money. Back then, that seemed like a lot.

I got kind of hooked. I enjoyed the thrill of getting the ball just as a souvenir. Then I started catching homers, and people really wanted them. Once in a while, I'd give them away; other times, people would give me a little money for it. They were meaningless to me at the time—it was just a form of hobby and collecting, and I got real good at it. I was getting as many as twelve a day back then.

As I got older, I got better. The players got bigger and stronger. We had the steroid era, and it just went on and on. Now I'm up to a ballpark total of 5,863. Among those balls, 244 are game homers. I've been told that's the most of anybody in the country. Five of those are grand slam balls. Another proud thing I have in my career is that I have twice in my life caught 4 game homers in one day. The last time I did it, fellow Ballhawk Rich Buhrke caught 3. There were 7 that day against the Giants; 1 was a grand slam, and Rich caught that one.

Wrigley was a unique ball field. The dimensions were such, and with the setup of the ballpark in the neighborhood like that, it was to where the balls were leaving the park. That's why my totals are so high. Until the Ricketts family took over Wrigley Field, I was almost always inside. Rich always used to say he was Mr. Outside and I was Mr. Inside, which was good for the guys on the street. I would be out there until the park opened, and then I would go in right away.

For many years, I had free access to the ballpark because, as a kid growing up there, lifting seats and everything, I made connections with all the security. I would go in just for BP. I still get in quite often, and I've been buying tickets when the wind's right. Sometimes people give me tickets and ask me to catch a ball and give it to them. It's rare that I don't catch one. They'd rather give the ticket to me than sell it to a scalper. Just like me, they resent scalpers.

Because I prefer inside, the outside situation with the changes—sure, it's cut back from 1,000-plus balls a year to where the first expansion took it down to 300 to 400 a year—has it now where we'll be lucky to see 150 balls. There were 3 street homers all year in 2015. In the old days, we'd see a whole lot more. You can attribute that to not only the expansion but

The most talked-about aspect of the 2014–15 renovation was undoubtedly the video boards in the bleacher areas. From ballpark aesthetics to the impact on some of the neighboring rooftop clubs to how fewer baseballs would reach the Ballhawks, the modern screens received mixed reviews from fans, although the Cubs held true to the promise to be tactful in their use by not going the cliché route of Kiss Cams and noise meters. *Rob Carroll photo.*

also the steroid era—we don't have the Mark McGwires, the Sosas, the Bonds, all these guys who hit the ball five hundred feet constantly.

Of all the baseballs over the years, everybody might think the number 62 Sosa ball would be a favorite, but it's not. That was an unfortunate event where people who thought that ball was worth $1 million—after I had it for five minutes—ripped it out of my hands. I literally passed out for a couple of seconds from the weight of people on me. I couldn't breathe.

My favorite of all time would be a ball hit by Andre Dawson—he is my favorite player—when he was playing for the Montreal Expos. He wasn't a Cub yet. I was sitting down the left field line in the lower box seats with about six firehouse guys. Dawson ripped into one down the line. I jumped out of my seat and ran up to the aisle—back then, it was about seven feet wide—and to the back fence about eight feet foul. I jumped on that little ledge, which is about six inches wide. I used my right hand to shimmy across the rail of what was the grandstand section, and I backhand caught the ball on the fly, jumped down and flipped it to one of three kids running toward me. Then I went and sat down with the firehouse guys.

The next day, when I got to the park, I ran into Arne Harris from WGN, and he says he's got all the video of my ball from Dawson. He showed me replays of it in the truck on the TV screens, so that was cool.

I'll continue doing this until my body says no. I'm going to be sixty-five, and I'm still very good shagging down balls in the bleachers. It goes without saying that my wife wouldn't expect me to be anywhere else but Wrigley Field for every playoff game. And yes, I would go die-hard out to get a World Series ball.

As for my collection, I've told the Ricketts family I would donate all these baseballs to the Cubs for display when they build their museum or hotel, for the fans to see and talk about the accomplishment and history of what I've done throughout the years. What I've asked for in return is a golden parachute—entrance in and out of the ballpark. I don't even need a seat; all I want is a way to get into the bleachers.

87. WRIGLEY MAKES THE TOP TEN

SCOTT FREDERICKS, WHITE SOX FAN/VISITED ALL THIRTY
MAJOR LEAGUE BALLPARKS; ROMEOVILLE, ILLINOIS

A lot of people have differing opinions on Wrigley Field. After twenty-one years and visits to all thirty current Major League parks and eight others that no longer exist, Wrigley is in my top ten, not in the top three, but it's definitely one of the best parks, and it always will be.

To me, there are not many better seats than the bleachers or sitting in the first couple of rows of the upper deck where you're just on top of the action. You just feel like you're in the game. I was eight years old in 1984, when I went to my first game at Wrigley. I was a Sox fan—not to the point I am now, but I absolutely hated the Mets, and the Cubs were playing the Mets. I remember sitting right above the dugout on the first base line in the first row of the upper deck. I was a little intimidated by sitting there, kind of hanging on to my seat a little bit and not wanting to lean over because I was afraid I'd fall. I was excited to cheer against the Mets.

Move ahead to 1994, and that's when the ballpark quest began, with four of us going to Jacobs Field in its first year in Cleveland about ten days before the strike. We also hit Detroit for a game on that trip. I took a little bit of a breather until 1998, when a group of us went out east to do Cleveland, Toronto, New York and Baltimore. That's when I got rained out in Boston;

Fenway Park was the final ballpark to complete the journey in 2015. I got a true appreciation for Wrigley when I sat in Fenway.

The Cubs-Sox interleague rivalry was at its peak in 1998, when they played the first meaningful games at Wrigley. The rivalry is not the same as it once was, but those first few years, to me, it was a different feeling. Those games were the highlights of the season for the teams. The intensity—and it was all about the civic pride. I don't think it was intense at the Cell. For three days, those were the biggest games of the year, which was both unfortunate and special.

I wasn't sure what to think walking into Wrigley wearing a Mike Caruso jersey and waving a white sock after a nine-hour rain delay. I think people respect you as long as you don't act like a buffoon. There was something special about being in the bleachers, especially those first couple of years. I'll never forget the Magglio Ordonez ball in the ivy. I remember how dejected I was on that note, and how high I was when Caruso put one in the basket for the sweep the next year. It was seventeen, eighteen, nineteen years ago, but I'll never forget those moments. These days, the Cubs-Sox thing has lost a little bit of its luster.

After leaving Fenway, I went and ranked every ballpark. It was really difficult; the first two and the last two were easiest. My top three: PNC Park, AT&T Park and Fenway. Wrigley is at seven. The Cell? I have it at twenty-three.

88. Sox Fan on the Cubs' Playoff Beat

Patrick O'Connell, *Chicago Tribune* reporter

I'm originally from Des Plaines, which you'd think would be the heart of Cubs territory, at least in the 'burbs, but I'm actually a diehard Sox fan. Have been since I was little. I'm not one of those Sox fans who is a Cubs hater, so getting these assignments wasn't so bad. I love baseball and always followed the Cubs as a baseball fan, even growing up.

The majority of my family and friends are Cubs fans, including a cousin I went to a lot of games with. I also attended games with my grandma on my dad's side. Often, we'd end up at the ballpark because she would ask, "What do you wanna do today?" And I'd say, "Let's go to the ballgame."

My fondest memory—in fact, it's one of my fondest memories of my grandma, and I talked about it at her funeral—was in 1987 **during** Dawson's

MVP year with the Cubs. She asked, "What do you want to do today?" I said, "Let's go to the ballgame." He hit two home runs against the Padres. And then the next day, again, she asked what I wanted to do. I said, "Can we go back?" She bought tickets, and we went back to the game the next day. And that's when there was some big hubbub with Eric Show, and Dawson got hit in the face. Then Maddux retaliated.

During the coverage from Wrigley during the 2015 playoff run and into the playoffs, I was thinking back to some of those games as a kid. And I think that sort of helped me with the coverage because I had a background of thirty years' worth or more of history related to Chicago baseball and the Cubs.

We really started this right after Labor Day, when it was sort of clear they were going to make it barring a huge collapse. I sort of kept joking in meetings about whether we were still doing the collapse story, if it was on the schedule. That was my only sort of Sox comment.

As a news reporter working sports features, you're seeking out these stories that are about a step and a half removed from the field and are of general interest to people who maybe don't follow sports but are now following it because the team is exciting or they're hopping on the bandwagon. Anytime the Cubs are on the cusp, it's a huge deal because it's the Cubs. They are in the public consciousness. The challenge, the longer we were doing this, was to find these stories that weren't just about the billy goat again. I was sort of bound and determined to not write those stories, although some of those are anchored in that sort of angst, like the one about the crazy things people wear. It wasn't about the goat or the curse.

The story about the vendor who has been there for sixty years was a favorite. I sort of lucked into the fact that he was a great interview. He spent almost two hours with me at lunch and gave me his whole life story. He was an open book. I really enjoyed that story, and it got a lot of good reactions from people.

I also liked some of the Cubs-Cardinals stories that I did when I went to central Illinois and talked to the family with four generations of fans in the heart of swing territory and the divided town. I think you got the sense of what baseball means to communities and families. The theme I was finding through a lot of this, it's about more than baseball; it's about relationships within friends and families.

Going to a Cubs playoff game is a huge thing for fans, so it's sort of weird to be at these games working, and you're there alone; you're not there with your brother or your mom to celebrate with. Everyone there is really excited one way or another, and you're there to just document it. You feel it, but

it's also sort of different as a reporter. It was great to be there, but it's also different from when you're going there as a fan.

The access was pretty cool. I ended up being there for six or seven games during the playoff run and playoffs. I just went to every corner of the park and took in the viewpoint from every vantage point. I got to be on the field. I asked Joe Maddon a question. I saw the park before and after the game. That kind of stuff as a fan was cool.

What I tried to do with these stories is show what the Cubs mean to the fans and the city. It's more than wins and losses. It's something that brings people together in a meaningful relationship.

89. It Wasn't Work for Jack

Pat Brickhouse, widow of Cubs broadcaster Jack Brickhouse

With his famous home run call of "Hey, hey!" Jack Brickhouse was the iconic voice of the Cubs on WGN for thirty-three years. The combination of day baseball from Wrigley Field and Brickhouse is a common memory for nearly two generations of Cubs fans. *National Baseball Hall of Fame Library, Cooperstown, New York.*

When Jack and I would go out to dinner, and he'd have fork to his mouth, that's the only time I'd ask fans to come back another time for an autograph or a photo. At Wrigley Field, I knew he was the people's broadcaster who would never refuse an autograph or to pose for a picture. That was the way he was, so considerate.

I remember his last game at Wrigley; he was on the catwalk, and the fans would not let him leave. They were screaming and shouting. It was incredible. I still have people come up and tell me, vividly, how they remember what Jack meant to them and carry memories with them. People stop me and tell me that they tell their children about Jack and what he meant to baseball and to Chicagoland. When he

stopped broadcasting, people would say one of the things they missed most was the rain delays because he was such a great interviewer.

When I've done interviews, I like to quote one of my favorite lines: though his voice is stilled, his memory lives on. Although I'm not sure what he would say about the renovations, I was totally delighted to see that on the giant Jumbo Tron they're putting up "Hey, Hey" whenever someone hits a home run. First they put it on the foul poles and now on the Jumbo Tron. That's awesome, that's pretty special.

No question about it, he was a fan and he loved it. His one regret was never getting to broadcast a World Series for the Cubs. He would have gone crazy if he had the chance to be part of a Cubs World Series.

Wrigley was his second home. He made the remark to me once: "I love this job, and maybe I'll have to go to work for a living one of these days."

90. Plenty of Time for a Playoff Game and a Wedding

Johnny Klimowski, Evergreen Park

I made it to Wrigley for Game 3 of the National League Division Series in 2003, when it was Prior versus Maddux. It was the night before my wedding. My buddy who took me to the game was one of my groomsman I flew into town for the wedding. He won tickets on the radio and asked me to go to the game. It was karma.

I didn't make it home until four o'clock in the morning. I wasn't thinking about the wedding during the game. The wedding was already scheduled. Whether the Cubs would win or lose and if I would make it home in time wasn't.

All of the barricades and cavalry they have outside now during the playoffs, they didn't have it back then. It was the first playoff game they had at Wrigley since 1989. The fervor of fans down there—not to say it wasn't strong in past years, but you didn't get these wild Clark Street celebrations. Now they have barricades up along Waveland and Sheffield. They didn't have those that night. It wasn't until Game 4 the following day when they put those up.

We had to dive into a window of a bar to basically avoid being picked up off Clark Street. We weren't even doing anything. We were just trying to meet our ride home because they were in the Irish Oak. We just forced our way in

through the window because I said, "I can't get arrested just for standing out on Clark Street peacefully tonight. I'm not going to miss my wedding."

It was no problem getting up the next day. You're running on adrenaline at that point. They played the next day during the ceremony. One of the groomsmen had an earpiece, listening to the whole thing during the ceremony. He never made it up to the altar. Roman Catholics really don't like electronics up around the altar.

91/92. Creating a Cubs Anthem with Heart

Daniel Martinez/Jorge Soto, cowriters, "My Kind of Team" song; Chicago, Illinois

Daniel Martinez

For me, the Cubs go back to my grandmother. I wish she could have seen them win a title. Every time we'd watch the Cubs games with her, she'd watch in her room while we'd be in the living room. A replay of a home run would come on, and she'd start screaming, "They hit another one!" We'd run there like, "Grandma, it's a replay." She was super excited about the Cubs hitting another home run back to back, and it was just a replay. It's memories like that, not to mention finding ways to sneak into Wrigley to see games when I was younger, that you don't forget when it comes to the Cubs.

When we wrote the song "My Kind of Team," we wanted to make sure the lyrics were speaking for all fans, from everybody's perspective: "It's going to be our time. We never give up on the team, we believe, we believe, even if it's not this year, it's going to be next year. Eventually we're going to win."

To get the song written took about fifteen minutes. It was recorded the same day in the next four hours. We had to get a singer in and do the mix, so the whole process to get it to sound the way it does took about a day and a half of work. There was motivation. When you're inspired by something, the words just come out. The beat was there, and the lyrics just came right out. Not much thought went into it; we just said let's say what we feel, and that's exactly what happened. That's usually when the best songs happen.

We definitely wanted to include the fact that the 2015 season was phenomenal and the players were outstanding. We needed to incorporate

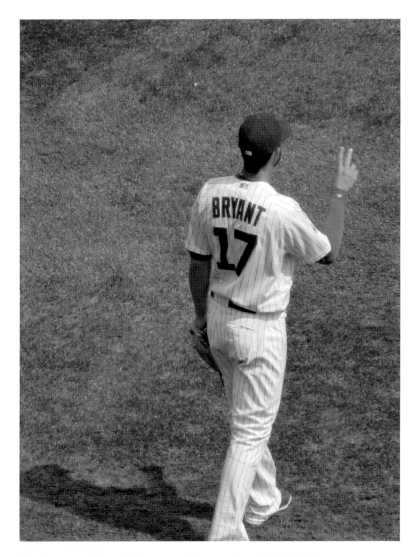

Kris Bryant and an exciting group of young players led the Cubs to an unexpected run to the playoffs in 2015. Despite finishing third in the National League Central, the Cubs won ninety-seven games and eliminated Pittsburgh and St. Louis from the postseason. *Dan Campana photo.*

something that fans and people like us can relate to, and what can we say that will motivate them the way we were motivated. The first thing that popped into our mind was: "Nobody thought we would make it this far, but here we are." That was the whole concept of the song. They always count us out; the Cubs aren't going to make. Well, we're here.

JORGE SOTO

The Cubs are something that goes deep with both of us. Our families are long-running Cubs fans. My first job that I ever got was as an usher at Wrigley Field. It was the most amazing experience of my life, meeting Ron Santo, Mark Grace and, back in the day, when Randy Johnson would walk out of the visiting clubhouse. Those are things as a child and as a Cubs fan you never forget. The passion that we share for this team is ridiculous. We've taken a lot of bumps and bruises over the years. We sit there and argue with Sox fans and everybody from every opposing team; we just have to grin and bear it because we are at the bottom of the barrel. Now, it feels good to be able to flex our pride for once.

The record itself was something we thought about before, but the opportunity came up for fans to put together some ideas and songs about their favorite team to submit for radio. Danny and I are both musicians, we love music, so why not do something about a team we're passionate about? Danny and I have both been die-hard Cubs fans as far back as we've known each other.

My dad used to make me watch baseball before I even knew what the game was. As I grew older, I understood. When I got to sixteen and Father's Day was coming, I wanted to do something for him since he was a die-hard Cubs fan. One day, I bumped into Mark Grace at Wrigley Field and asked him to sign a baseball for my dad. He gave me a batting practice ball and signed it "Happy Father's Day." I'll never forget the look on my dad's face, knowing it meant so much to him.

We've gotten a lot of great response to the song. To be honest, we didn't think the record was going to be as fruitful as it was. From creation to completion, by the fourth day, we were already on the radio, *The Jonathon Brandmeier Show*. Then, the fifth day, we were on WGN. Then the *Sports Mockery*, WGCI and we were on the "U" for *You and Me This Morning*. It was a snowball effect, an incredible thing. We've gotten nothing but love.

93. What It's Like to Meet Steve Bartman

Lin Brehmer, WXRT radio host

When the Cubs were in the postseason in 2003, I remember our tension getting ready for the games and trying to get to the games on time was unhealthy.

I was in my usual seat with my wife and my friends. We were up the first base line, so we had a direct view from a distance of what happened. It was just a foul ball that maybe Moises Alou could have caught, but then again, there's a chance he might not have caught it. Then again, it was just a foul ball. I remember a couple things vividly. Number one, there were five outs left before the Cubs were going to the World Series. I remember Mark Prior was as effective as he had been all year. I remember the score was 3–1, and I remember there must have been fifty thousand people outside the ballpark that you could see on the little television monitors they installed above our seats on the back of the sky boxes. I remember thinking, if they win—and it looks like they're going to—how am I going to get to my car? Am I going to want to drive my car because people are going to be turning cars over? Will my wife and I and our friends just stay in Wrigley Field as long as we can until the hysteria dissipates? That's what I remember just before the Bartman incident.

And then I remember how eerie the ballpark became. It was like everybody had been to the future already, and they knew what was going to happen. But you know, it was just a foul ball other than the fact people felt a little bit like they were kicked in the stomach with Moises Alou being so demonstrative about not being able to catch the ball. We were quickly distracted by a tailor-made double play bobbled by one of the best defensive shortstops the Cubs had seen in recent years. Then I don't remember how they scored eight runs. It was like a big Hollywood horror movie where the dam breaks and civilization is washed away. They just kept scoring. It was unthinkable. It was beyond belief. Even though at the end of the game we all said, "Well, Game 7, we'll all be back tomorrow. We've got Kerry Wood going. I mean they're not going to beat Kerry Wood, are they?" In the back of our minds, Cubs fans were all saying, "Oh boy."

I ran into Bartman. I was in a music club. I was at the bar, having a drink. The band had finished up. A youngish, handsome, black-haired guy came up to me and said, "You know I just want to thank you." People say strange things to me all the time that I don't always understand, so I just go with the flow. I said, "Oh, no problem," without really having any idea what he was thanking me for. Maybe he was thanking me for the years I had been on the air and he had been a listener.

He said, "I'm Steve Bartman." I said, "You're Steve Bartman?" He said, "Yeah, I just wanted to thank you because over the years I've heard you support me on the air." The Cubs gave up eight runs, that wasn't Steve Bartman's fault. The ground ball to shortstop, that wasn't his fault. We

talked for about five minutes. He said, "I'm a big fan of this band. I come here every year to see them play. I just wanted to say thank you."

You never would have recognized him. He wasn't wearing glasses. His hair was dark. It was kind of longish, and I thought he was a really good looking, young guy. He didn't conform to the nerdy image with headphones and glasses that everybody had of him in left field. You never would have picked him out of a crowd.

94. Triple Play Does the Trick

Jim Walaitis, Manchester, Missouri

I've been a St. Louisan for almost two decades now, but I grew up in Arlington Heights, the child of one healthy parent and one Sox fan. I was never much of a baseball fan while very young and didn't attend my first baseball game until I was eleven years old. I got to go to a Cubs-Pirates game on a school helper reward trip on June 2, 1983.

The Cubs weren't good yet. There were probably seven thousand people there, and we had a group of about fifty sitting up in the last row of the last section on the third base side about as far away from the field as you could get. There wasn't anybody else within five hundred seats of us, but there we sat.

In the second inning, with runners on first and second, Rick Rhoden hit a sharp ball to Ron Cey, who stepped on third, threw to Ryno at second and on to Buckner at first for a triple play. What crowd there was that day went crazy. No, my memory isn't quite that vivid—I double-checked it, thanks to the web—but to this day, I do remember seeing the triple play and being enamored by the Cubs ever since.

A little more than five years later, I would end up being the first fan in line to get into Wrigley Field for the first-ever night game. My family bought tickets for the August 9 game before the Cubs had announced August 8 would be the first official night game. We lived in Arlington Heights, and I was sixteen years old, but I asked my mom go down to Wrigley by myself to be part of the festivities for what was supposed to be the first night game and then stay there until the rest of the family showed up for the game. We had bleacher tickets for the next night. I figured I could be first in line that way. Being the last of six kids paid off because she said if I really wanted to do it, I could go.

I took the train from the suburbs to downtown and then the L to Wrigley, to be outside the park with many others who just wanted to be part of the grandeur of the lights being turned on for the first time. Of course, we all know that the rain wiped everything out. When it was all said and done, no one else stayed. I walked around the park a little and ended up with a lawn chair someone left behind by the bleacher gates, and that's where I stayed. The cops would stop by every few minutes, but it felt safe. It was really surreal. No one else showed up until nine or ten o'clock the next morning. They asked how long I had been there and were surprised when I said, "Oh, about noon yesterday."

As for the last nineteen years, even though it used to feel like I was wearing a meat suit in a tiger den, I have never shied away from proudly wearing my Cubbie blue.

95. WRIGLEY ALWAYS A PART OF LIFE WHEN YOU LIVE IN THE NEIGHBORHOOD

DEBRA ANN SIMON, GREW UP THREE BLOCKS FROM THE BALLPARK

My grandfather owned an apartment building three blocks east of Wrigley Field on Fremont. He owned the building from 1948 to 1972. They had eleven children, and it was actually all girls until the last three. I also had two aunts who lived on Sheffield near Waveland. Back then it wasn't Wrigleyville; it was a part of Lakeview. I never heard it called Wrigleyville until the last couple years.

He lived on the first floor of the apartment building. My parents, my sister and brother and I lived in the basement apartment. And I had an aunt and uncle with five daughters who lived on the second floor. They were big Cub fans, and their last name was Rizzo.

The Cubs were always on TV, and my grandfather watched them all the time. He closed off our back porches to make another room of the two apartments, but we still called it the back porch. He would sit on the back porch and get mad at Jack Brickhouse about something, so he'd open the window and could hear the crowd noise and just watch it with the TV sound off because he was mad at Brickhouse.

We all went to the Lemoyne Elementary School, and the eighth grade classroom faced Wrigley Field. The building had those huge old windows and

was three stories tall, so the sound wouldn't get blocked by other buildings. So when I was in eighth grade, this would have been in 1971, I could remember in the fall—we had no air conditioning so the windows would be open—the teacher brought TVs into the room so we could watch the game because we had all the noise coming in the windows, and we couldn't do anything.

We'd get out at 3:15 p.m., and during the weekday games there would be a lot of empty box seats. So we would go to the gate and the Andy Frain ushers would look the other way because we were kids who got out of school. So by the time we got there, it would be after the fifth inning. We'd just walk in and take an empty seat to watch the end of the game.

My brother loved Ernie Banks, and we moved away from there before he turned six. I can remember taking him for a walk, and it would be after a game, and we'd be by Wrigley Field and every so often we'd see Ernie out there always in a suit, always a cluster of kids around him talking to him. My brother just stood there and looked up at him. Whenever anyone asked him what he wanted to be when he grew up, he always said Ernie Banks.

I was born in 1957, and we moved in 1972, when my grandfather died and the building was sold. For those early years, Wrigley was always there and always a part of life for us.

96. A Road Trip Home

Casey Crosby, Chicago-area native, Detroit Tigers pitcher, 2012

I grew up as a Cubs fan and had a grandmother who would host players from the Kane County Cougars. So I knew some players who were on that team. When some of them would get to the Major Leagues and came through Wrigley, we'd sometimes get tickets from them. We'd hang around after the game and wait for them at this restaurant on the right field line. Fast-forward to when I'm twenty-three, and I'm there playing and my family is waiting for me there—that was pretty cool.

We lived in Wheaton, and then we moved out to Elburn, so we'd go in to Chicago a few times a year for a game. I just remember the fact you were in the big city, with all this concrete around, and you get to Wrigley and it's so open with all this green grass and color.

In 2012, I got the call up. I was really excited for my first start against the Yankees at home in Detroit. I didn't really look at the schedule until after

my start. Then I was like, "Oh, man, we're going to Chicago. We're going to Wrigley in a week." Then again, at the same time, the guy I came up for, Doug Fister, he could have been healthy by then. So nothing was set in stone that I was going to be there. But I thought it would be awesome if I could go there. When it turned out I would be going, I was ecstatic.

When we got there, I was acting like a tour guide a little by talking to my teammates about the different parts of Wrigley and how it's unlike other ballparks and how it was built the way stadiums used to be. I'm sure they didn't appreciate the long travel from the clubhouse to the dugout and the small clubhouse, but I certainly did because I knew how different it was from any other park. I just didn't realize how cool it is up in the clubhouse; it's like up in the rafters right above the concourse. That's something I didn't know about. I think my teammates really didn't want to hear about it, but I was really excited. At the time, there had been concerts through there, so the field wasn't in the best shape. I kept telling them it's not like this, I swear. I was kind of defending the park.

I shagged balls during batting practice in Detroit and Cincinnati, but I don't think I've given away as many balls to fans as I did in Chicago during BP. I was shagging like an eight-year-old again. I had a few people yell my name, and I would come over and talk to them. My longtime travel coach, who is the biggest Cubs fan you'll ever meet, he was there. I had friends who lived in the city at the time, and my wife stayed at the hotel with me. My mom and dad came out for a game.

Every game after BP, I wouldn't go straight to the clubhouse. I would hang out outside and just stretch or run a little bit and take it in. You're in that place where you've been as a kid, but it's just such a different circumstance that you just wanted to take it in.

97. More than Just the "Bleacher Preacher"

Jerry Pritikin, Chicago, Illinois

It's amazing, the relationship between baseball, the Cubs and Wrigley Field. It's amazing, the things I've seen and the people I've met.

The best way I can say why I'm a Cub fan like I am, it's my father's fault. The only official language at our breakfast table was baseball. And he used to tell us fascinating stories about guys by the name of Roger Bresnahan and Bonehead

Merkle and Tinkers and Evers and Chance. He took me to our first game, and it was like discovering the Grand Canyon. When the Cubs didn't win in 1945, he said we'd go the next time. I'm sure when he said that and when I heard it, I didn't think it was going to take seventy years before they got close again. The Cubs were indoctrinated in me at an early age, so I didn't know the other teams counted really. We used to clean the ballpark from about '46 to '50 to get in free. It turns out, my father did the same thing at the West Side Ballpark.

My dad took me to my first opener in 1947. It was the first game Hank Greenberg was playing in the National League. He had a two-out double in the sixth. It was the only run. I had mixed emotions as a good Jewish boy because Greenberg got the winning hit, but he did it against the Cubs again, like he did in the '45 World Series. A month later, I was at the ballpark for the first game Jackie Robinson played. I'm not just someone who holds up signs. I'm really someone who's been around.

In the beginning, because the Cubs ended up getting into the World Series in '45, they converted me easily to a Cubs fan. I've been loyal and always optimistic, even when they were cellar dwellers in the '50s and what not. The beauty of Wrigley from the beginning is that for really the first thirty years I was a Cubs fan, there was very little change in the ballpark. So I equate my youth with the Cubs. I used to clean the ballpark to get free tickets.

The first image I ever saw on television was the end of a Cubs game in 1946. And I started sneaking into a neighborhood bar to watch sports. When my father heard, he went out and bought the first television in Albany Park to keep me out of the taverns at the age of ten.

In 1985, Harry had me as a guest on the *10th Inning Show*. How many times do you remember a fan that wasn't a celebrity being on TV? And he introduced me as "John Q. Public," the fan. Harry Caray actually named me the No. 1 Cubs Fan in 1987. That was the last true year of fandom at Wrigley Field because it was the year before lights.

I originally called myself the Bleacher Creature, but there was an entire section in Detroit called the Bleacher Creatures, so I came up with Bleacher Preacher. There are many bleacher creatures, but only one Bleacher Preacher. I'd come up with a variety of signs and cat-calls for players of opposing teams. There was an outfielder for the Philadelphia Phillies by the name of Von Hayes. I actually got him laughing hard. I yelled to him, "Hey, Von, this ball is going over your head just like *Sesame Street!*" He turned around and started laughing.

The Cardinals had a couple of guys who got arrested, and instead of calling them redbirds, I called them the jailbirds. I learned to pick on the

ballplayers. One of the best visiting ballplayers ever was Roger McDowell. He used to entertain what I called the "Troops" in the bleachers. When it got hot, he used to go underneath and get a hose and sprinkle us to cool us off. When Lee Elia came back with the Phillies, I made the sign saying, "Welcome Back, Lee, This Bleeps for You."

I think it all boils down to the sign I came up with that Steve Stone mentioned on national TV in 1984: "How Do You Spell Relief: C-U-B-S."

98. Harry and More Wrigley Lore

Steve Stone, Cubs announcer, 1983–2004; Cubs pitcher, 1974–76

When Harry came to the Cubs, he changed. He was smart enough to understand that what he had done—especially with the White Sox, which was a completely different crowd from the Cubs—he couldn't do the same thing.

He became a kinder, gentler Harry, who was in the corner of all the players. Singing "Jo-dee, Jo-dee Davis" and all the other things, giving nicknames to the players. But the '84 team characterized everything. When we started, Harry told me, "Kid, you're going to be a good broadcaster, but I've got to humanize you somehow, and I'll try to figure it out." And he did it with cigars. That was a great bit between us. That year, 1984, I was getting two hundred cigars a week from all over the world.

Before they had stands up on the rooftops, they'd try to sell them for advertising. And Harry—and I'm pretty sure a lot of this was not happenstance, I think a lot of it was well crafted. But if he got the first name right of someone, he got the last name wrong, and if he got the last name right, he got the first name wrong. So Budweiser had the big Spuds McKenzie campaign, they had a huge blowup of Spuds on top of one of the buildings. It was a night game, and I look up and said, "Harry, take a look at your old buddy." He goes, "Oh, yeah, Scotty McKenzie." I said, "No, it's Spuds." He goes, "Ah, that's right, Spuds McFadden over the right center field wall."

Over the years playing and broadcasting for the Cubs, there was no shortage of moments. I remember Tuffy Rhodes hitting three home runs against Doc Gooden on Opening Day 1994. I believe that pretty much was the highlight of his Major League career. It aggravated Doc so much that if you check his lifetime record against the Cubs—it was somewhere

in the neighborhood of twenty-five or twenty-six and three or four, it was ridiculous—he was so incensed by Tuffy Rhodes taking him deep three times that he decided that the Cubs wouldn't beat him again, and we didn't too many times after that.

In 1974, my first year with the Cubs, George Mitterwald hit three home runs himself very early in the season because he was so pumped up and enormously strong. He wound up with seven home runs that year, but that was the highlight of his career at Wrigley Field. That was the same year I gave up five solo home runs in a game against the Big Red Machine in less than three innings. The wind was blowing out, and as soon as a ball got above the stands, the ball just rocketed out. Jim Marshall wanted to take me out, but I said the record is six home runs. He said that was enough. I was disappointed.

During Games 6 and 7 of the 2003 NLCS, TV kept getting shots of all the people who were around Wrigley Field. It was a phenomenon. If the Cubs win the World Series, regardless of where they win it at home or on the road, when they have the parade, there will probably be four million people there. And people will probably fly in from all over the country to say they were there. I don't believe that this city will have ever seen the likes of what it will experience when the Cubs win the World Series—because they will eventually win it. People always ask me, "Will the Cubs win in my lifetime?" My standard answer is: "How long are you planning to live?" It's just a question of when. And when they do, hopefully, it's in the lifetimes of a lot of people I know who are tremendous Cubs fans.

99. Living in the Moment on the Mound

Turk Wendell, Cubs pitcher, 1993–97

The beautiful thing about playing at Wrigley, from a player's perspective, was that you get to kind of have a normal life where you can go to dinner or a movie after the game like a normal nine-to-five job, so to speak. I loved it there.

The thing that makes Wrigley Field and being a Cub so special is just the fan base, the way the fans treat you, how into the team they are. Their support is phenomenal. To go to Wrigley is a big event. Sitting in the bullpen, you actually get to be friends with a lot of people who have season tickets in

those first couple of rows. I also got to know all the ushers and the security guards. It's not so great when it's a cold windy day in April and you're sitting, freezing your tush off, in the bullpen.

My first relief appearance in the big leagues was pretty memorable. Warming up, of course, I was nervous, and I threw a couple balls to the back stop. I guess Tony Muser, who was bullpen coach at the time, got into it with Paul Runge, the home plate umpire that day. I had launched a couple balls, and I'm rapid-firing getting ready to go in. I threw one or two pitches after he called me into the game, so I got on the mound, and Runge said I got six pitches and that's it. I'm sitting there thinking I got eight, but I guess in the big leagues it's different. Tony ended up getting thrown out of that game while I was out taking my warmups.

One of the coolest memories at Wrigley happened in '96, when I got to be the closer, which I thought was the best gig in the big leagues. This one game I was closing during a June series against the Padres. Ken Caminiti, who won the MVP that year, is up, with bases loaded and two outs in the twelfth inning. The place was just going crazy. I remember stepping off the mound and looking around to absorb the moment, which I hardly ever did. It's one of the only times I can remember living in the moment. I thought to myself, "Whatever happens right here doesn't matter because this is what it's all about." I threw the ball a couple inches outside, and the umpire called it strike three. I wish I could say it was a strike. I mean, technically it was a strike, but I know it was a ball, and I was lucky enough to get the call.

It was a sad day when I got traded. I was crushed. Being a Red Sox fan growing up, I never wanted to play for the Yankees because I hated them, and I never wanted to play in a big city like New York. Chicago's more spread out. Well, the baseball gods bit me in the ass. In hindsight, it was probably the best thing for my career. I went on to do great things in New York and got to play in a World Series.

But I was absolutely treated well when I came back to Wrigley. I'd go in and sit for half or a third of our batting practice in the grounds crew's room and talk to the guys, catch up with them and talk about old times. I got to be friends with everybody from the grounds crew to the front office to the ushers.

My goal when I got to the big leagues was to play my entire career for one team, but unfortunately that was out of my hands and out of my control.

CUBS 100

100. My Friend Helen and the Cubs

Pat Sparling, Orfordville, Wisconsin

The first time I saw a Cubs game was sometime in the summer of 1966, I was a young boy, the age of six. I remember hearing them on the radio in the garage, but the first time I saw them was on what seemed to me a large black-and-white TV set in our living room in Winthrop Harbor. I sat on my dad's lap watching the grainy images of Ernie Banks, Billy Williams and Ron Santo. I guess what I remember most was sitting with my dad that summer in the last year of his life watching what I learned later on was "the Spoilers of Summer."

That's what my father would call them. He, as I am today, was a lifelong Cubs fan. My mother used to tell me he thought of them as spoilers—always good enough at the end of the season to spoil the hopes of other teams and just good enough to give you hope for the next season.

I lost my father in the fall of 1966, still a young man but not old enough to watch the Cubs win it all. That memory would live with me forever. What happened that day sitting on my dad's lap turned me into a Cubs fan for life. I became obsessed, a baseball junkie. I not only loved to play, but I had to know the history, the stats, the interworking of baseball.

I would read box scores as my friends read comics. I would grab the sports section from my mom's newspaper to read the standings and pore over the league leaders with the hope the Cubs did something other than lose. I hoped if I read the standings long enough that somehow the Cubs would be on top.

Then it happened. I went to my first Cubs game in the summer of 1969 against the Houston Astros. I walked into Wrigley Field and was stunned, as everyone is once they walk in and see the green grass and the ivy on the walls. But what stunned me the most at nine years old was the color, just as everyone was stunned in *The Wizard of Oz* when Dorothy lands in the Land of Oz and everything turns from black and white to color. I had only seen Wrigley Field in black and white, and here I walked into one of the most amazing places I had ever seen. I was really hooked even more.

The wonderful smells and sounds of the ballpark got me that day, as well as some bad pizza from a vendor. I threw up and got sick, perhaps a sign from above about my future as a Cubs fan. Yes, it was 1969, and after attending my first game, I was seeing something in the standings: the Cubs were on top. I was young at the time and thought this was it. Yes, I had read all about the Cubs' misfortunes of the past, but here they were that year on top, and it

happened all summer. Then, the Cubs broke my heart. But I didn't give up hope. I continued the following year to read the stats, follow the standings and run home from school to watch the last few innings of games. I even attended a few more games at Wrigley.

By 1984, I had settled down, gotten married a few years earlier and had refocused my energy as a Cubs fan. Again, they broke my heart along with that of every other Cubs fan. It seemed there was really a curse.

That same year, I met Helen, a dear friend of my mother's who lived in the same Chicago high-rise. She was a Cubs fan, and although we talked baseball a few times that fateful year, I didn't realize how that would change things in years to come.

Years went on, and the Cubs would pop in and out of first place. I moved to Wisconsin, got divorced, remarried and still the Cubs were there—as were conversations with Helen when we would talk and commiserate about the Cubs' fate. She was always asking me if this was gonna be the year. I would always smile and say, "You never know." I imagined she had lived with even more disappointment than I had because she was a bit older than me.

You see, Helen was born in 1916 and will turn one hundred years old the same year the Cubs celebrate their 100th season at Wrigley. Helen first became a Cubs fan when she was eleven years old listening to games on a radio at the general store in this small town in Wisconsin where her family's farm was located. Her family didn't have a radio at that time on the farm. This was in 1927, so I can only imagine listening to the radio, listening to the call of a Hack Wilson home run. Beginning in 1925, WGN would have farm and commodities reports around noon and, after that, came the Cubs broadcasts. There are Cubs fans everywhere because of WGN, and Helen was no different. She became hooked on baseball after that first broadcast.

She moved to Chicago after high school and started seriously attending games and following the Cubs. Then came a few bombshells: she had attended the 1938 World Series sitting behind third base and sat in the bleachers, her only time in the bleachers, at the 1945 World Series. She rarely has missed a game since becoming a Cubs fan.

During the last few years, I started feeling really bad for her. The Cubs were in the rebuilding mode again, but this time I had a feeling it might just go right. With the power of the Internet, I could see the team's vision happening, and I relayed this to Helen. You could feel her smiling through the phone as I told her to just hang in there and it will happen. How do you tell a ninety-nine-year-old Cubs fan to hang in there?

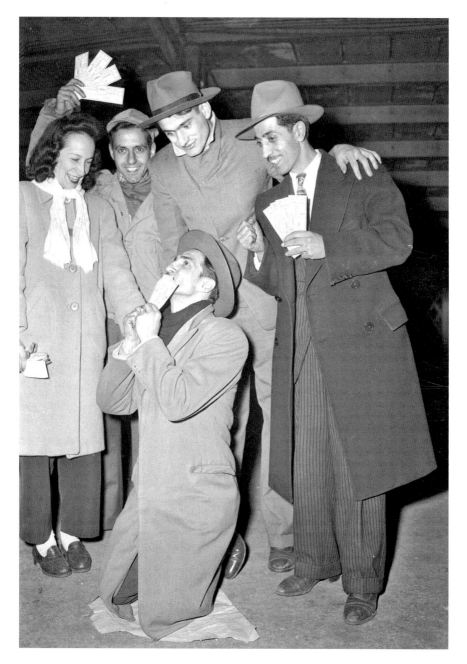

Fans rejoice after snagging a ticket to a game at Wrigley Field during the 1945 World Series, the last time the Cubs participated in the Fall Classic. *National Baseball Hall of Fame Library, Cooperstown, New York.*

Our phone conversations started before spring training in 2015 as I called to wish her a happy ninety-ninth birthday. She asked me again, "Is this the year?" And I said the same thing, "You never know." This time, I said it with a little more conviction. I would tell her about what the Cubs had on the farm, and she was just as giddy as I was as we wondered what would happen with this new season.

As every Cubs fan knows, the season kept getting more exciting. She wanted to take me to a game, but being busy on our farm, I declined. I did tell her she could take me to one if the Cubs go to the World Series. She said she would.

When the Cubs finally clinched a playoff berth, she was just like that little eleven-year-old girl from eighty-eight years earlier. She called, and I knew she was smiling. After the Cubs beat Pittsburgh in the wild card game, she was smiling but nervous again because next up was the Cardinals.

She brought up the World Series tickets and how she read in the *Chicago Tribune* about the cost of the tickets. She didn't think she would be able to afford them. Kiddingly, I said a deal's a deal. We would talk before and after every one of the games between the Cardinals and the Cubs. She would break down every play and pitch it seemed. Helen doesn't just watch the game as a fan; she watches it as keen observer. This wasn't a ninety-nine-year-old Cubs fan I was talking to; this was that eleven-year-old Cubs fan who was born down the road from where my farm is now.

Then came the Mets, and our hearts were broken again. Before the series began, I let her off the hook for the tickets to the World Series, not because I didn't think they would make it but because I could just imagine the cost of the tickets and the bodyguards I would need to protect us from the onslaught of a rabid fan base ready to explode.

After Game 4 against the Mets, I needed to decompress, and I knew she did, too. We had talked almost every day during the summer, and when we finally talked a few days later, we were both sad and happy at the same time. They gave us hope for the future, and I think we both had a chance to be young kids again.

INDEX

INDEX

ABOUT THE AUTHORS

Dan Campana, a freelance writer and communications consultant in the Chicago suburbs, wouldn't be around if it weren't for his parents meeting in Wrigley Field's bleachers. Aside from working and family, Dan's life has involved countless hours justifying his love for the Cubs to those who don't get it and even more time commiserating with other blue-clad fans who more than understand the special breed of people we are to endure this baseball journey we share. You can find Dan; his wife, Jen; and their son, Ryne, driving to Wrigley with BRXNIVY license plates on his car.

Rob Carroll is a writer and editor originally from Lacon, Illinois. His newspaper career began as a paper carrier when he was ten. By age nineteen, Rob was working in his first newspaper office. He held various positions at newspapers throughout northern Illinois and the Chicago suburbs. In addition to his newspaper career, Rob also spent time as a radio host. He saw the Cubs lose to the Giants on his first trip to Wrigley in 1984 but was treated to a Sha Na Na concert on the field after the game. Rob is currently a digital managing editor for a cluster of radio stations in Rockford, where he resides with his fiancée, Jillian, and their dogs, Benny and BlackJack.

In 2013, Dan and Rob co-authored *Wrigley Field: 100 Stories for 100 Years*. The *Chicago Tribune* described the duo's first effort as ideal bathroom reading among books released to mark the ballpark's 100th anniversary.

Visit us at
www.historypress.net
...
This title is also available as an e-book